W9-BBM-235

CAR ART

To Karen with best
wishes and good
painting!

Jo Taylor

WATERCOLOR WISDOM

Watercolor Wisdom

Lessons from a Lifetime of Painting and Teaching

Jo Taylor, AWS

NORTH LIGHT BOOKS
CINCINNATI, OHIO
www.artistsnetwork.com

About the Author ❧

Jo Taylor is a well-known artist and teacher who has earned local, state and national recognition. Her formal education was at North Texas State University in Denton, Texas, and at the University of Guanajuato, Mexico, where she studied as an exchange student. For years, Taylor took every possible opportunity to study with professional artists and teachers from the California and New York professional art schools. Her entries and awards earned her active membership and signature status in the American Watercolor Society in 1977, making her the first woman from Texas to achieve that honor. She is one of the charter members and a signature member of the Southwestern Watercolor Society in Dallas, Texas. She was elected an honorary member of the New Mexico Watercolor Society and the watercolor society in Mt. Pleasant, Texas, and she has been made an honorary member of the board for the Rockwall Artist's League in Texas.

Taylor painted full time for gallery shows for nearly seven years. Her paintings appear in museums as well as private and corporate collections. Several of her award-winning paintings have been accepted into the permanent collection at Baylor University in Waco, Texas, as part of a collection from a private entity.

Taylor has taught seminars and workshops throughout the country. She taught as a full-time painting instructor at Northeast Texas Community College in Mt. Pleasant for fourteen years, attaining faculty emerita status. It was while teaching there that her basic concepts of design were more finely honed and became the central focus of her painting and teaching. Her reputation well established, students were soon driving great distances to study with her. Taylor carefully analyzed and critiqued her advanced students' weekly output while gently guiding the beginning students through their preliminary exercises. The college gladly sponsored successful summer workshops for Taylor at the Instituto in San Miguel de Allende, Mexico.

Taylor resides in Rockwall, Texas. Visit her website at www.JoTaylorAWS.com.

Watercolor Wisdom. Copyright © 2003 by Jo Taylor. Manufactured in Singapore. All rights reserved. No part of this book may be reproduced in any form or by any electronic or mechanical means including information storage and retrieval systems without permission in writing from the publisher, except by a reviewer who may quote brief passages in a review. Published by North Light Books, an imprint of F&W Publications, Inc., 4700 East Galbraith Road, Cincinnati, Ohio 45236. (800) 289-0963. First edition.

07 06 05 04 03 5 4 3 2 1

Library of Congress Cataloging-in-Publication Data
Taylor, Jo.
 Watercolor wisdom : lessons from a lifetime of painting and teaching / Jo Taylor—1st ed.
 p. cm.
 Includes index.
 ISBN 1-58180-240-4 (alk. paper)
 1. Watercolor painting—Technique. I. Title.

ND2420 .T39 2003 2002029529
751.42'2—dc21 CIP

Editor: Stefanie Laufersweiler
Cover designer: Lisa Buchanan
Interior designer: Wendy Dunning
Production artist: Rebecca Blowers
Production coordinator: Mark Griffin

Metric Conversion Chart

To convert	to	multiply by
Inches	Centimeters	2.54
Centimeters	Inches	0.4
Feet	Centimeters	30.5
Centimeters	Feet	0.03
Yards	Meters	0.9
Meters	Yards	1.1
Sq. Inches	Sq. Centimeters	6.45
Sq. Centimeters	Sq. Inches	0.16
Sq. Feet	Sq. Meters	0.09
Sq. Meters	Sq. Feet	10.8
Sq. Yards	Sq. Meters	0.8
Sq. Meters	Sq. Yards	1.2
Pounds	Kilograms	0.45
Kilograms	Pounds	2.2
Ounces	Grams	28.4
Grams	Ounces	0.04

Acknowledgments ∿ I give my deepest appreciation to the great artists and teachers from the past and present who generously shared their knowledge with me.

I want to thank every one of my family members who in so many ways contributed to the making of this book. Thanks especially to my son-in-law, Ron Morgan, who taught me how to use a computer and gave me his personal emergency phone number, which we quickly came to refer to as 9-1-1. Thanks to my daughter Mary Aslan for her help, especially for transporting paintings to the photographers and for her constant encouragement. Thanks to my dear son, Bob Taylor, whose "right arm" of support extended a long distance, and to another daughter, Beth Morgan, who lived next door and listened to page-by-page problems. Thanks to my dear sister Nenie Duncan—an artist herself—for her evaluations and for saving us from bologna sandwiches. If my husband had been my press agent all of these years, I would have had international and universal recognition; thank you, Jodie, for your interest and support. Last but not least, I thank my friends who gave me encouragement, love and friendship despite years of absolute neglect on my part.

Deepest appreciation to my friend and colleague, Dr. Olive J. Theisen, for proofreading my manuscript and making me look like a good speller. Many thanks to my dear friend Faber F. McMullen for many years of giving me motivation, confidence and encouragement for the development of this book.

Thank you to Angie Kedersha and the entire staff at BWC Photo Imaging in Dallas, Texas, for their cooperation and efficiency in doing the photography for this book. A special thanks to Cindy Newton for her excellent photography.

It has been such a pleasure to work with every person that I have come into contact with at North Light Books. Thanks especially to Greg Albert, who first contacted me years ago about doing a book. My sincere thanks to the entire staff, who gave me the ultimate compliment in their selection of the title for this book. My deepest appreciation to Rachel Wolf and Stefanie Laufersweiler, whose help and encouragement were invaluable to me.

Dedication ∿ This book is dedicated to my students, who have perhaps taught me the most.

Many of the students mentioned in this book were in my private classes before I began teaching at Northeast Texas Community College. Many of these students joined my classes there. Some of these students are of professional status now and have signature ranking in top art organizations. I am forever amazed at their individuality, which can only happen when students originate their own subject matter and modes of painting. To all of these wonderful students I directed my information, love and encouragement. They gave me the inspiration to gather material for this book. I make my humble bow to you, dear students.

Table of Contents ❧

CHAPTER ONE
Color ～ 12

CHAPTER TWO
Brush Practice and Texture ～ 32

CHAPTER THREE
Composition ～ 56

Foreword ～ This book documents Jo Taylor's long and successful career as a painter and teacher. It provides useful counterpoint to the prevailing notion that art has no standards, no academic rules and no common movements. Taylor shares her teaching workbook with us, an enjoyable read, which is full of personal anecdotes and beautiful images. Out of nearly a half century of painting and teaching, she has constructed a classic book on watercolor painting with strong emphasis on the elements and principles of design.

These design elements have often been set aside in the exuberance of experimentation and innovation that has characterized so much of the previous century. With the formal rules of design and composition set aside, painting students were left to work out technical and structural problems alone. Some instructors often withdrew in interest of personal issues, hoping that the law of averages would produce good painting in the end.

Taylor's comprehensive book on watercolor reaches back into the classic strategies for the development of strength in painting. Taylor has had the opportunity to study with many of the master East and West Coast teachers of painting and has distilled their techniques into her own unique way of teaching and evaluating painting. In this text, beginners will find a solid foundation for the study of painting, while advanced artists are likely to discover evaluative approaches that will strengthen their work.

Olive Jensen Theisen
Art Program Chair and Faculty Emerita
Northeast Texas Community College

AUTUMN TREASURES · Jo Taylor · Watercolor and mixed media · 22" × 30" (56cm × 76cm)

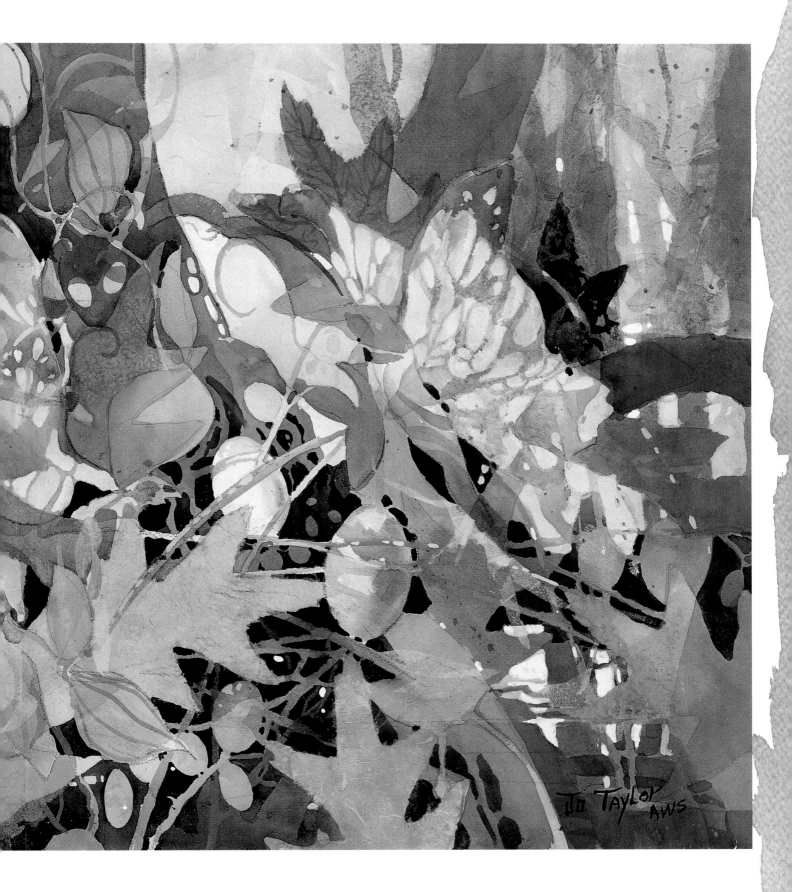

Introduction ❧ This book is for the beginning painter, the advanced painter and the accomplished artist. It has been an important part of my teaching materials for years, providing useful tools for many student artists. I have learned much in my years as a practicing artist and teacher, and what you see in this book is what I believe will help you the most in your own journey as an artist.

As with any developed skill, the beginning must consist of the basics. In the game of golf, some of the first things learned are the proper stance and position of the feet. Even small details like the placement of the thumbs when gripping the club become critical to your accuracy and skill. In painting, you must start with the basics of color, texture, value, technique and composition. Small details such as how you hold your brush, the mix of colors you use and the paper you choose all create the difference between an ordinary painting and a remarkable one.

Few books on painting emphasize the importance of understanding design as this one does. The elements of design create a structural language for the painter. In this book, you will learn this language and how you can use it to create beautiful, original paintings. You'll also discover many practical suggestions, such as what to do when "the well runs dry," how to learn from your mistakes, and how to save a "bad" painting. Along with numerous examples of my own painting as well as some student work, you'll find assignments and design exercises to help you grasp key concepts.

One of the goals of any artist is personal development and growth. The path taken in any field of endeavor, as we all know, can often determine success or failure. This book suggests a pathway—a foundation for growth through the study of the structural language of art. In music there are the notes, keys and chords with which to compose. In the visual arts there are the elements and principles of design. This language of art is applicable to any style of work, whether absolute realism, abstraction or nonrepresentation. This book fuses technique, style and design—the keys to great painting.

Through understanding the basic fundamentals—and a lot of practice!—success is sure to follow. It is my greatest hope that this book will make the pathway easier for you on your journey of painting discoveries. Once past the basic fundamentals and exercises, you will discover new ideas, shapes and details seen through the eyes of the artist within. This book will be your starting point. The discovery will be yours.

KISS OF THE PRINCE · Jo Taylor · Watercolor and gouache · 15" × 11" (38cm × 28cm)

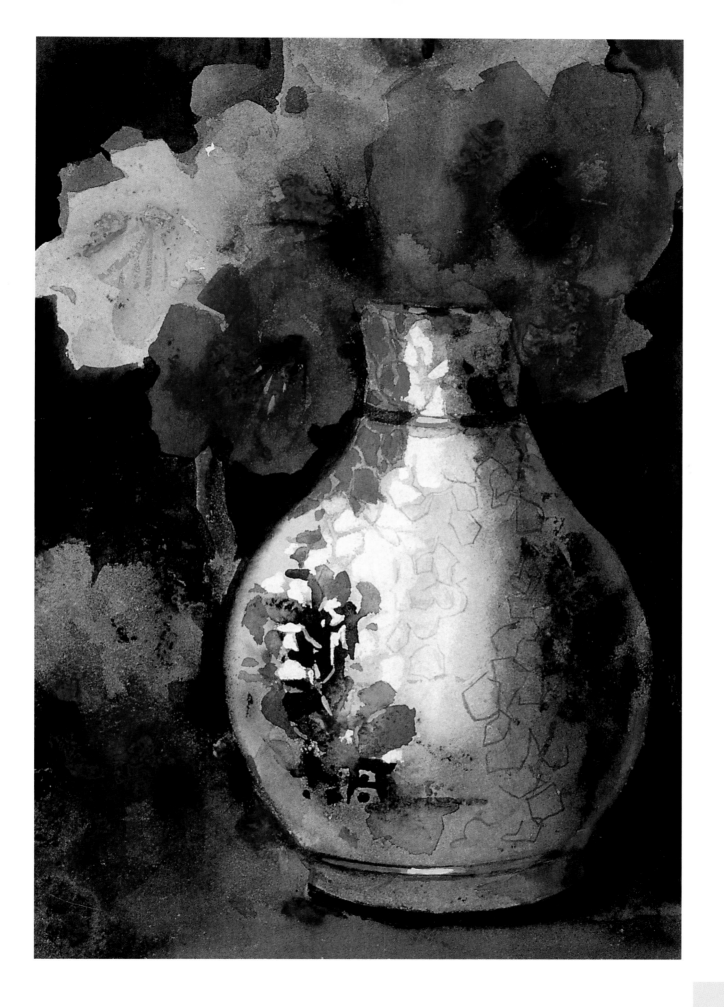

ONE ~

Color ~

For many years there has been an abundance of information written about color. Everything from the very simple to the most complicated theories seems to have already been written. However, as redundant as it may be, it seems appropriate that this book should also begin with color. My first realization that painting was the thrill of a lifetime for me came at the age of five or six when I discovered colored rocks. I filled pans from my mother's kitchen with rocks of every color from the fields and streams where I grew up. No sidewalk around my home or school escaped my creative urges.

Artists always want to know more about color. I encourage many of my long-term students to attend as many other workshops and seminars as possible. They always "have to know" every color that all the other teachers use so they can try them out. It is amazing to look in their supply boxes at the array of paint tubes, color wheels and books about color. These students have an insatiable desire for the knowledge of color, reminding me of my constant search as a young child for different colored rocks that might be even more beautiful.

In this chapter, we'll get started with the basics of color, including how to set up your palette and mix color. You'll also learn the different color plans you can choose for a painting. As you have undoubtedly heard before, "Knowledge is power." Knowledge of color will be one of your most powerful painting tools. ~

The color wheel

The very first artists did not have a color wheel. They mostly used whatever colors they could find to depict the colors of the things they saw. In the seventeenth century, Sir Isaac Newton discovered the prism or scale of colors. It was some time later in the early eighteenth century that the color wheel came into being.

The color wheel shows in a simple way the relationships of colors to each other. Make use of this important tool to help you understand color and how you can use it to create better paintings.

Color terms you need to know
You're likely to hear the same terms brought up time and time again when color is the topic of discussion. But do you know what they really mean? The first step to understanding color is to know the language. Here's a primer:

Hue—A color as described by its location on the color wheel.

Value—The relative lightness or darkness of a color.

Intensity—The brilliance of a color, ranging from dull to bright.

Key—The value of a color or value dominant in a painting, ranging from light to dark.

Primary colors—The three basic colors (yellow, red and blue) from which all other colors are created.

Secondary colors—Colors created by combining two primaries (violet, orange and green).

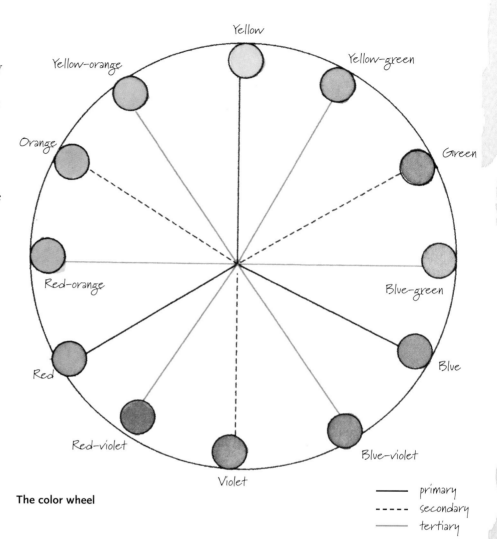

The color wheel

——— primary
- - - - secondary
——— tertiary

Tertiary colors—Colors created by combining an adjacent primary and secondary color (blue-green, red-violet, etc.).

Complementary colors—Colors that are opposite each other on the color wheel.

Analogous colors—Colors that are next to each other on the color wheel.

Warm colors—Colors that generally appear warm in temperature (red, yellow and orange). The perception of the warmth or coolness of a color is always relative, so even a warm color can have a cool version. For example, red-violet is typically cooler than red-orange. Any warm color will appear warmer when placed next to a cool color.

Cool colors—Colors that generally appear cool in temperature (blue, green and violet). Cool colors can appear warm depending on their comparison colors.

Setting up your palette

My palette of colors has been in transition for many years as the pigments and their manufacturers have changed. However, the layout of my palette has remained the same.

I use a John Pike palette, which is heavy in weight, durable for scrubbing and cleaning, and isn't likely to be knocked off of a table and spilled. I like its raised cups because the muddy paint in the center of the mixing area doesn't flow into the other colors. I don't like palettes that have wells for the color because the muddy paint stays in the paint cup.

If you can imagine that my rectangular palette is a circle, you'll see that the colors are laid out like a color wheel. Spaced fairly equally are the primary colors, with the secondary colors placed in between. This is a useful setup for beginners who are sometimes uncertain of how to mix the secondary colors. With this arrangement you can easily see, for example, that red and blue make purple.

On the palette on the opposite page, I've included formulas for mixing your own green and gray. These are transparent colors that give life and luminosity to your darks. (You'll learn more about mixing color on the next few pages.)

I keep some white gouache beside my palette when I'm painting. I sometimes use it for highlights or special effects, but mostly for painting small areas (*not* large ones) where I wasn't able to save the white of the paper.

Transparency and opacity

There are two kinds of pigments: *transparent* and *opaque*. You should know which colors on your palette are transparent or opaque because it will affect what colors you use as you paint. Transparent colors allow light rays to penetrate them and reflect the white paper beneath. This gives luminosity or brilliance to the color. When light rays return from an opaque color, the white of the paper is blocked and only the grain of the pigment is reflected. In watercolor, the only source of light is the white of the paper; therefore, the more transparent the color, the more luminous it is.

To test the transparency or opacity of the colors on your palette, try this: Paint a rectangle of India ink on a piece of watercolor paper. Allow the ink to dry completely. Next, paint small strips of each color over the dried ink. If the color you are testing is opaque, you will see a residue of pigment on top of the ink. If it is transparent, it will sink into or merge with the ink and not be visible to the eye.

Generally, transparent colors are used for the larger washes of a painting, and the more opaque colors are used in smaller areas. For instance, all cadmium colors are opaque, so save them for smaller areas most of the time.

Staining and non-staining colors

It's important for you to know the characteristics of each color on your palette, including whether it is staining or non-staining. Staining colors are more permanent and more difficult to lift from the paper. Paint swatches of color from your palette onto a large sheet of watercolor paper and allow them to dry completely. Then wipe each color with a silk sponge and water to see which ones stain the most. The ones that leave the most stain are the more permanent colors (usually the transparent ones).

Buying your paints

Since Liquitex quit selling watercolor paint years ago, I still consider my palette to be in transition. I can only tell you what I am presently using and it may change as I explore other manufacturers. I use four Winsor & Newton colors (Winsor Red, Winsor Blue, Indigo and New Gamboge). I choose Grumbacher for the other colors because they have had a very long history in making both oil and watercolor paints, and most of their colors are of a good consistency. They stay moist on the palette longer, and the fresh paint doesn't run to the center of the palette.

When starting out as a student, I used the more inexpensive student-grade paints for a number of years. Your practice painting will be more effective when you can be free to explore without being concerned about waste. Also, for beginners, it is difficult to tell any difference between student-grade and professional paints. However, as you progress and your painting improves, you will become more concerned about the preservation of your paintings. At that time, it's better to start using professional-grade paints if your budget allows.

On a budget? ❧

If you can't afford to buy all the paint colors you want, do without something else—a trip to the movies, a dinner out, junk food, etc.—and buy a variety of a good manufacturer's red, yellow and blue, since these are the three colors from which all other colors can be mixed. It will take practice, but your mixing skills will pay back tenfold.

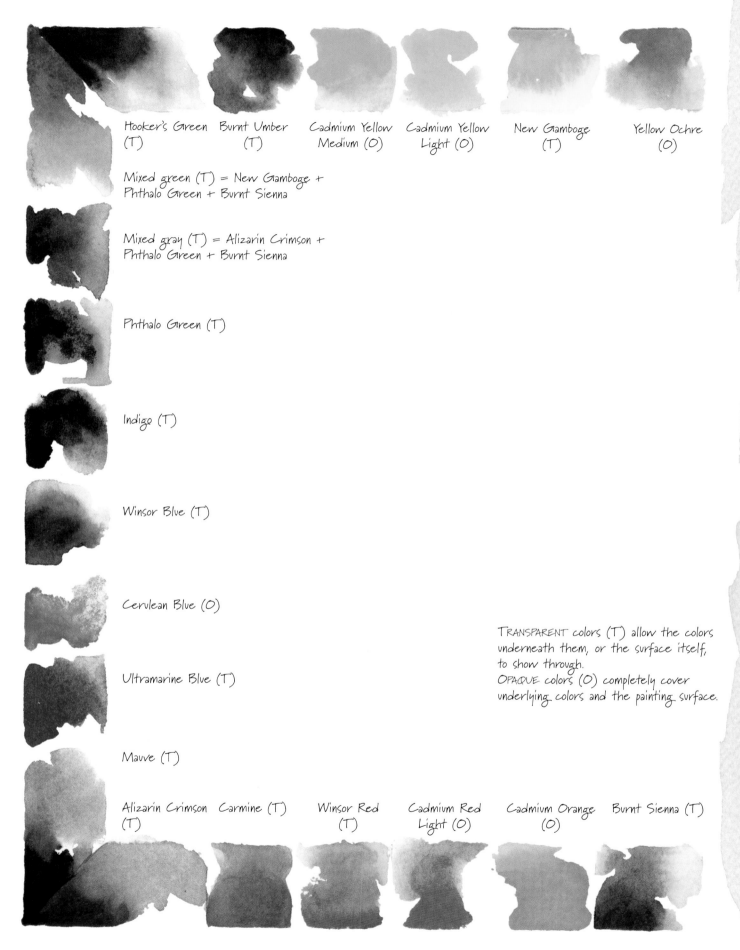

Hooker's Green (T)

Burnt Umber (T)

Cadmium Yellow Medium (O)

Cadmium Yellow Light (O)

New Gamboge (T)

Yellow Ochre (O)

Mixed green (T) = New Gamboge + Phthalo Green + Burnt Sienna

Mixed gray (T) = Alizarin Crimson + Phthalo Green + Burnt Sienna

Phthalo Green (T)

Indigo (T)

Winsor Blue (T)

Cerulean Blue (O)

TRANSPARENT colors (T) allow the colors underneath them, or the surface itself, to show through.
OPAQUE colors (O) completely cover underlying colors and the painting surface.

Ultramarine Blue (T)

Mauve (T)

Alizarin Crimson (T)

Carmine (T)

Winsor Red (T)

Cadmium Red Light (O)

Cadmium Orange (O)

Burnt Sienna (T)

Mixing color

Few painters paint with pure or "raw" color straight from the tube. While pure color sometimes has its purpose, understanding color mixing is an important aspect of painting. For example, Phthalo Green makes beautiful nature greens when tempered with Burnt Sienna. Carmine is useful for warming up certain colors (see page 17).

Most of my colors are mixed in the center of a clean palette. I frequently adjust colors as I paint because all colors need to be toned down or grayed as they recede into the distance. This is applicable to still lifes as well as landscapes.

I almost always gray down a color by adding its complement. A very small amount of a complement will gray a color a lot. To adjust the value to a darker version of the same color, adding a color from the same family will keep the color more vibrant and luminous than if you added black or the complement (which grays). For example, if I need to darken Winsor Red, I add another version of red such as Alizarin Crimson.

As you practice painting and mixing colors, your own personal taste will influence your color choices and combinations. The best way to learn about color mixing is to paint, paint, paint!

Matching color

During the painting process there is a lot of not only mixing color, but matching color. Matching color is more exacting and difficult to do than mere mixing. Unless you can create a painting in one sitting without interruption, there will be times when you must walk away from a painting and return to work on it after the watercolor has dried. It will be easier to pick up where you left off if you can easily match your colors.

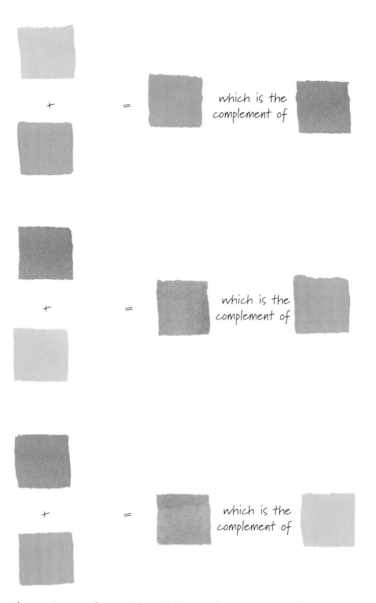

Three primary colors and how their complements are made
The complements of red, yellow and blue are made by combining the other two primaries.

To sharpen your skills, pick out an old or unsuccessful painting and try to match the colors exactly. Judge the color you are trying to match by asking yourself: Is it lighter or darker? Warmer or cooler? Watercolor always dries lighter by one or two shades, so wet the old painting first with water, using a very soft brush. This will make the color you're matching as dark as the color you're mixing. Then put swatches of matching color beside the colors on the painting.

Original color	Lighter	Darker	Toned down

| New Gamboge | + water | + family color (Burnt Umber) | + its complement (violet) |

| Winsor Red | + water | + family color (Alizarin Crimson) | + its complement (green) |

| Winsor Blue | + water | + family color (Indigo) | + its complement (orange) |

EXERCISE

Adjust colors

With practice, mixing and adjusting color becomes second nature. Try lightening, darkening and toning down various colors on your palette. Adding water automatically lightens any color. Adding a family color to an original color typically darkens it. A color plus its complement results in a toned-down version of the original color.

Original color	+	Carmine

Ultramarine Blue

Winsor Red

Alizarin Crimson

Cadmium Orange

New Gamboge

Mauve

EXERCISE

Warm up colors

Paint swatches of color down one side of a piece of watercolor paper. Then add a bit of Carmine to each individual color and paint a second column of swatches. See how the simple addition of the same color affects each original color differently? Sometimes the Carmine simply warmed up a color; other times the addition resulted in a complete color change (from yellow to orange, blue to violet).

Let your eyes do the mixing ∿

In the nineteenth century, Impressionism introduced the idea of optical color mixing. Georges Seurat (1859-1891) advanced the technique. In Impressionism, there is no actual mixing of paint. Mostly primary colors are used to make small dots in the form of an image. From a distance, the eye mixes the dots to create other colors. For example, when red and blue dots are placed next to each other, the eye sees the two colors as purple, just as it is when they are actually mixed. Together, blue and yellow dots look like green.

Glazing

Glazing is an overlaying of different colors that allows each color to dry before the next layer of color is added. This is very different from another traditional watercolor technique, wet-into-wet, in which the paper is wet on both sides and kept wet while painting.

In glazing, there is no physical mixing of paint, but you'll notice a change: Your original color may seem intensified or toned down, or you may even see that a new color has been created. The light of the white paper shows through the transparent layers, giving the colors a richness and vibrancy that cannot be achieved in any other way.

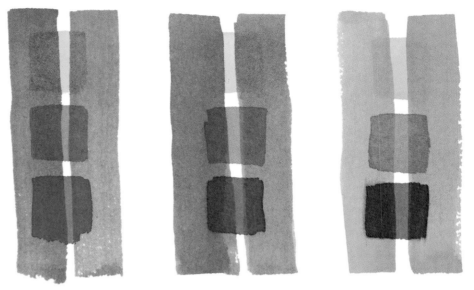

A long journey for the three primaries
See how much of a difference a glazing of color can make? In this example, the secondary colors have been glazed over the three primaries, creating unique results for each combination of colors.

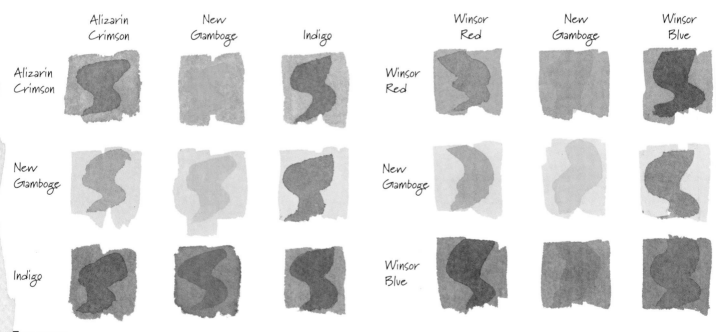

EXERCISE

Make glazing charts

Most inexperienced painters know that red and blue make purple, but in this example you can see that Alizarin Crimson and Indigo make a different purple than the combination of Winsor Red and Winsor Blue. Make charts with many different color combinations to learn the differences, however subtle or strong.

Try this: Paint a vertical strip of each color from your palette onto your paper, leaving some white in between. Allow the strips to dry completely. Then, in the same order, paint the same strips of color horizontally across the first colors. You will be able to see what all of the colors on your palette look like when glazed over each other. You'll also see which colors are opaque and which are more transparent.

Value range of colors

Every color is simultaneously a certain value, and every color has its own range of values, from dark to light. For instance, add varying amounts of water to a color straight from the tube and you suddenly have many lighter values of that color to paint with.

Measuring value

In art, values of color are numbered according to their range from very light (1) to very dark (10). Most of us are familiar with the gray scale of values, but it is important to also understand the value range of each color. Some colors, as they come from the tube, are light and some are very dark. Understanding the value range of each color can help you create contrast in a painting to give it the visual impact it needs.

Try the following exercise. You will not only become familiar with the value range possible for each color, but gain valuable practice in creating a graded wash (a wash of color that starts dark and gradually gets lighter, or vice versa).

EXERCISE

1. **Pre-wet your paper** and prop it up on a slightly slanted surface. This will allow gravity to help the flow of the color.

2. **Load your brush** with a very light shade of the first color (a bit of paint and a lot of water).

3. **Holding your brush** much like you would hold a pencil, lightly rest your arm and hand on the slanted surface, then slowly pull your entire arm toward you, painting a strip of color. While doing this, focus your eyes on the inside edge of your brush, watching the line as you make it. This is good practice for defining and controlling edges in a painting.

4. **With the strip now wet** with the light shade of color, continue to darken the strip at the top by applying less pressure on the brush, then lighten it gradually as you pull down to the bottom. Keep repeating this as necessary to make the color at the top as dark as the color is when it comes from the tube.

Don't be discouraged if your strips of color are not as neat as mine. I cheated and cut out the strips when they were dry!

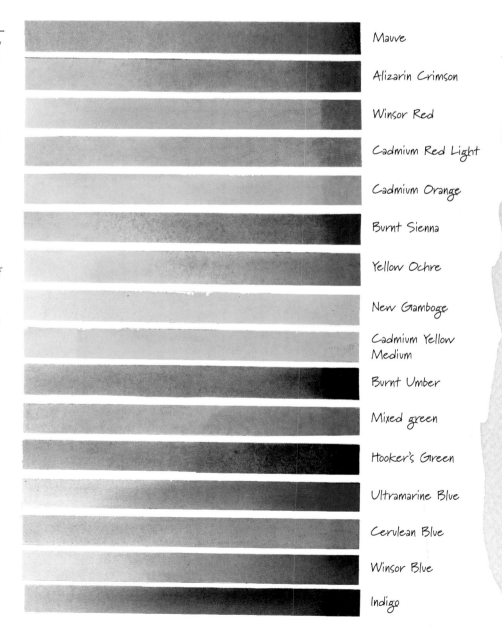

Mauve

Alizarin Crimson

Winsor Red

Cadmium Red Light

Cadmium Orange

Burnt Sienna

Yellow Ochre

New Gamboge

Cadmium Yellow Medium

Burnt Umber

Mixed green

Hooker's Green

Ultramarine Blue

Cerulean Blue

Winsor Blue

Indigo

Mixing your own blacks for luminosity

Black is not just one color in watercolor. Some blacks are transparent with a limited value range; some blacks have a long value range and are fugitive (fade rather quickly); other blacks, made from charred bones, create dull and uninteresting darks. If we want luminosity in a painting, the most desirable pigments are the transparent ones that contain no actual black at all.

I use two combinations for mixing my own black. When the black will be used with warm colors, I mix about half-and-half Alizarin Crimson and Indigo. If the mixed black will be used with cool colors, I use Alizarin Crimson, Phthalo Green and sometimes Burnt Sienna. It is better to use the mixed black only for darker values and not to darken shades of individual colors. Use the family of color to make any color a darker shade.

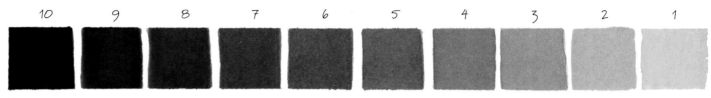

| 10 | 9 | 8 | 7 | 6 | 5 | 4 | 3 | 2 | 1 |

EXERCISE

Create darker shades of the same color

Try doing this value scale. First, mix a large puddle of Alizarin Crimson and water for an approximate value 1, to be used throughout. Paint each of the ten blocks with this mixture, and let them dry. Now, beginning with value 2, glaze the same mixture over squares 2 through 10 only. Let this dry, then begin with value 3 and glaze the same mixture over squares 3 through 10. Continue this until the scale is finished. To achieve the darkest possible 8, 9 and 10 values, it is usually necessary to add more pigment. Adjustments of value will have to be made, but your control of color value will be increased.

Mixed black with Winsor Red

Mixed black with New Gamboge

Mixed black with Winsor Blue

Mixed black with green

Mixed black with violet

Mixed black with orange

The subtlety of black

These examples are mini value scales representing the light, midtone and dark of these colors. Notice how a mixed black will take on the subtle influence of the color beside it, although the black is painted on plain white paper beside each color without any mixing.

Yellow tip ❧

All yellow pigment has a limited value range, whether it is transparent or opaque. A quick way to create a value 10 yellow—which is often needed—is to use Burnt Umber, a very dark, transparent yellow-brown. Burnt Umber mixes well with New Gamboge to make a good value 10 yellow. It is grouped with yellow on my palette for this specific purpose.

Mixing grays

Have you ever heard the saying, "Gray makes color sing"? Any color will appear brighter when placed next to a gray. Mixed grays can be especially useful when you are trying to achieve a warm- or cool-color dominance in a painting. If you are using predominately warm colors, you should also use warm grays. In a predominately cool color scheme, use cool grays.

The three primary colors (red, yellow and blue) make gray when mixed together. Any individual primary mixed with its complement will make gray. The mixed gray created from Alizarin Crimson, Phthalo Green and Burnt Sienna is a favorite of mine also— I sometimes use this mixture to draw a composition on my watercolor paper (in a very light shade), or for a quick value study of light and dark shapes, but never to gray a color.

Of course, you could always buy gray in a tube, but in the selection of grays available, there are few if any warm or cool shades to choose from.

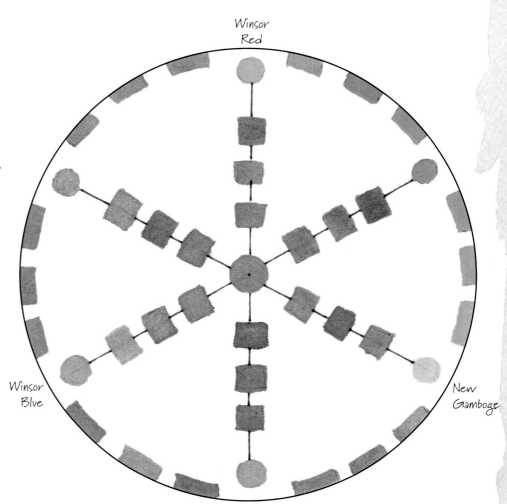

The many shades of gray
The mixture of neutral gray in the center of the wheel was made by mixing the primaries Winsor Red, Winsor Blue and New Gamboge. To this neutral gray, shades of all the other colors were added to show the many varieties of gray. Incidentally, this color wheel has been expanded to show more varieties in the tertiary colors (the rectangles).

The intensity of color

Intensity and value are not the same thing, although some artists have trouble with this concept. *Intensity* refers to the brightness or dullness of a color. *Value* refers to the lightness or darkness of a color.

The intensity of the colors you use in a painting will help convey the feeling or mood you intend. High-intensity colors are used frequently in advertising to attract attention. You would use a high-intensity triad to express a happy, carefree or blissful mood, or maybe the feeling of lovely wildflowers in springtime. A low-intensity triad can set a very different stage. It may successfully convey a rainy day, fog or a somber mood in your painting.

Tip ❧

When you have reason to intensify the warm colors, try tempering them with a little Carmine or Opera Pink.

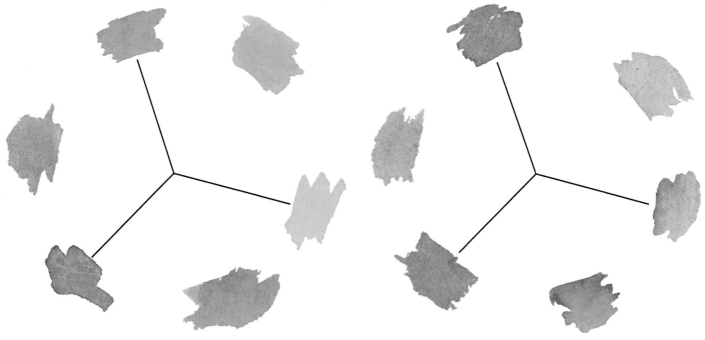

High-intensity triad
This triad was created with combinations of the primary colors Winsor Red, New Gamboge and Winsor Blue.

Low-intensity triad
This triad was created with combinations of the primary colors Burnt Sienna, Yellow Ochre and Indigo.

Colors are affected by their surroundings

A color's appearance can change depending on whether it is placed near its complement or next to a similar color, and how light or dark, warm or cool the adjacent color is. I call this the keying of color. Some teachers call this "pushing" a color.

When I tell you that the two purples in the centers of the squares below are exactly the same, you may not believe me at first. The purples appear to be different because of the influence of the surrounding colors. The oranges, greens and blues in the center of each of the remaining squares are also exactly the same but appear to be different merely because they are surrounded by warmer or cooler, lighter or darker colors.

For a moment, stop and think about what this can do for your painting. With the right use of color, you can lead the viewer's eye where you want it to go. You can bring attention to the focal points in your composition or create a pattern for the eye to follow.

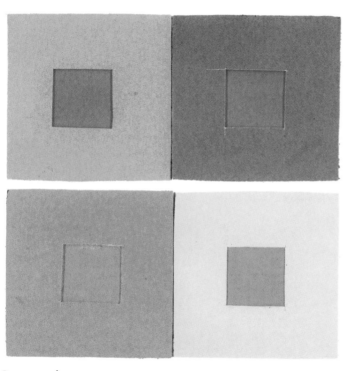

Same purple, same orange
The purple center on the top left is surrounded by a warm orange and appears to be cooler than the purple center on the right side. The purple center on the top right looks lighter and much warmer because it is surrounded by a cooler, darker blue.

The orange center on the bottom left appears to be lighter because, although the color is close, the value is darker. The orange center on the bottom right looks much darker because it is surrounded by a lighter value.

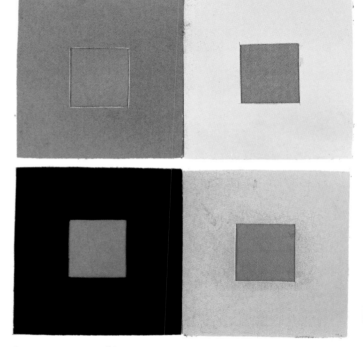

Same green, same blue
The small green center on the top left appears warmer in color and much lighter in value than the same green on the right side. The small blue center on the bottom left appears to be much lighter in value than the blue center on the right because it is surrounded by black. By definition, black is the absence of color. Consequently, it is interesting to note that there is little or no difference in the warmth or coolness of the two center blues.

EXERCISE

Paint blocks of color and surround them with different values and shades of warm and cool grays to see how grays can influence color.

Five color harmonies for realistic painting

There has been a great deal of research about the effects of color. One such experiment was conducted with prison inmates who often became irate or had violent reactions. They were calmed when put into a room painted vivid pink. Blue was found to lower blood pressure and heart rate. Certain colors have a calming effect, while others stimulate excitement, cheerfulness or tranquility. We've all heard of "having the blues" and "seeing red."

The largest area of color usually creates the color dominance in a painting. It will be the most important color you'll use to express the mood of the subject matter. Traditionally this area is less intense and balanced by smaller areas of brighter color.

Interior designers, architects and professional artists have been using the color harmonies on these pages for many years. Personal preference will inevitably affect the colors you use. However, since color has an effect on your viewers, ask yourself these questions: What emotional effect do I want the painting to have on the viewers? What am I trying to express? What colors would best describe my feelings about the subject? Your colors should always support the purpose and content of your painting. It is only then that you can use color to express or convey feeling and mood rather than merely reporting fact.

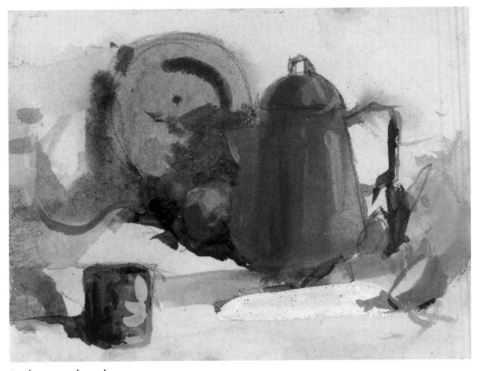

Analogous color scheme

This scheme has a closer harmony of colors with less contrast than most of the other schemes. It is usually made up of three colors and one tertiary color on each side. Analogous color schemes are often chosen to express calm and restful feelings because there is no contrast of color from across the wheel. This is not always the case, though; in this quick study, the red is brighter and more expressive of motion and activity.

Just because you are limited to a few colors doesn't mean you are limited in tints of color or value contrast. Varying the intensities and values of analogous colors will help you create a strong painting.

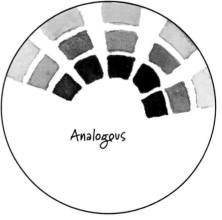

Analogous

Use two or three colors that are next to each other on the color wheel. The colors may be warm (reds, yellows and oranges) or cool (violets, greens and blues).

Don't let a limited palette limit you ❧

The complementary color scheme is more limited because of the use of only two colors. However, you can achieve variety with fewer colors by:

• Using some of the tertiary colors on either side of your two complements. These colors are sometimes called near complements. Instead of using just plain blue, you could use blue-green and blue-violet. You would not only have orange, but yellow-orange and red-orange, too.

• Varying the intensity (dullness or brightness) of each of your colors.

• Varying the values of your colors, using lights, darks and midtones in different areas.

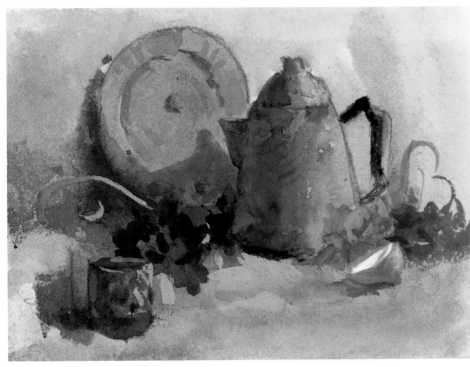

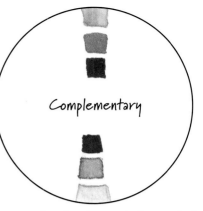

Use two colors directly opposite from each other on the color wheel. One color should dominate.

Complementary color scheme

This color scheme is a good choice for an exciting subject because of its strong contrast of color. In this example, violet is the dominant color, and the range of yellow extends to the yellow-greens. The range of violet extends to the red-violets and blue-violets. Contrast of value can add further drama and excitement to this color scheme.

Dominance of one color may be achieved by increasing the amount of area it covers (as in this example), or through intensity of color or value contrast.

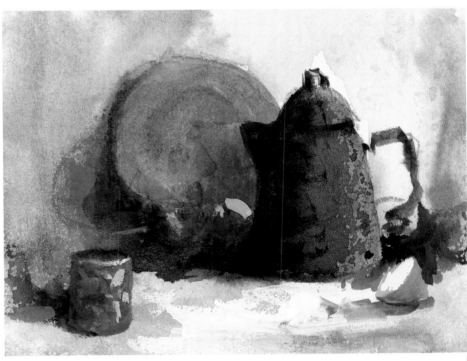

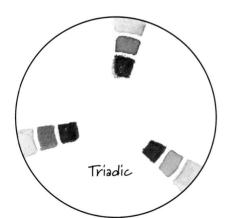

Use three colors that are equidistant from one another on the color wheel. One is usually the dominant color and the other two are either used less or are less intense.

Triadic color scheme

When your subject has many different colors, this might be a good choice for a color scheme since there is a wider range of color to choose from. The triad of red, yellow and blue is a combination that appealed to me the least, but a thought like that usually triggers a challenge for me, so I tried it in this quick study and in a few paintings.

Harmony will be destroyed if all three colors are used in full intensity. One of the colors should dominate. In this example, blue is more dominant than red or yellow.

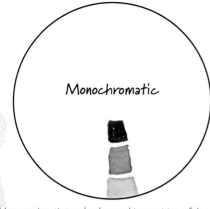

Monochromatic

Use varying tints, shades and intensities of the same color.

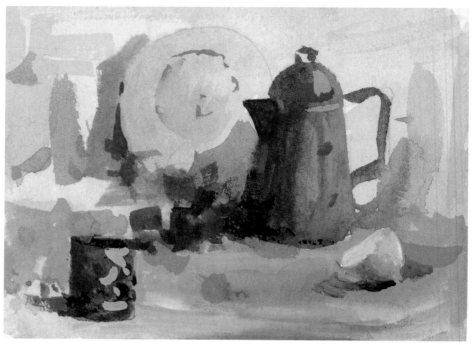

Monochromatic color scheme
This color harmony is a good scheme for beginners to use for working out value plans, since it usually seems like too much at first to consider values of several different colors at the same time. The wide value range of one color can be beautiful. It is not as exciting as the schemes that use a wider range of color, but it produces a restful, understated effect that also has its purpose in painting.

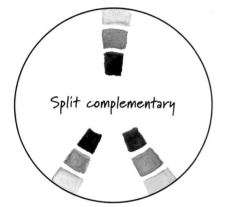

Split complementary

Use two colors from one side of the color wheel to balance a dominant color on the opposite side.

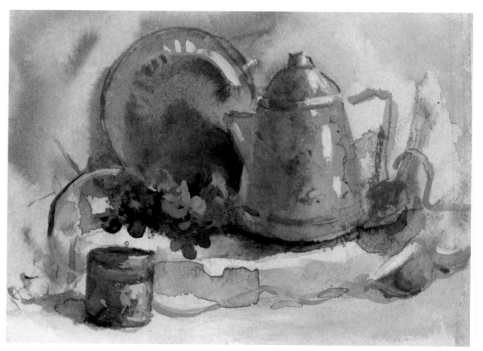

Split complementary color scheme
This is often the color scheme that I choose because it has a wide range of color and value contrast, which is known to be stimulating and exciting.

Not every color can have top billing ❧

Allow only one or two colors to be the star of your painting, and give the other colors supporting roles. Unity will exist where there is dominance.

Five color harmonies for abstract painting

The same color harmonies used in realistic paintings can be applied to abstract paintings. On the next few pages are examples of specific color harmonies in an abstract style. In the first image on each page, the color harmony is chosen but each piece seems to have little relationship to the other pieces. In the second image the same colors are used, but through repetition of color, value, line and texture, an overall compositional unity is achieved.

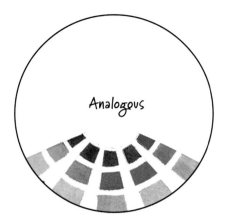

Analogous

Can you repeat that? ꕥ

By repeating colors throughout your painting, particularly the brightest colors, you can create an interesting path for the eye to follow. A pattern of darks and lights can provide focal points that will lead the eye around your painting in a rhythmic pattern.

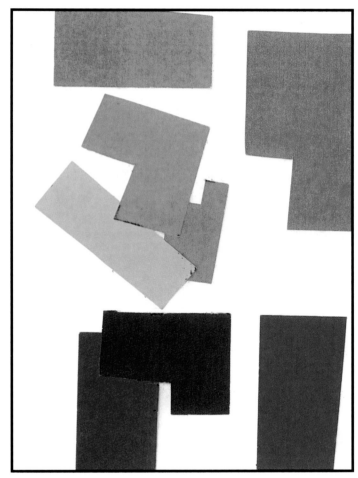

Not unified
In this image there are only separate colors and shapes without any connection to each other. Your eye moves slowly from one piece to the other.

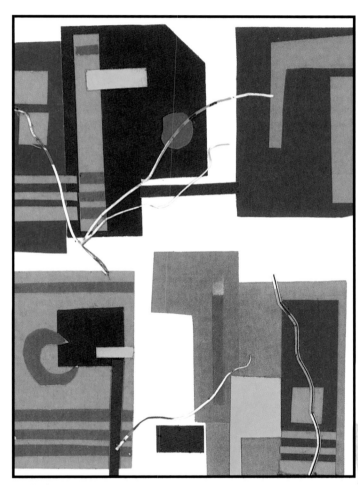

Unified
As you look at this image, your eye will not stay still. Repetition of color, shape, value and line creates movement that carries your eye through the composition.

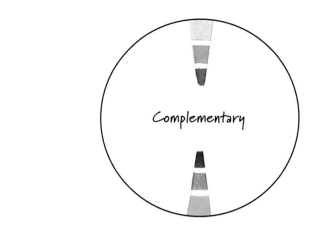

Complementary

Unified

This composition is given unity with only a minimal number of connecting lines and repetition of color, line and value. There is also variety in the size of the shapes and the spaces in between. This is a dynamic arrangement.

Not unified

This arrangement looks static. The pieces do not connect to make an overall shape. Without repetition of color and other elements such as line and value, there can be no unity.

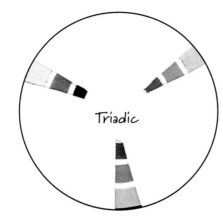

Triadic

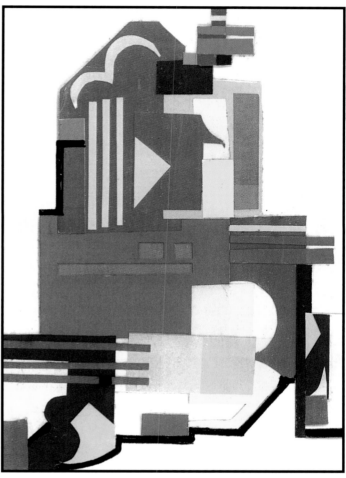

Unified

Use of overlapping shapes holds the pieces together. Dominance of line, value, texture and shape helps create unity. The shapes are varied in size, and the eye is drawn in a vertical direction. Repetition of color and shape also supports a unified image.

In this image, the yellow is used in no greater amount than the other colors, but is more intense, making it the dominant color.

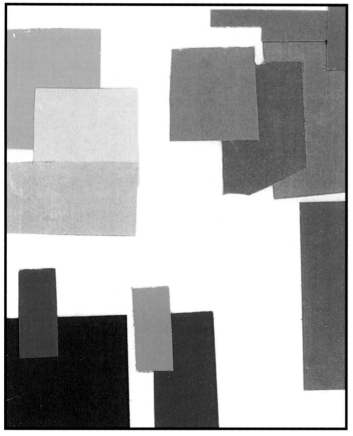

Not unified

This image suffers from a lack of connection among the colors and shapes. There is no dominance of color or size, resulting in shapes that compete with each other instead of working together.

Monochromatic

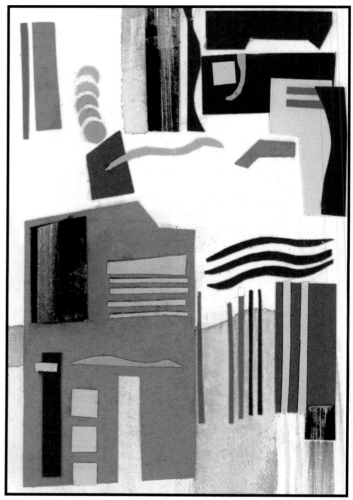

Unified

The monochromatic color scheme is the most limited of the schemes, but there can be many varieties. A dramatic range of value and the use of texture contributes greatly to this pulsating rhythm pattern. A color harmony that is usually thought to be quiet and soothing excites the eye in this case.

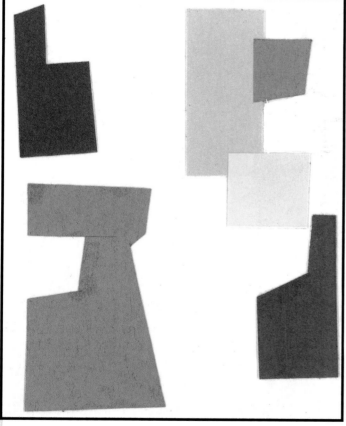

Not unified

Light, midtone and dark shapes are shown here, but they appear only as disconnected shapes of color without an underlying design.

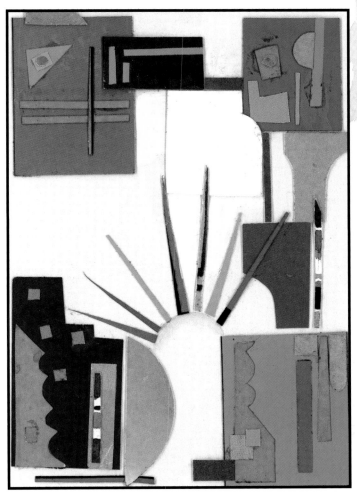

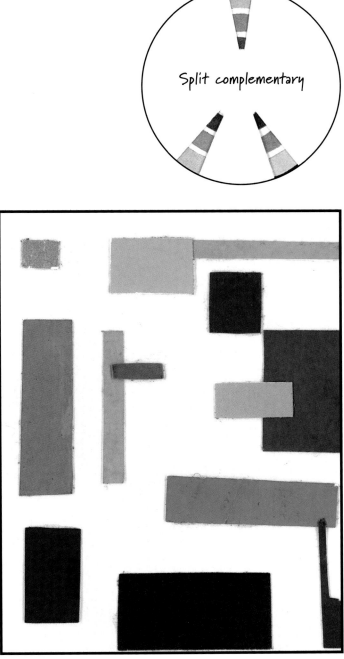

Unified

This is much better. Repetition of color has been used to create unity. Each of the three colors has been repeated in at least three quadrants of the rectangle. The sunburst provides a focal point. Although it doesn't touch the top rectangles, it points your eye in that direction, creating an implied line. The small rectangle in between the two bigger rectangles at the top is a connector, pointing the eye toward the other rectangle. Test your eye to see where it travels in this composition. Look away for a moment, then look back and notice the path your eye takes.

Not unified

In this example, a split complementary color scheme has been chosen, but there are only separate pieces of color—no shapes, no connections and no focal points. As a result, this image has no movement and no center of interest.

Brush Practice and Texture

For centuries, painters, sculptors, designers and architects have depended on varieties of textures and materials for their works of art. Whether it was created from stone and brick or paint and canvas, every work of art has a surface of some kind. Color and texture do more to create surface interest and aesthetic beauty than any other element of design. Texture, whether actual or simulated, can draw attention more quickly than line, color, form or value.

Sculptors, designers and architects are more dependent on actual textures for pleasing surfaces—rough sandstone, soft cashmere, smooth marble, and so on. The painter must create the illusion of texture.

Focusing on texture while studying art is a good way to become more aware of the world around you in a more detailed way. One of the most commonly heard statements made by beginners is that by studying art, they see so much in the world around them that they had never noticed before. Gathering texture tools and spending hours learning what these tools can do is a stress reliever because you can become familiar with the abilities of watercolor without the pressure of having to produce a painting right away.

In this chapter, you'll learn about the types of paper for painting, and you will become familiar with your brushes as you practice some simple brushwork. Then, it's time to loosen up and have fun creating a variety of textures, including stampings, stencils, scrapings and spatters. Nature provides an abundance of textures for artists to imitate; the fun is in learning how to interpret them. ∾

Choosing paper

There is much variation in quality, surfaces and weights of watercolor paper. Try different weights and surfaces and buy the paper most appropriate for the effects you want. Buy at least a few sheets of 90-lb. (190gsm), 140-lb. (300gsm) and 300-lb. (640gsm) paper in cold-press, rough and hot-press varieties and use both sides of the paper for practicing the brushstrokes and techniques in this chapter.

Even with the high prices of paper, I recommend that you buy good paper. You will not spend your time well or learn as much if you buy inferior paper. I use Arches 100 percent cotton rag, mouldmade paper. There are other good papermakers, but I've always been able to depend on the quality of Arches.

Rough paper (300-lb./640gsm) Rough paper (140-lb./300gsm) Cold-press paper (140-lb./300gsm) Hot-press paper (140-lb./300gsm)

Weight and size

As I understand it, the weight is arrived at by measuring the weight of an entire ream of that kind of paper. For example,140 pounds (300 grams per square meter) is what a ream of 500 sheets would weigh.

In my experience, the lightest weight suitable for watercolor is 90-lb. (190gsm) paper. However, I recommend nothing lighter than 140-lb. (300gsm) paper, which is suitable for painting wet-into-wet watercolor or stretching for the glazing technique. The heavier 300-lb. (640gsm) paper will lay flat enough while wet to save the time of stretching the paper. Once the 140-lb. (300gsm) paper is stretched, it will be as nice a surface as the heavier paper. The heavier paper is much more expensive, so let your pocketbook be your guide.

Watercolor papers come in several sizes. The full sheet, 22" × 30" (56cm × 76cm), is the most often used. Fold it in half, then fold it back in the other direction and carefully tear it to make a half sheet or even smaller sheets. By tearing instead of cutting you will have a lovely deckle edge like the other sides of the paper. The deckle edges help shed the

water so you don't have as much bleeding at the edge of your paper while painting.

You need not buy large amounts of paper, though it is usually cheaper in large quantities. It can be purchased in ten-sheet packs of different weights as well as ten- or twelve-sheet assorted packs (usually three sheets each of 140-lb. [300gsm] rough, cold-press and hot-press).

Watercolor paper is also available in rolls or blocks, in which individual papers are glued together at their edges and may be pulled off as needed. The blocks are not standard size but are smaller with cut edges. I don't recommend them when other standard and larger sizes are available, but they are convenient to use on field trips and when painting outdoors.

Illustration board and other experimental surfaces can be used. However, remember that for the sake of permanency, watercolor needs a surface on which the pigment and water may be absorbed. We know that good rag paper is long-lasting because it has a long history. You may paint your masterpiece next, and it deserves to be on a permanent surface.

Texture

You can buy hot-press paper (very smooth), cold-press (a medium-rough surface) or rough (with even more surface texture). I prefer cold-press most of the time, partly because there is a slight loss of color intensity when using the more textured rough paper. When texture is very important to your painting, you may desire a rougher surface. Hot-press is often chosen by painters who use bleeding (sometimes called *ballooning)* as a painting technique. Hot-press is also good for ink drawings or ink drawings combined with watercolor washes.

Supports

There are different supports for paper determined by the painting technique being used. For example, my favorite support for wet-into-wet painting is white Formica board. It has a Masonite backing but the front side is a very hard, white surface that is more permanent and less likely to warp during the wetting process. This hard surface keeps the watercolor paper from drying too soon. It can be purchased at any building supply store and cut into any size.

Getting acquainted with your brushes

Each of your brushes will do special things, and in time you will find out which ones give you the best results for what you are trying to do. Remember, there are no shortcuts! It takes practice.

Good brushes are a must and they are fairly expensive. But if you take proper care of them, they will last an amazingly long period of time.

How many do I need?

There are so many different kinds of brushes that it can be very confusing. Riggers, wash brushes, pointed rounds, mop brushes, brights, skyscrapers…the list goes on. There are uses for all of these brushes, but don't feel that you have to use all of them. I have purchased many of these brushes and only occasionally use them. The brushes pictured on this page are the mainstays of my entire painting career.

There is no need to buy more than one of each of your brushes since good brushes last a very long time. Often when doing demonstrations for classes, my students would remark, "You have your brushes trained." In a sense this is very true because you get used to the feel of each brush. Get a feel for various brushes to see which ones you like.

Should I buy natural or synthetic bristles?

Pure red sable brushes are the finest brushes and are the most expensive. They are marvelous if your pocketbook allows. There are combinations of other natural hairs as well as synthetic brushes that will also do well. A mixture of sable and synthetic can be very good. Sablene brushes are a combination of sable and squirrel hair and are also a good choice.

A good brush can't always be judged by the price you pay. A good way to test a brush is to wet it and see if it shapes into a defined

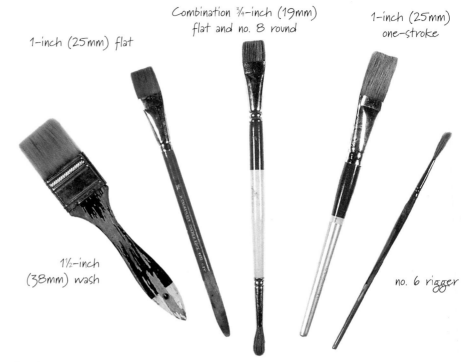

1-inch (25mm) flat

Combination ¾-inch (19mm) flat and no. 8 round

1-inch (25mm) one-stroke

1½-inch (38mm) wash

no. 6 rigger

My brushes
These are the brushes I have used consistently over the years. Today, you'd be hard-pressed to find a double-sided brush like the one shown. The maker of this particular brush has since stopped making it. If you have ever searched frantically for the right brush while painting, it is easy to see why a double-sided brush can be convenient! Instead of a double-sided brush, you'll use separate bright and round brushes of the same size. Look for shape, spring and resiliency when buying your substitutes.

edge or point. Dip the brush in water only and make a stroke to see if the brush is limp or has spring to it. I know artists who ask the salesperson for a cup of water to test a brush before buying it. I merely hold the bristles between my forefinger and thumb and flip it slightly to test its spring.

Many of the same natural hairs are used for both watercolor and oil brushes. However, acrylic brushes usually have synthetic bristles because acrylic is fast drying and abusive to the delicate natural hairs. Don't use your watercolor brushes to paint with either acrylics or oils because it will ruin them.

How should I wash and care for them?

There are some dos and don'ts. Try not to scrub the bristles on the paper when applying

paint. Never let paint dry in them. Wash your brushes thoroughly with water until the water runs clear at the end of each day of painting. After every four or five days of use, wash them with soap and water until there is no color visible in the soap suds. Then rinse until the water runs clear.

If the bristles start spreading, that is a sign that it's time to wash them with soap. Sometimes brushes lose their shape from being crowded in a paint box. When this happens, do several washes with soap and water and rinse until the water runs clear. Then put a little more clean soap in the brush, form it into its original shape and let it dry. Store your brushes in an enclosed box and add a few mothballs to disappoint the moths that tend to adore the bristles.

Brush exercises

Now it's time to find out what your brushes can do. Try these exercises on different types of surfaces to see how the paper can affect your brushstroke.

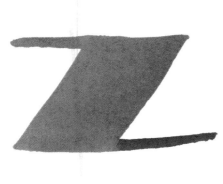

EXERCISE

1½-inch (38mm) wash

As its name suggests, this brush is good for applying a broad wash of color. Practice painting Zs and Ss and notice how evenly the color can be applied.

Take your brush for a walk!

This brush, like most of your brushes, is capable of some special effects. Load your brush with color and hold it vertically with the back edge of the brush toward you. Place only the back edge of the brush on the paper. Now with the back tip firmly in place, let the bristles spread out on your paper, and flip the brush toward you. I call this "walking" the brush. This will create a pattern that looks like palm fronds.

EXERCISE

1-inch (25mm) one-stroke

The one-stroke is also referred to as a lettering brush, since this is how it was first used in commercial advertising. This brush comes in different sizes and carries an amazing amount of water and pigment. Practice painting various strokes with it. By turning your brush and dragging it along the paper in different ways, see how many different types of lines and shapes you can make.

Keep an eye on your edges

Use this brush to define edges. Practice by loading your brush with plenty of pigment and water. Tap the edge a few times to give you a sharp edge. With the brush upright (to give a better flow of paint) and with your eye focused on one edge of the brush, paint a face, a vase or any shape in one continuous stroke.

EXERCISE

¾-inch (19mm) flat

This brush is good for making thirsty brush lifts. This technique is often used to create highlights. Paint a wash with your 1½-inch (38mm) wash brush. Then, wet your clean ¾-inch (19mm) flat, squeeze out any excess water with a dry cloth and drag your brush across the wash. If the timing is right, the paint will lift back almost to the white of the paper. Try lifting paint again with just the tip of your brush.

There is a "just right" time to make thirsty brush lifts. *It is when the gloss or shine begins to leave the paper.* You must move fast when that time comes or the paper will be too dry to make a good lift.

EXERCISE

No. 8 round

There is greater variety and versatility in round brushes than with any other type of brush. They come in large to very small sizes and are capable of thick or thin strokes. The larger round brush may be used for washes and decorative strokes of flowers, weeds and vegetation. When loaded with water and pigment then laid almost flat on the paper, it can be dragged across the surface for a rough brushstroke. This kind of stroke looks like the glitter and sparkle often seen on water.

Highlights

The small teakettle was painted solid with several colors in the brush, then allowed to sit for a few minutes until the gloss began to leave the paper. At that point, the highlights were lifted.

Small rounds

Although you can get thin or thick strokes with a no. 8 round, sometimes you may want to use smaller rounds, which are excellent for painting the smallest of detail or enhancing a painting with line. I used a no. 1 round to paint this tree.

No. 6 rigger

While not suitable for painting larger areas, this brush is useful for making thin strokes and drawing. The script liner is used in the same way except that it has a tapered end (instead of flat) and comes to a very fine point. In both the rigger and script liner, the bristles are much longer than other types of brushes. This is for flexibility as well as for the purpose of holding a lot of water and pigment. There are different lengths of bristles available (usually 1-inch [25mm] or 1½-inch [38mm]).

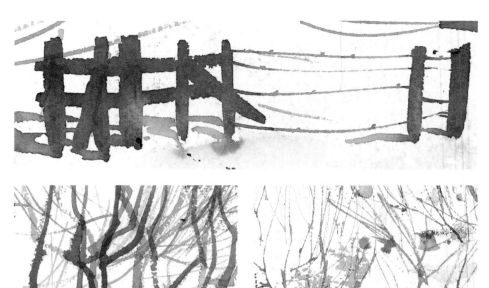

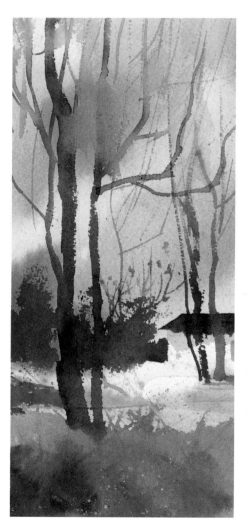

Brushstroke variety

These tall, thin trees were created entirely with a rigger. Hold your rigger upright for thin strokes and flat against the paper for wide strokes.

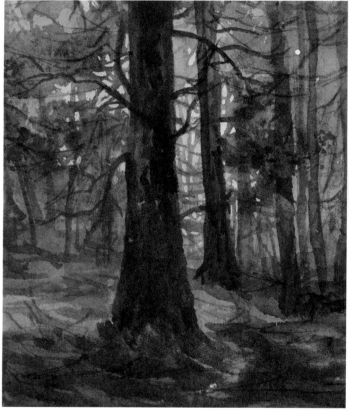

Painting trees

In this example, only the limbs and twigs were painted with a no. 6 rigger. Try loading the brush fully with water and pigment and place the bristles flat on the paper, pointing toward you. Lift the brush slightly as you draw forward. You will have a wide stroke that tapers to a smaller size as the brush is gradually lifted. While doing this gradual lift, make a sudden change of direction then a little twist of the wrist as you finish the lift. Natural-looking tree limbs and twigs can be made this way.

Washes

A wash is one of the most often used and important procedures in watercolor painting and can be done in a variety of ways. In watercolor there are only two *basic* painting techniques: glazing and wet-into-wet. Washes are used in both, but in each technique the washes are done very differently.

In the wet-into-wet technique, wet paint is applied to wet paper. The paper is wet with water on the back and front, and I place it on a hard Masonite board to keep it wet as I paint. The first washes are applied, usually in light value. In watercolor it is common to paint light values first, midtones next and darks last. As long as the paper stays wet, you may add color, midtones and darks on top of other colors in multiple washes as needed. Each addition you make to the painting is a wash until it's time to add darks and the last details.

Washes are used much more and are more important to the technique of glazing.

The painting is done on dry paper with an overlay of many wet washes of color, which are allowed to dry between layers. If a wash of any kind is applied to an only partly dry painted area, the watercolor paper acts as a squeezed-out sponge and absorbs the excess water and pigment, causing unwanted "balloons." If you are glazing over a large area, you will get a smoother wash by pre-wetting. Use clean water and wet only the area to be painted over.

Flat wash on dry paper
Load your brush with water and pigment and brush over any size area of the paper in a uniform wash of even color for a flat wash. A flat wash has no gradation of value from light to dark or dark to light.

Flat wash on wet paper
A flat wash will have a very different appearance when painted on damp paper or very wet paper.

Flat wash on very wet paper

Graded washes are commonly used in larger areas of a painting (a sky, for example). Graded washes can go from light to dark or dark to light, and can be done wet or dry. The paper support should be elevated slightly so that gravity can help the flow of water and pigment. Hold the brush in a vertical position with bristles softly touching the paper, and begin by painting a generous amount of clean water in a narrow horizontal strip across the paper. A bead of water will form, which along with mixed pigment and water will be carried to the bottom of the paper one stroke at a time.

Charge the brush with plenty of water and pigment, tamping the brush on the palette to see that all of the bristles are wet with water and the pigment is dissolved. Make your brushstrokes slowly, brush upright, with half of the brush in the bead of water and half on the dry paper. Make the stroke continuously to each edge of the paper. Add a little pigment to darken the wash as you continue with each stroke across your paper.

Graded wash on dry paper (light to dark)

Graded wash on wet paper (dark to light)

Have water drops ever ruined your day? ☙

I have heard some interesting stories about water drops and the problems they cause. I thought these suggestions might help since I have experienced some of those stories. When you must reach across the painting to charge the brush with water and pigment, it is very likely that on its return the brush will shed some excess water on your painting. If you are right-handed, work with your palette, water pan, brushes and a sponge or paint rag to the right of your painting. Reverse this if you are left-handed.

Keep a fairly large dampened kitchen sponge or a dry paint rag on that same side or even hold it in your hand. Get into the habit of picking up water and pigment with your brush, mixing it well on your palette and tamping your brush on both sides to see that the brush is fully loaded and without clumps of pigment. Then as you bring the brush from the palette, place it on the sponge or paint rag for a brief moment. This will absorb the excess water and leave the pigment in the brush.

Texture tools

The tools and painting techniques used in watercolor are more diversified and can be explored in more depth than in most of the other painting mediums. Shown on this page are texture tools I have collected. Some are used in the application of paint; others are used to lift paint from the paper, sometimes in a pattern or design. All have the ability to make your watercolor painting much more interesting.

Take a look around you—in nature and within your own home—to find things that could make interesting stamps, stencils or paint resists. Search for texture tools in the woods, your garage and kitchen drawers. Sometimes beauty supply stores will have interesting bottles and gadgets. Always test your textures on dry and wet watercolor paper to see how this changes your results.

As you're trying out some of the textures on the following pages, play around and have fun! It takes a lot of practice to find out what each tool can do. Don't worry about creating a masterpiece at this point. With practice and experimentation, you will soon begin to see how the textures you are creating might be used in a finished painting.

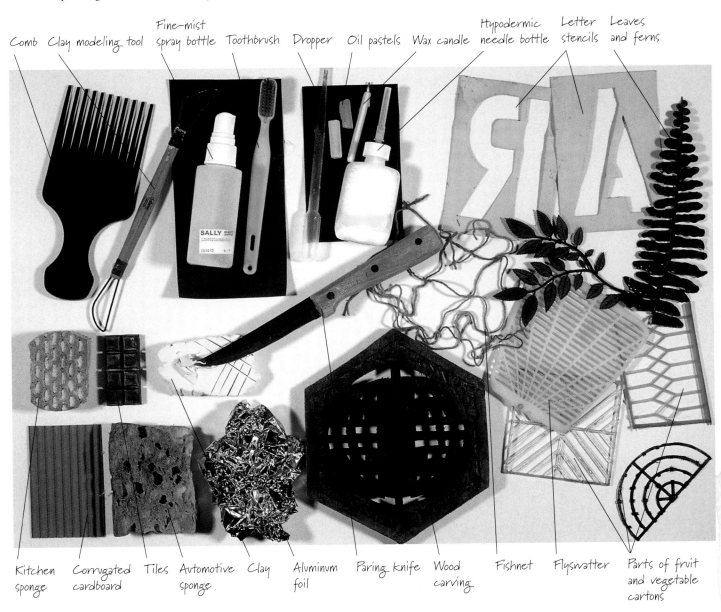

Comb · Clay modeling tool · Fine-mist spray bottle · Toothbrush · Dropper · Oil pastels · Wax candle · Hypodermic needle bottle · Letter stencils · Leaves and ferns

Kitchen sponge · Corrugated cardboard · Tiles · Automotive sponge · Clay · Aluminum foil · Paring knife · Wood carving · Fishnet · Flyswatter · Parts of fruit and vegetable cartons

Resists

To create texture through the use of resists, the product used must be something that repels water and pigment. The product may be painted, poured or drawn onto the surface of the watercolor paper. Generally, the resist itself should be a product that dries clear or can be peeled or rubbed off so it will not be visible when the painting is finished.

Several brands of masking fluid are available in art supply stores or catalogs. Other resists could include crayons, starches, wax candles and masking tapes of all sizes. I'm sure you will find your own resists to add to the list.

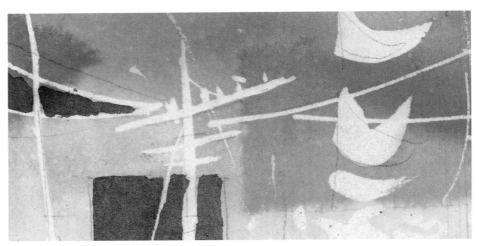
Resist with acrylic matte medium

Resist with oil pastel

Texture tools

Old medicine bottle dropper • Oil pastels • Wax candle • Crayons • Hypodermic needle bottle filled with a resist substance • White glue • Acrylic matte medium • Masking fluid or tape • Starch • Salt

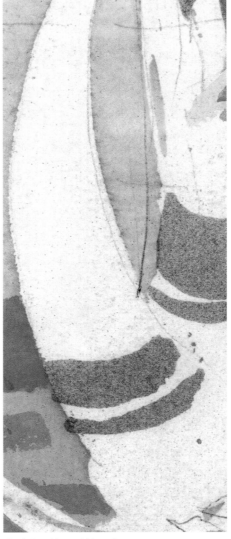
Resist with white glue

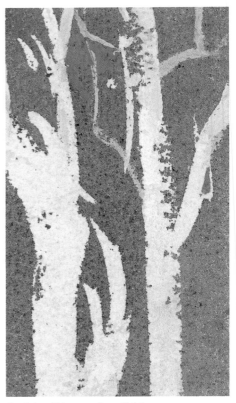
Resist with masking fluid

Salt sprinkled into wet wash

Stampings

You can create innumerable textures with stampings. Sometimes, the paint will need a little help in making the transfer from stamp to paper—much like farmers who use a sticking agent when spraying crops to make the chemicals stick to the leaves of the plants.

When your paint isn't sticking, try this: Put a small amount of soft soap in the middle of your palette. Wet your brush and press the water out with your fingers or a rag. Next, dip the brush into the paint and then into the soap mixture. After mixing well, paint the soap and pigment mixture onto the foil, sponge, carved object or anything you want to use as a stamp. This is not harmful to your paint or paintings, and the soap will help the paint adhere to your paper much better.

There are other interesting things you may use to create the illusion of textures in nature that are not pictured here. Try stamping with corrugated cardboard or rickrack to create the effect of a tin or ceramic tile roof. Small squares of tile stamped on a painting can give the effect of brick or stone.

Try your stampings on wet and dry paper. The possibilities are endless.

Kitchen sponge

Kitchen sponge, with holes painted in

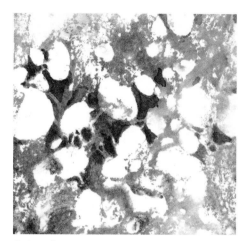
Automotive sponge

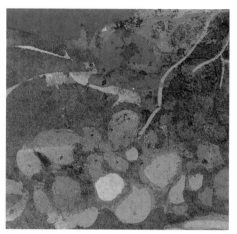
Automotive sponge, with holes painted in

Texture tools

Kitchen sponge ◆ Automotive sponge ◆ Tiles ◆ Clay (carve, cut and stamp) ◆ Clay modeling tool ◆ Fishnet ◆ Leaves and ferns ◆ Flyswatter ◆ Corrugated cardboard ◆ Crumpled aluminum foil ◆ Packing paper or bubble wrap

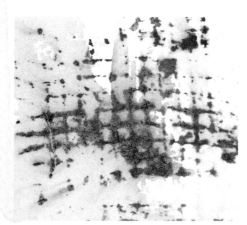

Netting

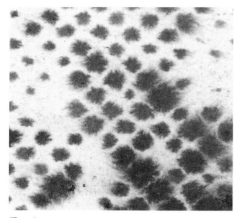

Packing paper

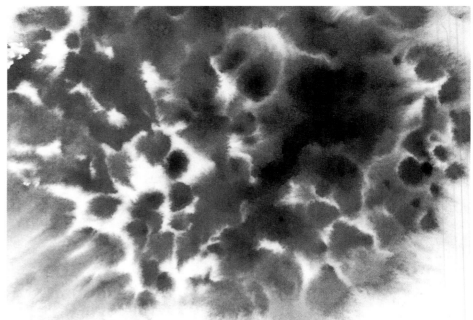

Crumpled foil on wet paper

Crumpled foil on wetter paper

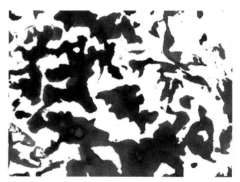

Crumpled foil on dry paper

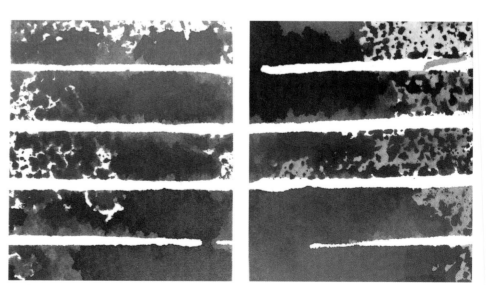

Strips of watercolor paper glued down and used as stamps

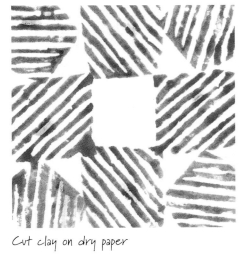
Cut clay on dry paper

Cut clay on wet paper

Cut clay on a painted wash

Leaf on wet paper

Flyswatter

Leaf on dry paper, with a wash glazed over print

Stencils

Stencils are another favorite way to get both interesting shapes and textures. A stencil can be a positive shape that you place on a piece of paper to either spray or paint around to create an image. You may use a found object for this or a shape cut out of strong paper or plastic that will resist water and paint. Some stencils are cut out of a larger sheet of paper or plastic, leaving a negative space or "hole." The opening is then painted or sprayed to create an image. Whether painted or sprayed, wait a few moments for the paint to soak into the paper before lifting stencils. This will cut down on smearing.

You can paint with stencils using a regular brush, toothbrush spatter or a fine-mist spray bottle. You may want to try out an airbrush. The airbrush will give you a very fine mist and sharper edges than the toothbrush or a spray bottle. Many artists are reluctant to use an airbrush because it must be connected to a compressor with a long hose, and it is loud and disruptive to some people. However, it is the most efficient way of spraying paint for stencils.

The compressor provides compressed air to the airbrush, which forces the paint out for spraying and painting. The airbrush can be adjusted to emit a very fine mist or a more coarse spatter. Art supply stores usually sell the airbrush and compressor and will show customers how to use it. There are small empty bottles for color that come with the airbrush, and there are also airbrush colors available for purchase. I prefer mixing my own colors from my palette and thinning them with water because the colors will then match my painting better.

There are alternatives to the use of a compressor for propelling the airbrush color. There is a product called Propel, which is a can of compressed air very much like an ordinary can of hair spray or spray paint. There is a small orifice on the top of the can that connects to the airbrush hose.

Texture tools
Spray bottle ◆ Toothbrush ◆ Airbrush ◆ Letter stencils ◆ Leaves and ferns ◆ Washers ◆ Fishnet ◆ Sea coral ◆ Berries ◆ Flyswatter ◆ Fruit or vegetable cartons ◆ Wood-carved stencil

Vegetable carton (spray bottle)

Strawberry cartons (toothbrush spatter)

Fishnet (spray bottle)

Washers (spray bottle)

46

Maple leaves (spray bottle)

Fern (painted with a green wash, then background airbrushed)

Leaves using gold paint (airbrush)

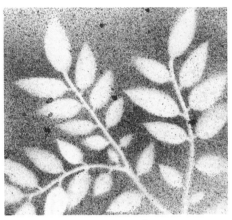

Plastic leaves (spray bottle)

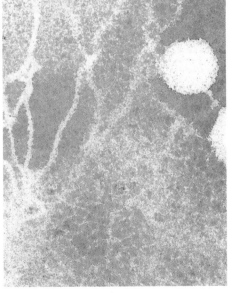

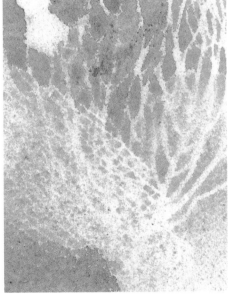

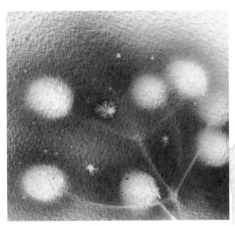

Fishnet (spray bottle)

Sea coral (airbrush)

Berries (airbrush)

Scraping and bruising

Scraping and bruising sounds more like the description of a crime scene than a technique for creating texture in watercolor. However, scraping and bruising can be deliberately executed on that beautiful piece of watercolor paper, when ordinarily we take the greatest of care to keep accidental scraping or bruising from taking place.

Scraping pushes the pigment away so the paper beneath becomes visible, creating a lighter value. If the scrape is made while the paper appears wet and glossy, the pigment and water mixture that has been scraped off will rush back over the scrape. There must be a matte appearance to the area where the scrape is to be made.

Bruising is to mark, streak or pound on the paper. Unlike scraping, the bruising action pulls the water and pigment into the bruised area and creates a darker line or mark. This may be done on dry paper before it is painted over, or most often it is done while the paper is still very wet with water and paint. Although a mark or bruise may not be visible on the paper at first, the marks will absorb more of the pigment and be much darker when painted over.

Texture tools

Brush handle • Comb • Clay modeling tool • Sandpaper or sandpaper block (strip of sandpaper wrapped around a block of wood, approximately 3" x 5" [8cm x 13cm]) • Paring or mat knife • Plastic spatula

Paint scraped off with plastic spatula when wet gloss leaves paper to create light and shadow

Paint scraped on sideways with plastic spatula (a little of each color loaded on its edge)

Paint scraped on with plastic spatula

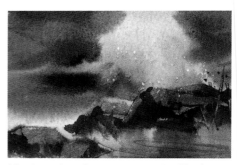

Light on top of rocks scraped off with plastic spatula; foam at edges picked out with mat knife

Comb dragged across glossy wet wash

Small, dark tree lines created with rigger handle on very wet paper; larger light trees made when wet gloss leaves paper with beveled end of skyscraper brush, held slightly to the side for more width

Drawn with pointed handle of rigger on wet paper

Scraped out with beveled end of skyscraper brush when gloss leaves paper; sandpaper block brushed over dry paper; larger white flakes picked out with mat knife

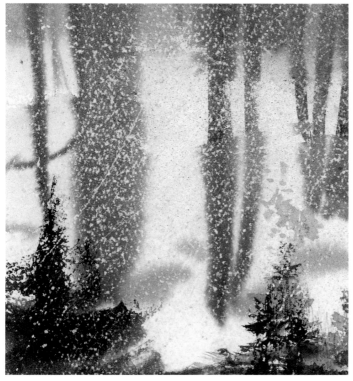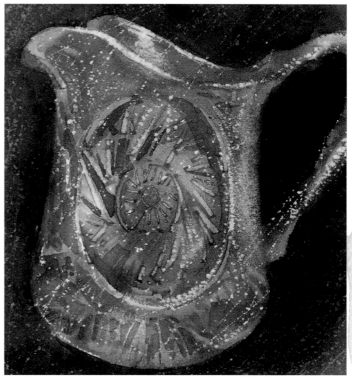

Sandpaper and mat knife applied when completely dry

Thirsty brush lifts after first wash to indicate light source; scraped with plastic spatula; bruised with sandpaper and mat knife

Spattering

There are many uses for spattering paint in watercolor. Rocks, tree bark, pebbles or wild-flowers in a field are only a few of the many things spattering can help create.

Usually spattering is done when a painting is nearly finished, so be sure to protect the rest of the painting where spattering is not wanted. I often use facial tissues for this purpose. A stencil may also be used, and it is the safest choice. Take a large sheet of paper (any kind will do) the approximate size of the painting. In the center of the paper, cut out the same size and shape of the area that is to be spattered, leaving a large amount of paper around the edge to protect the background.

Different tools are used for spattering. You can see the difference that spatter from a fine-mist spray bottle and a toothbrush makes in comparison to an airbrush. Another comparison is spatter done on a wet surface as opposed to a dry surface.

The largest object on this page is an interesting piece of handmade Mexican pottery. The toothbrush spatter, done on dry paper, seems to give it a lot of interest and intrigue that it would not have otherwise. What can you see in these examples that reminds you of something similar that you have seen in nature?

Toothbrush spatter and fine-mist spray bottle spatter (some dry, some wet)

Texture tools
Fine-mist spray bottle • Toothbrush
• Airbrush • Paintbrush

Toothbrush spatter and no. 6 rigger spatter on very wet, tilted paper

Toothbrush spatter on very wet paper

Toothbrush spatter on dry paper, with leaf stencil

Toothbrush spatter on dry paper, with stem stencil

Toothbrush spatter on dry paper; some larger dots painted with round brush

Cadmium Yellow Medium (then Light) spatters on wet paper; both colors are opaque and have more body because of their white content, making them particularly good for spattering

Toothbrush spatter on wet paper (color spatters first; then, when paper had a matte appearance, a spatter of water was used to get the white spots)

Rocks and pebbles applied with fine-mist spray bottle (thinned mixture of water and Burnt Umber) or spattered on with rigger

Painted textures

The textures in this chapter, most of which have been mechanically created or simulated, are fascinating to see and do. It's interesting to see the effects you can create with ordinary (and not so ordinary) gadgetry.

In the two student examples on this page, the textures cannot be felt and were not created with special tools, but instead were meticulously hand-painted to create the visual effect of texture. Sometimes there is no substitute for painstaking, beautiful brushwork.

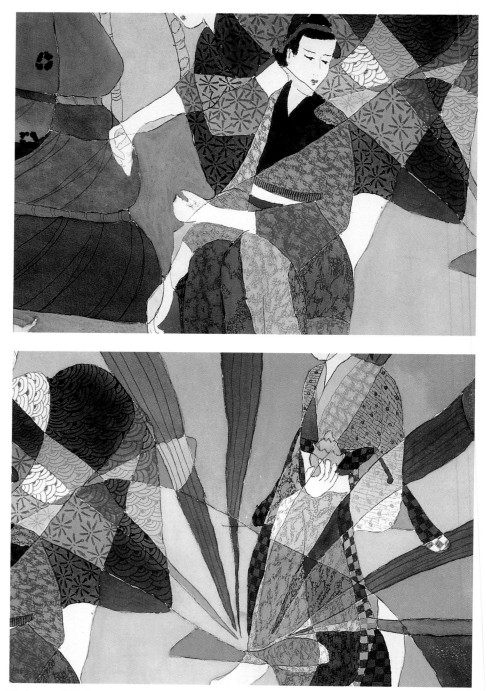

Textures of fabric
The textures in these paintings represent fabric patterns of the clothing in a collection of China dolls.

UNTITLED (DETAILS)
Hellon Catlett · Watercolor · 22" × 29½" (56cm × 75cm)

Same subject, two different uses of painted texture

The inspiration for this painting came while I was in Jamaica some years ago. I was staying up in the mountains in an old plantation home that had been made into a wonderful small hotel. After lunch each day the waiters and waitresses would gather under the banyan trees to sing and dance to calypso music. Even their religious songs were done to the calypso beat.

As I observed the dancing, I wondered how their rhythm and movement could be expressed in a painting. It suddenly occurred to me that texture could be an important design tool, and the idea for this painting was born. I used painted texture—staggered, multicolored acrylic lines—to create rhythm and movement. There are times when I glance at this painting and the figures actually seem to be moving. It is an optical illusion, which is much of what painting is all about.

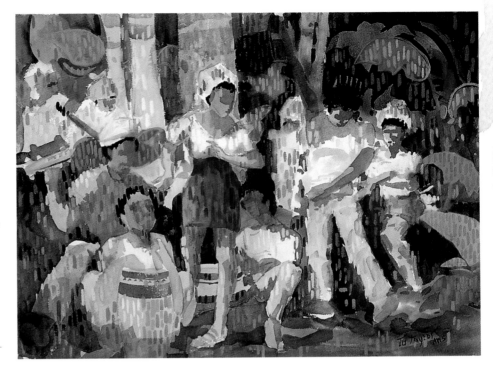

CALYPSO RHYTHM
Jo Taylor · Watercolor with acrylic lines ·
22" × 29½" (56cm × 75cm)

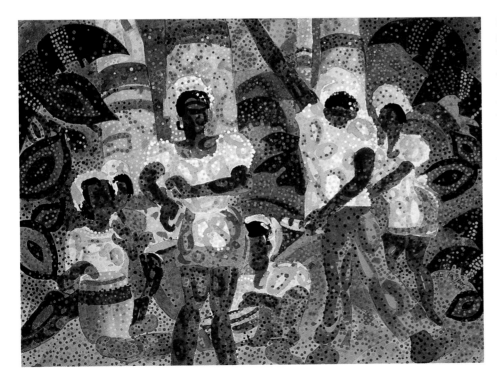

In this version, I used peaceful curves and round dots to to capture the essence of the setting—those wonderful afternoons where the music of Jamaica seemed to move with the breeze and penetrate the fresh mountain air. I used mostly complementary colors in the dots to create the vibrations of rhythmic movement of the calypso dancers.

JAMAICAN AFTERNOON
Jo Taylor · Watercolor with acrylic dots ·
22" × 29½" (56cm × 75cm)

Natural textures

The camera takes a picture to record the subject. As wonderful as the camera may be, the artist must do more. It isn't enough for artists to simply record what they see. I was made intensely aware of this truth the first day I walked through a beautiful forest along the coast in the far northern part of Maine. There were colors and textures I had never seen

before. I made one attempt after another to paint what I was seeing, but without success.

The sun's rays shone through the woods, exposing a rugged textural environment. There was a feeling and reverence for these woods that was mysterious and majestic. I picked up a small piece of bark that had fallen off of one of the magnificent trees. I glued

it down on the paper and painted a small picture around it so the actual bark is barely noticeable.

This small example of real texture helped set the key for value and color. I had to experience it rather than merely see it. I had to "feel" this forest to be able to express it. You may want to try the same idea.

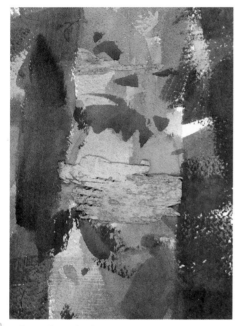

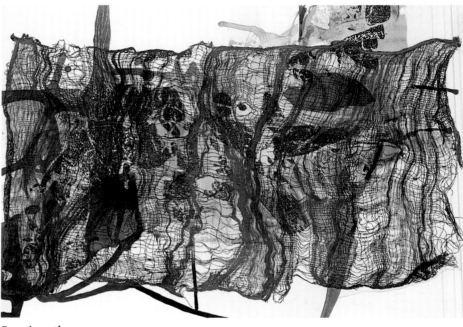

Take a closer look
Can you see where the real bark is located on this painting?

Experiment!
When you experiment with natural textures, you may find yourself stepping outside of the watercolor medium entirely. Go ahead! Part of being an artist is experimenting with the unfamiliar and having fun with it. I used cheesecloth, acrylic inks, torn paper and translucent acrylic paint to make this collage.

EXPERIMENTAL JOURNEY
Jo Taylor · Mixed media collage · 15" × 22½" (38cm × 57cm)

Applying textures in a painting

Look at these examples and see how different textures can be used to create an entire painting. In chapter 5, you'll see more examples of these techniques in paintings, and put some new techniques into practice.

This was a painting demonstration done from the memory of a beautiful sunny day in San Francisco. The dominance of warm color helps you feel the sun and its warmth, which is unusual in San Francisco with its abundance of cold and fog. Different texture tools were used to enhance the wharf and buildings.

A Day of Sunshine—Fisherman's
Wharf, San Francisco (detail)
Jo Taylor · Watercolor and gouache ·
11" × 15" (28cm × 38cm)

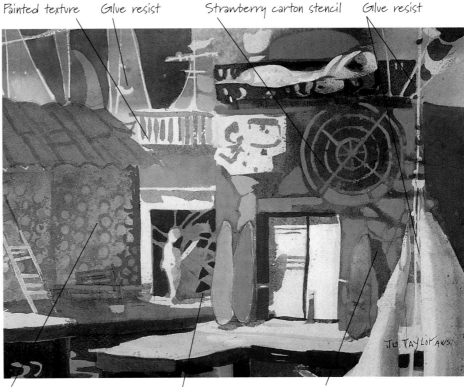

Painted texture Glue resist Strawberry carton stencil Glue resist

Automotive sponge stamp
with gouache painted on top

A part from a model
car used as a stencil

Painted texture

Washer stamp Rickrack stamp
(flat braided fabric) Trees painted with
plastic spatula Carved wooden stamp

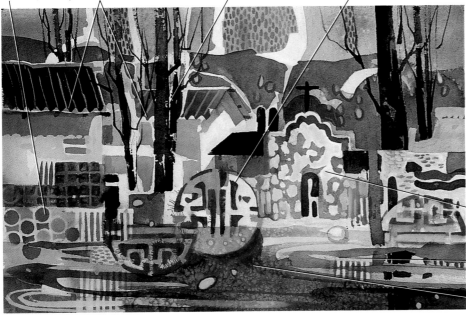

Many texture techniques were employed to create this painting, including the use of salt. When salt is sprinkled into wet color and allowed to dry, the salt absorbs most of the pigment, leaving light spots where it is brushed away. The spots give the appearance of a spatter, only light instead of dark.

The Spirit of Chihuahua
Jo Taylor · Watercolor and gouache ·
15" × 22" (38cm × 56cm)

Automotive sponge stamp
with gouache painted on top

Strawberry carton stencil

Salt

55

THREE

Composition

We have English composition, musical composition and composition in the visual arts. In a written piece of music, composition has to do with the arrangement of notes, keys and chords. In a work of art such as a drawing or painting, the elements of line, value, color, texture, shape, size and direction are combined or arranged artistically using the principles of design, which will be covered thoroughly in chapter 6. A composition is made up of these parts. To compose a painting, we must put together or "stage" a scene in an arrangement of parts that are in proportion to each other.

Every teacher has his or her own analogies and terms. Usually they are getting at the same theory. This is an effort to make an easier pathway and to quickly create the "A-ha!" moment for the student. It takes time and practice to become comfortable using the compositional principles you will learn in this chapter, but it is reassuring to know that they do not limit you in any way and they apply to any mode or style of paint-ing. There are people who consider rules and guidelines in art con-fining or restrictive. However, within the structural language of art, the rules are not binding but rather provide the artist with freedom within their boundaries.

Dividing the space

The element of size and the principle of dominance are two of the parts used in artistic arrangement and composition. Because of this, dividing the space in a painting into large, medium and small (L-M-S) areas will give you dominance of spatial areas. This variety will have more character and will be more pleasing to the eye of the viewer.

An important component of intelligence is relating all information obtained to every-thing else that is relative to it. Therefore, since the L-M-S system works, use this information not only in spatial areas but also for buildings in landscapes, objects in still lifes, flowers in a floral or shapes in a non-representational painting.

Avoid half-and-half space divisions of any kind. Unequal division of space makes for a more interesting painting.

Small sky

Large land mass

Large sky

Small land mass

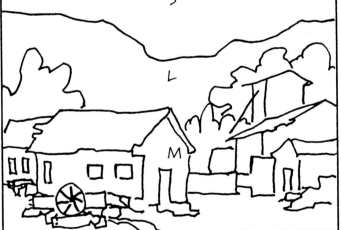

L = Large land mass
M = Medium area of structures
S = Small sky

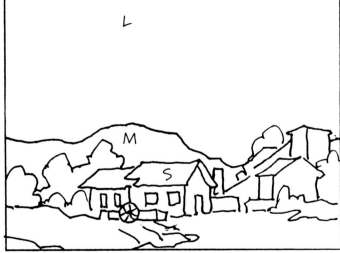

L = Large sky
M = Medium land mass
S = Small area of structures

Different divisions create new paintings

The three compositions on this page were created simply by focusing on different sections of the same subject matter and varying the space division. You can easily put together several good compositions by looking at a subject in a number of different ways. This can provide an endless amount of subject matter for paintings and at the same time help the viewer see many things they never would have noticed.

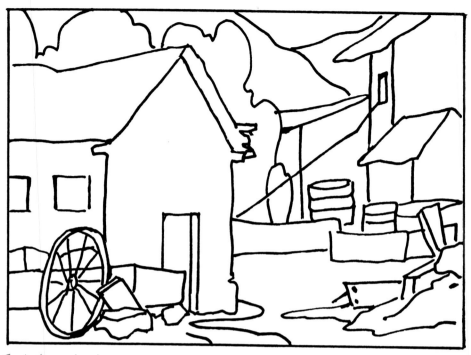

Emphasis on structures

Looking closer...

...and closer

Six guidelines for a good shape

Once the space has been divided in a certain way, based on the purpose and intent of your painting, there must be shapes placed within that space, creating an overall good shape.

I have been asked many times how I came up with the beginning shape that I commonly use in my paintings (shown below). Regretfully, I did not think of it myself. I first heard of six rules for a good shape from Edgar Whitney, a very dynamic teacher, who for many years taught watercolor at Pratt Institute in New York. Occasionally I have had students who rebel at the idea of rules, so I chose to substitute the word "guidelines."

All shapes in nature are derived from basic geometric shapes (square, circle or triangle). Following the six guidelines will ensure that the shapes you paint don't remain this basic. For instance, a perfect circle is a static shape. It would not make an interesting (or accurate) shape of a tree. However, if five or six circles overlap in different ways, the resulting asymmetry creates a more interesting shape.

In composing a painting, we may overlap the shapes of buildings, trees and clouds for a landscape, or vases, bowls and fruit for a still life. It is often necessary to overlap several objects to create an overall good shape. The guidelines apply to any or all of these shapes, even the circles that were deliberately overlapped to make the asymmetrical tree shape.

A child doesn't know about the guidelines for good shape, so he draws a tree that looks like a lollipop. Without these guidelines we might do practically the same thing.

1. Two different dimensions. This, simply said, means taller than its width or longer than its height.

2. Oblique placement. A painting should have a "high" on one side and a "low" on the opposite side. Some call this an entry and an exit.

3. Interlocking edges. Connecting the edges of your subject matter provides interest along the edge of any shape. Without these connections, the shapes would look isolated.

4. Gradation of value (within the shape) and 5. Gradation of color (warm to cool). Gradation is a simple way to please the eye. When painting in a realistic style, inexperienced artists often paint skies as flat as a wall. Gradation of value and color can result in immediate improvement.

We sometimes see flat shapes of color and value in abstract or nonrepresentational art. However, gradation of value and color could be used in these styles of painting.

6. Variation at the edge. There should be variety at the edge of any shape, from rough to smooth, sharp to soft. This keeps the eye engaged and moving.

A good shape
This is the start of a good shape, and therefore the beginning of a good painting, because it follows the first three guidelines. As you begin to paint remember the other three guidelines and use gradation of color and value and variety at the edges. These simple guidelines will help make interesting shapes within the painting.

Two different dimensions

Oblique placement

Interlocking edges

Staging an entry

While "staging an entry" is a theatrical term, it is a concept we use in painting as well. When beginning a painting, imagine your blank paper as a stage and that we are planning a production. We have a leading actor and two supporting actors. How shall we arrange them? The lead will not like to have anyone upstaging him, since he is the star.

The drawing to the right is a dynamic arrangement to help build a stage setting. For the artist, this can translate to a landscape painting or a still life. To begin your arrangement, choose three major pieces and place them in the approximate locations shown, with the star center stage. Then add other objects or scenery to link or connect the three major pieces to make a good shape. Below are four ways of connecting shapes in a painting.

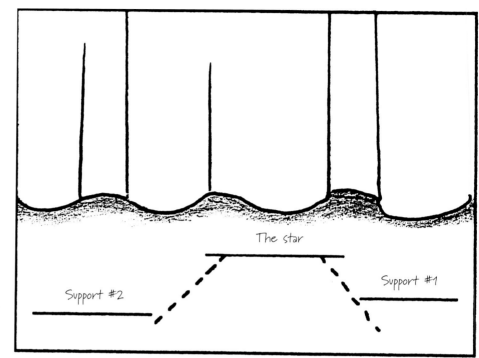

Set the stage
What works for the stage can work for a painting: one star flanked by two supporting roles, and all eventually connected.

Overlapping
Overlapping of shapes is the most common means of connecting shapes.

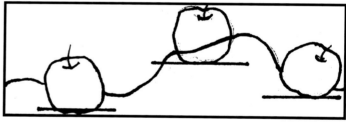

Actual line
The line actually touches because it comes in front of the apples.

Implied line
These lines do not actually touch as they are drawn behind the apples; therefore they are implying that a connection is there.

Implied direction
With a little encouragement, the eye can be led in a specific direction. Here, the grapes seem to point toward the apple.

Static

Dynamic!
Offset placement gets the eye moving and can carry it throughout the composition.

Static

Static vs. dynamic placement
Static and dynamic are two important terms that must be understood because they are parts of the composition of any painting. Static is immobile or stationary and might serve a purpose in some paintings. Dynamic, meaning active, is important in moving the viewer's eye throughout a composition.

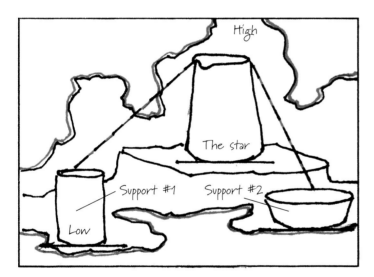

Set the stage, then connect shapes in a dynamic, offset placement
Avoid placing any object directly above or below the major pieces, which would result in a static arrangement. Also, extending the composition beyond the picture plane will help establish two different dimensions.

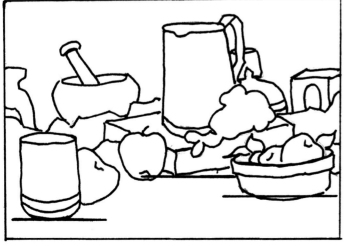

Like this

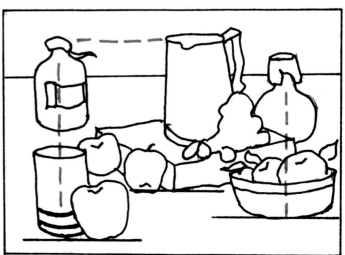

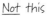 Not this

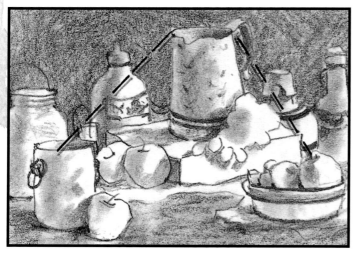

Two planes: Foreground and background
In this still-life arrangement, the dynamic placement of objects is indicated by the broken lines leading to the three major pieces in the foreground. This two-plane composition uses a more shallow space than the three-plane illustration on the right because you only have the foreground and the background.

Three planes: Foreground, middle ground and background
In the first two-plane image, all of these objects were rendered as if they were part of the foreground. In this three-plane image, the objects that are drawn behind the three major pieces have been pushed into the background. This creates a middle ground. There is little or no detail and the objects are in silhouette, very much like distant mountains would be in a landscape. The solid, horizontal lines are a reminder of "staging," the placement of the three major objects in the composition.

Overlapping
Notice that although all of these eggs are drawn fairly near to us, the eggs are overlapping in appearance and become smaller in size as they recede into the distance.

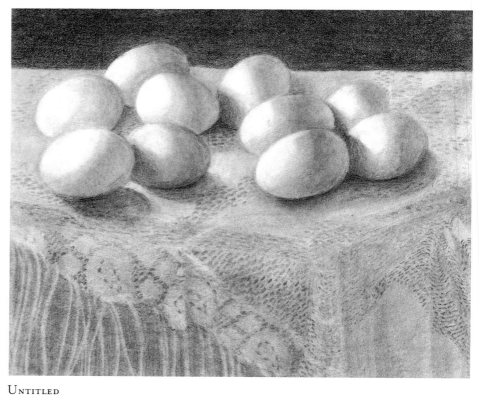

UNTITLED
Leigh Morgan · Pencil · 7" × 9" (18cm × 23cm)

Overlapping tips ∿

Overlapping is one way of connecting objects to make a good shape and of creating in-depth perspective or the effect of an object diminishing into space. There are two important things to remember when overlapping:

- Two objects side by side should either be overlapped or separated but never just touching or, as some say, just kissing.
- If overlapping is used, only overlap one side of any form. If both sides are overlapped it will be a symmetrical and static placement.

Fitting different subjects into a good shape

In the beginning it is a little difficult to adapt a good shape to new subject matter. However, the guidelines for a good shape never change, only the subject matter that is to be fit into the shape. The format may change from a horizontal to a vertical or even a square.

Practice and change of subject will help you become more comfortable with the use of good shapes in composition. As a reminder, even after many years of painting, I have developed the habit of lightly drawing this shape onto my paper before I begin a painting, and then I fit the subject matter into the shape. Make sure that the good shape you begin with has an entry on one side and an exit on the other (a high and a low). This will create dynamic movement through an oblique placement of any shape made.

In these sketches, the good shape has been drawn in red.

Overlapping
In this sketch, the linking or connecting of the three major pieces was done by adding other objects either in front of or behind each other.

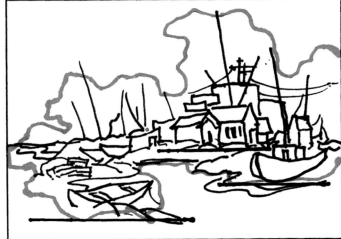

Staging a seaside scene
This harbor scene sketch would be suitable for an in-depth painting or a vignette.

Try a vertical format
In these sketches, good shapes are positioned vertically. Interlocking edges are still used since they give interest to any shape. In a vertical format, there is usually not much in-depth perspective used, making it more suitable for subjects that are closer to you.

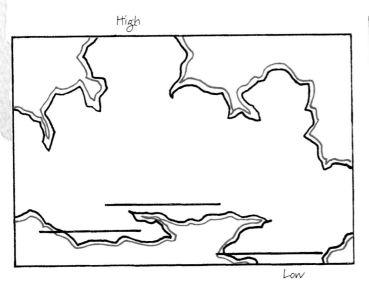

High

Low

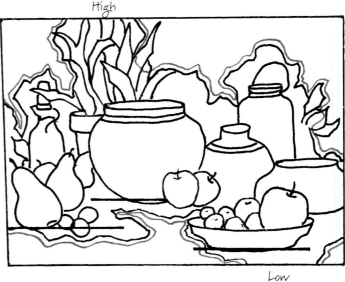

High

Low

EXERCISE

Apply different subject matter to the same good shape

Using a pencil line only and the shape shown, do several sketches each of the following: (1) still life, (2) landscape, (3) houses or boats, (4) floral.

EXERCISE

Test your connecting skills

Start with three main pieces—the big vase, the pears and the bowl in front. Connect them by adding other objects such as fruit, shadows, leaves, bottles, etc., as I have done here.

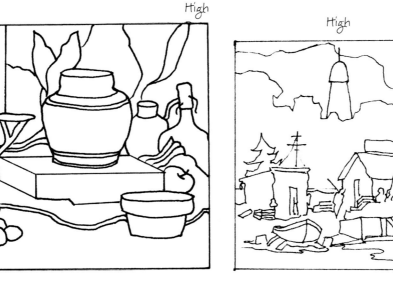

High

Low

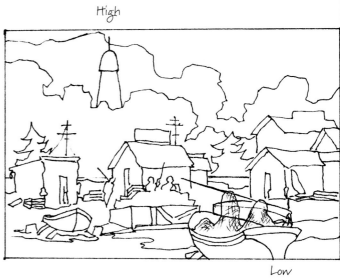

High

Low

EXERCISE

Try another still life

It will be good practice for you to reverse the high side and low side of the good shape. Place the high side on the right and the low side on the left. It is still important to place the three main objects first. Connect them by adding other shapes and shadows.

EXERCISE

Try a landscape

This waterfront scene has five or six fisherman's shacks and is linked together on the left side with a figure and some lobster pots. On the right side the buildings are connected by overlapping another smaller building and by a fence or part of a wharf. The central focus or "star" will be where the figures are at work. As you look at this sketch, try to visualize the good shape and the placement, on different levels, of the three major pieces.

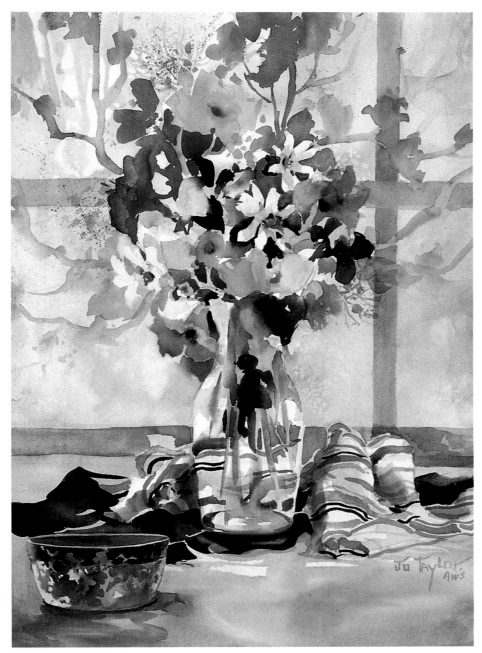

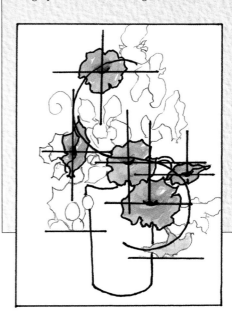

Floral tip ∾

A floral arrangement will be more dynamic if the center of a flower is neither directly opposite nor above another. It can be helpful to build an arrangement along an S curve to keep this from happening. Some flowers should face the viewer and others should be in profile, with some looking up and others looking down.

Staging a floral still life

This still life was staged for a more dynamic arrangement. There are usually three objects in the foreground, each located on a different level. This creates an entry into any composition. The bottom of the white striped cloth on the right side of the vase serves as the third object in this painting.

THE PURPLE CLOTH

Jo Taylor · Watercolor · 30" × 22" (76cm × 56cm)

Applying good shape to abstract painting

The artistic person plods along in the never-ending search for truth, understanding and a personal way of expressing the self. In part, this is how abstract art came to exist. "Abstract" is such a broad term it is almost like setting out to sea with an inner tube and a broken paddle. However, the artist's need to explore and understand is part of one's basic nature.

The most important thing to remember is that a good design structure is required of all art, whether that art is realistic, abstract or nonrepresentational. The challenge lies in exploring the application of good design to the different modes of art. An abstract painting needs a good shape just as much as a realistic painting.

Dynamic movement

The guidelines for a good shape are used in this first sketch for the finished painting *The Argument*. This ensures movement throughout the composition rather than a static arrangement. To see if it really works, try this: Glance away from the sketch for a moment, then look back at it. Observe where your eye goes first and then the path it travels. The subjects were fit into the good shape with a high side and a low side, which starts the movement of the eye. Since there is no in-depth perspective, there is no "staging." However, the guidelines for a good shape are the same.

Finished painting

See pages 158-159 for the complete demonstration of this painting.

THE ARGUMENT
Jo Taylor · Watercolor with acrylic dots ·
22" × 30" (56cm × 76cm)

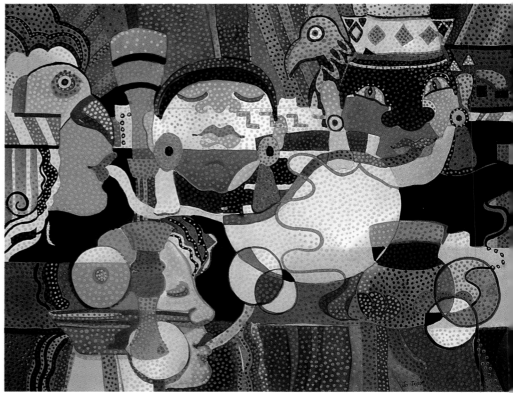

Using reference photos

Most artists travel to get inspiration and input for paintings, but many times it is not possible to stop and make sketches. Most painters need architectural references, especially since few of us know how buildings are built or how a roof fits together. Taking photographs of complex subjects is a good solution to that problem.

Nature is most often our greatest source of inspiration, but we seldom find the correct composition without selecting, eliminating and rearranging for a painting. This is another good reason to take reference photographs.

In any case, avoiding the pitfall of copying a photograph presents another challenge. One way of dealing with this problem is to

select components of several photos and place them within a good shape, very much like you would arrange still life objects. To connect the component parts, use overlapping, cast shadows, figures, foliage, etc. This method will keep you from copying the photograph and force you into a more creative approach.

Reference photo 1

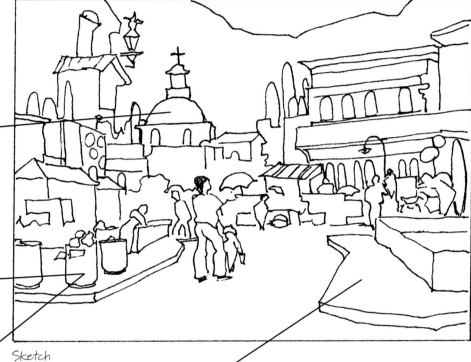

Sketch

Reference photo 2

Recognizing negative shapes

Someone once described negative space to me like this: "Reach out to touch something, and if you can touch it, it is a positive shape. If you cannot and there is only air and space, then it is negative space."

In terms of design, the two important elements involved are size and shape; the key principle is dominance. Each negative space is at the same time a shape. Negative spaces can and should vary in size throughout a painting, forming interesting shapes of their own.

Crossing over ❧

As a teenager, I took private oil painting classes under a very good teacher. Later I experimented with many other mediums such as acrylic, egg tempera and pastels.

I studied oil portrait painting for many years with a wonderful teacher, Ramon Froman, who had a love of watercolor as well as oil. It was at his insistence that I finally gave water-color a try.

Because I paint and teach equally in watercolor and oil, people very often ask me which medium I like the best. My answer is always the same: "The one that I am painting with at the moment." I could never give up one for the other. However, I usually have a strong feeling about which medium would work best for certain paintings. I think we gain skill and flexibility by experimenting with other mediums.

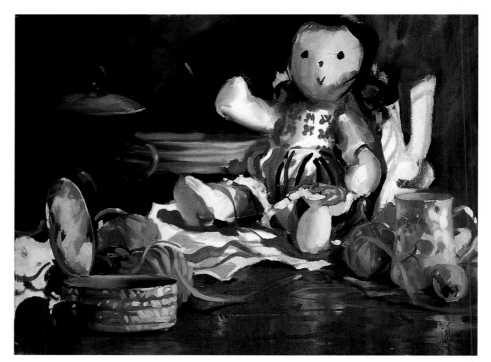

I DO HOPE MY DOLL IS FOR SALE · Jo Taylor · Oil · 18" × 24" (46cm × 61cm)

Negative shapes
The negative space around the still life above is pictured in purple. Each shape of purple is a different size and shape from the others and makes an interesting shape all its own. If all the negative shapes were the same size, it would place the doll exactly in the center of the painting, which would not make a good composition.

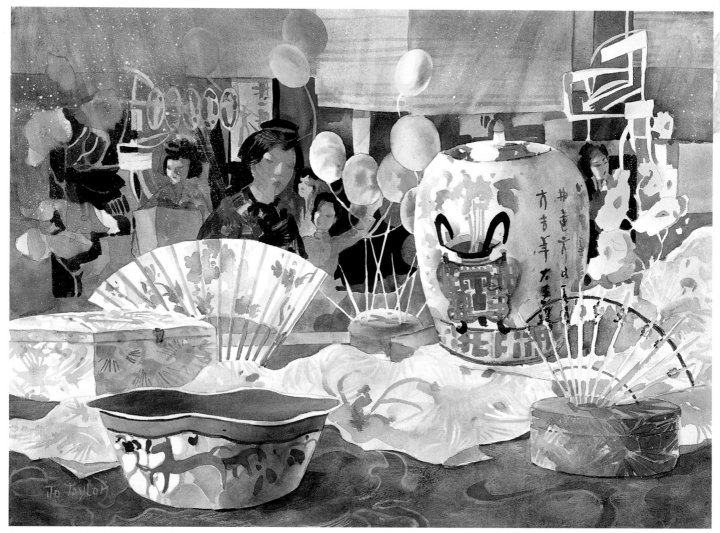

Same composition, different subject

This painting uses a very similar composition, only with different subject matter. This painting is very different in feeling than the still life on the previous page. The objects in the painting on page 68 came from Mexico and have a handmade, homespun look. The setting of the still life on this page is in Chinatown, San Francisco, and it has a more sophisticated, dressed-up look and feel to it. Even with these differences, you can easily see that the compositional arrangements are the same.

Compare the negative shapes in this painting to the negative shapes on the previous page. There is very little negative space here because it is closed in and crowded, characteristic of the shops in Chinatown.

CHINATOWN—SAN FRANCISCO
Jo Taylor · Watercolor · 22" × 30" (56cm × 76cm) · Collection of Linda Taylor

Don't perfectly center your "star" ∾

Each visually important object in any composition should be placed in such a way that it is a different measure from each edge of the paper. Make your subject the center of interest, but don't perfectly center your subject.

Six things that describe form

In realism, good composition relies in part on the ability to create convincing form. In order to do this there must be an understanding of how to "light" the form and how the differences in light falling on a form help define it.

There are six things that describe form:

1. Direct light. The source of light, either natural or artificial, that is shining on the form.

2. Reflected light. Light caused by the direct light hitting some area or object that is lighter and bouncing the light back onto the shaded side of a form. The reflected light, while lighter than the form shadow, should never be as light as the direct light.

3. Form shadow. The darkest part of the shadow on an object.

4. Highlight. Describes the surface texture of a form. A shiny surface will reflect one or more strong highlights. A matte surface will absorb the light and there will be little or no highlight. Highlights can be warm or cool.

5. Cast shadow. An object blocking the light to any area or another object causes a cast shadow. It may be warm or cool, light or dark depending on the local color and value on which the shadow falls. A cast shadow is darkest near the object.

6. Underneath and inside darks. Underneath darks occur at the base of an object. Have you ever seen an object that seemed to float in space? Put a shadow and a dark accent underneath and it will appear to sit on a surface. An example of an inside dark would be the dark resulting from a door cracked open.

Characteristics of form shadows vary a great deal. Form shadows on rounded forms are soft and blended. There is a gradual gradation or blending between the light side and the dark side, referred to as a halftone. Halftones are not ever-present, but may appear in transitional areas where indirect light hits a form. You will see halftones on round objects, but not always on rectangular objects.

In a rectangular shape, the form shadow has a hard edge because of the abrupt plane change at the corner. On the shaded side of the rectangle, the value becomes gradually lighter as it recedes into the distance. As a result, the darkest part of the shadow will be at the near corner.

Pay attention to the differences between painting an object in natural and artificial light. The type of lighting and the time of day affect the shadows. Set up a spotlight on a group of round and rectangular objects in a dark room. Slowly move the light around the objects and observe the changes in shadow. Try this exercise outside at different times of day and in various weather conditions.

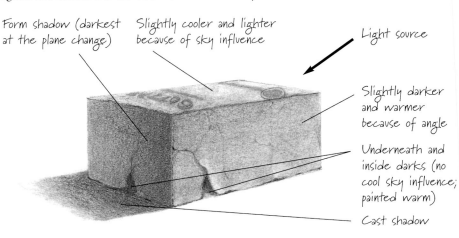

Light and shadow characteristics of rectangular forms
This box was painted outdoors in natural light. There are no highlights because the light is falling on a matte surface.

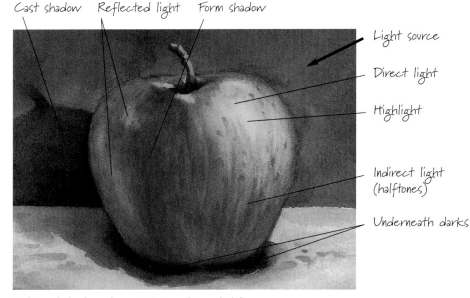

Light and shadow characteristics of rounded forms
This apple was painted under a spotlight. Indoor lighting is more consistent than the ever-changing light and atmosphere outdoors, and it can be either warm or cool. Notice that the cast shadow falls on two different surfaces, resulting in two different values.

Using values to create the illusion of form

The understanding and use of value, the measure of light and dark, is a necessary tool in describing form. In these examples, values are assigned to the different areas to help you paint them more accurately.

Form or flat in abstract?

Form description in realism is essential, but it's not entirely limited to realism. Sometimes form and volume are used in abstract painting. An example is surrealist painter Salvador Dali, who used form description although his work was entirely different in style than realism. Other artists disregard form as well as in-depth perspective when creating abstract art, working only with flat shapes of color and value.

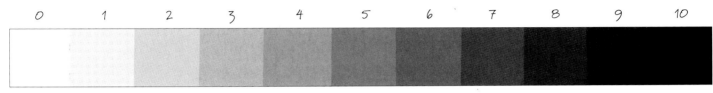

Value scale

There are many more values existing than can be measured. However, this scale is an ample tool for approximating the measure of light and dark needed to create convincing form. The zero represents white, and ten represents the darkest dark. In some value scales these numbers are reversed, but the scale works the same either way.

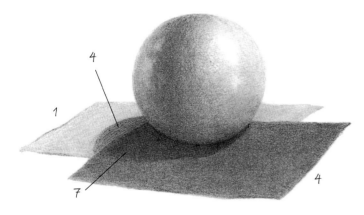

Cast shadows in pencil

This example with two pieces of construction paper of different values illustrates the complexities of cast shadows. In addition, it indicates the importance of the use of value in creating form. It is interesting to note that the ball only casts one shadow but the shadow is two different values as it falls across the two pieces of paper. On a sunny day try to observe this happening in nature.

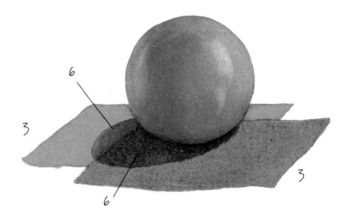

Cast shadows in color

The red and green construction papers in this exercise are approximately the same value in light (value 3). The shadow made from the ball is the same approximate value (value 6). In this instance, however, the shadow is made up of two different colors.

Make the jump ॐ

There should be a difference of three or four values between the part of the object in direct light and the part in shadow where the plane change occurs.

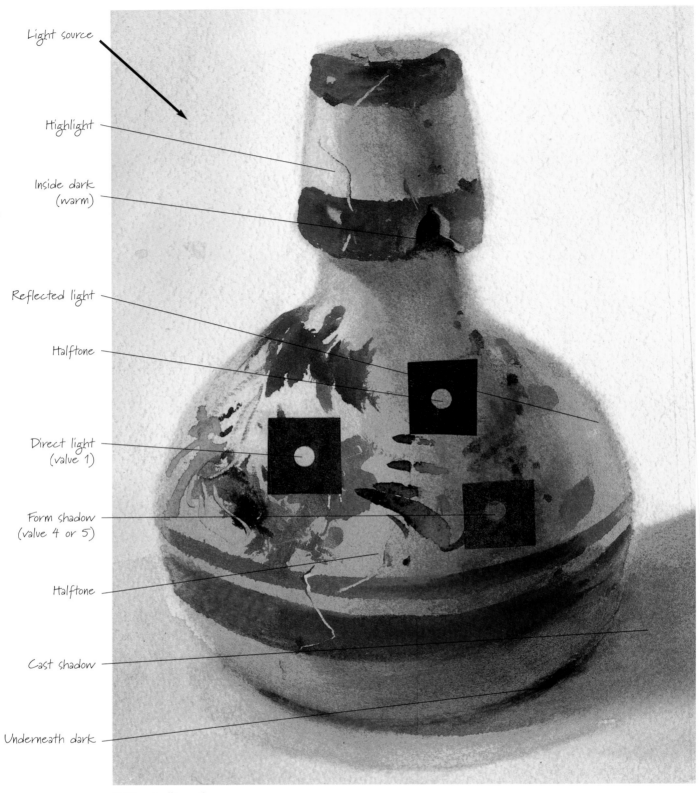

Light source

Highlight

Inside dark
(warm)

Reflected light

Halftone

Direct light
(value 1)

Form shadow
(value 4 or 5)

Halftone

Cast shadow

Underneath dark

Putting it all together

This example shows how light and shadow fall on this rounded jug, along
with some of the values applied to its different areas.

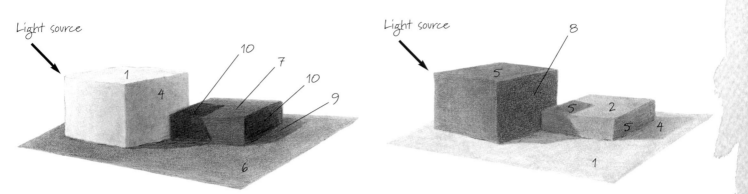

Value studies in pencil

In these studies, I have given you the value numbers for both the light areas and the shadows. Remember, there should be a value jump of three to four values from the light side to the dark side of any object to give the illusion of depth and volume. On any square or rectangular shape, the form shadow will have a distinct, hard edge because there is a sudden, abrupt plane change at the near corner.

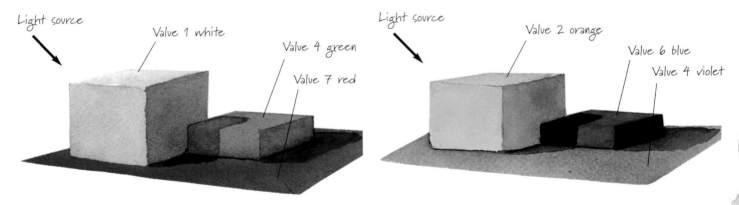

Value studies in color

The transition from pencil to color value study is a challenge, although the same theories of light, shadow and value still apply. There is still the value jump of three or four values between the direct light and the form shadow.

Sometimes we have preconceived notions that certain colors can only be dark or light. A lot of people can't visualize red as a light. It is difficult to think that yellow can be dark, though at times there is a need for a value 10 dark yellow (that is why I have Burnt Umber grouped with the yellows on my palette). This is why the value scale is so important in learning to create the illusion of form.

EXERCISE

It's your turn!

In this example, I am giving you only the value number of the color in light. What are the value numbers of the shadows?

Practice doing many pencil and color studies like these, assigning different value numbers to them. This will give you a better understanding of form and value.

The shape of shadow

A great teacher and friend of mine, Edgar Whitney, once said, "As artists, we are entertainers, shape makers and symbol collectors." Besides the credence this statement gives to shape, anyone having read this chapter would gather that shape is very important. Shadow itself is important. However, the shape of shadow is even more important. Its responsibility in composition is great. It links or holds objects together, describes form and creates a transition of value between darks and lights.

The shape of shadow can lead the eye throughout a composition with a rhythmic movement. Look at the images on this page. Rest your eye by looking away and then back at them and observe the path your eye takes. You will see that your eye follows the shadow pattern.

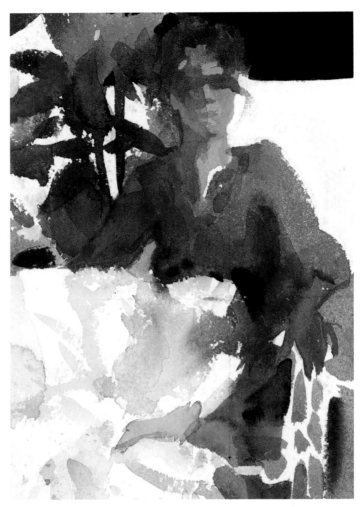

Shadows define the form of this woman's face and the folds of her skirt.

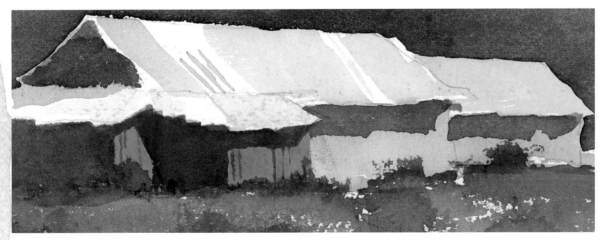

Your eye is able to recognize these buildings as three-dimensional forms because of the use of shadow.

The shapes inside of shadow

This is a good example of lost-and-found (or soft and hard) edges and economy of means. Only a single brushstroke describes the piece of fruit inside the shadow. The edges are totally lost except for the single red brushstroke that tells us there is a piece of fruit inside the shadow—an apple. A cast shadow falling on the apple, characterized with a distinct hard edge, also helps to establish the form.

Planning a composition

Many times there is a better procedure for the things we do. A good example of this is the way in which I struggled with compositional problems before realizing that this specific sequence of steps was the answer. For example, there is no need to do a line drawing for the placement of objects before the space division is decided. There is no point in establishing a value scheme before deciding on a light direction because this is what determines where shadows fall.

There are artists who have a natural tendency to draw very small, and others draw very large. Try making your "good shape" sketch the same size as in step 1, then draw objects inside the shape. You will then be more likely to have good scale relationships and proportion for the overall image.

Remember to place three major pieces first for dynamic staging. Then add other overlapping objects and shadows to connect and tie the pieces together to make a shape.

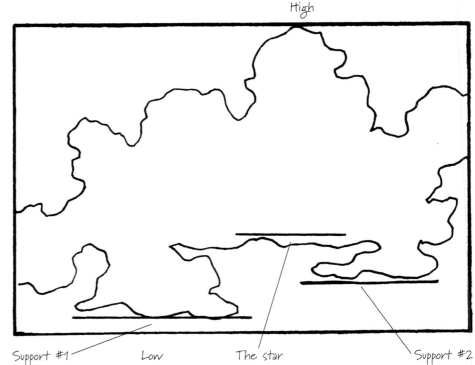

1 Start with a good shape ∾ Start on the high side and draw an arbitrary, irregular shape to create interlocking edges as you draw toward the low side. This will create an oblique placement. Observe the three horizontal lines, which are the locations for the major pieces, as you now draw the rest of the shape.

2 Fill the good shape ∾ When you have drawn a shape that is obliquely placed, with two different dimensions and interlocking edges, fit your subject into the shape. In this example, the teapot is the "star."

As you will see, this is not an exacting shape, and its boundaries are only a guideline for your subject.

3 Establish the light direction ◈ Knowing where shadows fall will be necessary before planning your values. In a still life, the advantage is that there is usually a spotlight used instead of sunlight, which is glorious light but ever changing. Move the spotlight around in a darkened room and see the pattern of shadows created by the spotlight. Once you have chosen the direction of light and best pattern of shadows, use a broken line (I use red) in the sketch to indicate where the shadows fall. Once this is done the light can be turned up bright for painting good color.

It seems to work better when you plan the light source to come from the high side of the composition. The reason for this is that you usually have smaller objects and more background space on the opposite side from where the largest object or "star" is placed. In that case the cast shadows can work to connect or link the objects.

4 Plan your values ◈ This is the next step in planning a composition for a painting. There are six broad value schemes possible, without having equal areas. The basis for this stems from the principle of dominance and the element of size. The value schemes are explained in detail in the following chapter. The definition of this broad value scheme is a piece of darker value in lighter value. This scheme is without a light shape within it, which makes it similar to a silhouette.

Whichever value scheme you choose, it is best to do it in the fourth step of this planning sequence. After this step, you can choose your colors and begin painting!

FOUR ∾

Value ∾

When entering a room full of paintings, it is interesting to observe what your eye will do. After a single glance around the room, your eye will come to rest on the painting with the brightest colors or the one with the greatest amount of value contrast. In this chapter, you'll see many examples of value schemes suitable for paintings. Place one of them on a wall and stand back a bit. You will quickly see the visual effect it has, or doesn't have.

A value chord is equally important and yet is different from a value scheme. A value chord in a painting has to do with the relationship of intervals between lights and darks. The light is at one end of the value scale; the dark is at the other. There will be a more beautiful value chord in a painting if there are several midtone values used in between. This is similar to the harmony created with a chorus of soprano, alto, tenor and bass voices. The bass and soprano voices are so far apart—one so high and the other so low—that it would sound thin without the voices in between. Adding the altos and tenors makes a more complex, yet beautiful, sound.

In painting, think of the soprano as the lightest light value and the bass as the darkest dark value. Using these two values alone would result in a thin painting. However, by adding two or three shades of midtone value between the darkest dark and the lightest light, you can have a painting with a rich, beautiful value chord. This is to the eye what four-part harmony is to the ear. Choosing a value scheme and creating a value chord for your composition will result in a strong finished painting. ∾

Six broad value schemes for realistic paintings

If you use one of these six value schemes for a realistic painting, your painting will be well on its way to having a powerful visual impact. Deciding on a value scheme before you paint will pay dividends in the quality of your painting.

You may ask, "Why six?" Based on the element of size and the principle of dominance, I have been told by mathematicians that there are only six combinations of value possible without having equal areas. Since I am not a mathematician, I won't argue with this theory!

First drawing
This still life is ready for a value scheme. There are six different paths this composition can follow.

A piece of darker value in lighter value

A piece of lighter value in darker value

A large light and a small dark in midtone

A large dark and a small light in midtone

Gradation in any direction

Allover pattern (disconnected lights and darks)

Value scheme examples

Let's take a closer look at examples of each value scheme. Look for the similarities as well as the differences; this will help you remember them and it will be much easier to use them for visual impact in your paintings.

SCHEME 1

A piece of darker value in lighter value
This scheme is very much like a silhouette. It shows a dark shape in midtone value, with no emphasis on a light shape. The middle ground was added in order to have a richer value chord. This plan would be suitable with any light background. It also would be effective when your subject, either in landscape or still life, has naturally dark, dramatic shapes that you wish to feature. It is especially suitable for a subject placed in front of a window. The shapes would be emphasized and show up better against the contrast of a strong light in the background.

SCHEME 2

A piece of lighter value in darker value
This scheme is the opposite of scheme 1, showing a light shape in midtone value without emphasis on a dark shape. This scheme sets a very different mood. There is a feeling of direct light on the subject, making it more suitable for a higher-key painting.

No middle ground was added here, which makes it a two-plane organization. There would be a richer value chord if there were more midtone shapes added as in the plan above. When adding more midtone shapes, be sure to keep the form shadows in the piece of lighter value lighter than the midtones used in the background. If that is done, it will still read as a light shape.

Scheme 3

A large light and a small dark in midtone

The emphasis is placed on the large light area in this scheme. It is possible to use the entire value scale, although it's not essential. This scheme is capable of being more dramatic because of the wide contrast in value when using values 0 to 10. When your subject matter consists of both light and dark shapes, this would be a good plan to use. It will usually be noticed before the other schemes.

Scheme 4

A large dark and a small light in midtone

This scheme simply reverses the size of the dark and light. This plan is very similar to the silhouette in scheme 1, except it places emphasis on a small light shape. This plan could be used when there is a lovely light or light shape you wish to paint. Even though the large light in the last scheme drew more attention because of being larger, this plan can still be dramatic because a wide range of contrasting value is possible.

Midtone variety ∾

In a preliminary value sketch, the midtones are traditionally done quickly as a flat tone without much detail. However, when you begin to paint, there should be a lot of variety in the midtones—at least three values. This variety is important for two reasons: (1) The midtones serve as a transition between the lightest light and the darkest dark to create a good value chord, and (2) Midtones help develop the middle ground, which gives your painting depth.

Scheme 2 shows a two-plane organization in need of more midtones. Compare its value chord with the remaining schemes. There is more variety in the midtone value in the two schemes on this page. In these schemes you will probably use the entire range of the value scale. There are an infinite number of values between one and ten, but if you choose only three or four midtone values between the lightest light and the darkest dark, there will be a harmonious value chord.

SCHEME 5

Gradation in any direction

This means darker to lighter gradation of value across an entire painting from any side to the opposite side. It can also be from the outside perimeter into a spotlighted area, which is also called radial gradation.

This scheme is a favorite, but you will probably have to work harder to make this one work. The forms must have shadow and must cast shadows, making this more of a challenge with the gradation from light to dark. It requires more careful thought and planning and takes more control to create the gradual change of value.

When using this scheme, you may want to locate the "star" on the light side because the eye naturally goes toward the light. The detail of form and cast shadows is more visible in light than in the darker area. The "star" will have form and cast shadows, and that puts the shadow on the side that is grading toward darker value.

SCHEME 6

Allover pattern (disconnected lights and darks)

This scheme adapts well to abstraction. It forces you to be more inventive, whether you're working in a realistic, abstract or nonrepresentational style. A good way to begin this scheme is to first surround light shapes of varying sizes with midtones. (Use light midtones so the lights will be easily visible.) Next, begin to build up the darker midtones. After these lights and midtones are established, it's easier to know where the disconnected darks should go (some may be added over the midtone or light values).

This scheme is very different in character and style from the other schemes, but it is still desirable to have unequal distribution of darks, lights and midtones, just as in the other value schemes. I have heard this value scheme referred to as "checkerboard animation." This is a very accurate description of the movement the eye makes while viewing this value scheme.

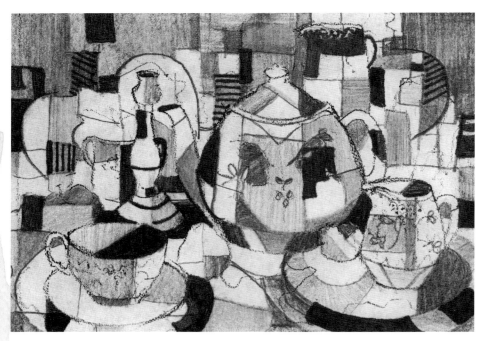

VALUE STUDY BY OLIVE JENSEN THEISEN

Six broad value schemes for abstract paintings

What works for realism works for abstraction. Many artists think it is enough just to be different or innovative. Anything for the sake of being different! However, the elements and principles of design are the means for organizing *any* work of art, the underlying structure for any kind of painting. Without structure, a painting is like a song composed without any knowledge of music theory, keys or chords. You could get lucky once in a while with your results, but you will never have consistently successful compositions.

Seldom does an artist know ahead of time what value scheme will work best for either the realistic or abstract style. That is one of the important purposes for doing quick value sketches. However, the effect of using a value scheme will be the same for any style of painting. These value sketches can be done in only a few minutes, and you will be so much more certain as to which works best when you sketch your subject in each of the six value schemes.

First drawing
This drawing is my abstract interpretation of one object, a spray bottle.

A piece of darker value in lighter value

A piece of lighter value in darker value

A large light and a small dark in midtone

A large dark and a small light in midtone

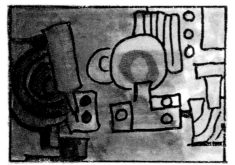

Gradation in any direction

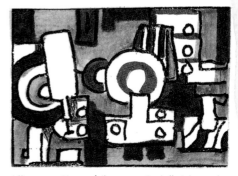

Allover pattern (disconnected lights and darks)

Make a construction paper value plan
This allover pattern of disconnected lights and darks is done in a more realistic way with the shapes of light and dark cut out of black and white construction paper. The shapes are glued onto a piece of midtone cardboard. This method may be a little less confusing if you are just beginning to work on these value plans for the first time. This composition and value scheme was used for a 4' x 4' (122cm x 122cm) oil painting. It was invaluable to have a simple plan for such a large painting. There was great variety in the shades of dark, light and midtone color used. However, the control of value in the colors was held to this simple value plan.

Bigger is not always better ∾

A small painting with a value plan is better than a large painting without one. Don't mistake size for success.

Applying value to colors

We can't use color without considering value; it is one of the three properties of color. Relating color to value is sometimes difficult. We often have preconceived ideas of what value a color should be. At first thought, blue is usually sky blue. Red seems to always be midtone to dark. A daffodil may come to mind when we think of yellow, and we find it hard to believe that yellow can also be midtone or dark. Remember that every color is simultaneously a certain value, and you can make any color the value that will make your value plan work.

How distance affects color and value

In order to create the illusion of an object receding into the distance, there must be a diminishing of color and value. The more distance represented in any composition, the greater these differences will become.

Bright colors in the foreground become less intense in the distance. Dark values in the foreground become relatively lighter. The lightest lights in the foreground become slightly darker and grayer, depending on the atmospheric conditions and colors in the sky. In a still life, the distance is shallower but theoretically should be painted the same as receding objects in a landscape. There is also less detail in the distance.

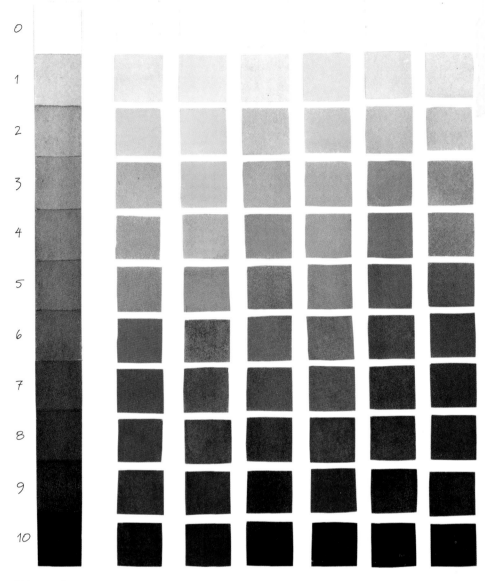

Value scale
The same 1-to-10 value scale that measures the lightness or darkness of gray can be used for colors.

Realistic value schemes in color

In the usual process of planning a painting, the composition should be worked out first in a small sketch in the same proportion as the paper on which you'll paint it. Once satisfied with your sketch, do a quick value plan using one of the six broad value schemes. If you are still unfamiliar with them, try all six plans in quick sketches done first in pencil and then in color so you can see which one is best for your subject.

Even if you know what colors you wish to use, that doesn't tell you the value of those colors. Painting these small color value plans can save you from indecision and excessive corrections while painting.

The plans on these pages illustrate how the same subject, a farm, can be altered and how each value scheme can give an entirely different effect and feeling to the same setting. These plans measure only about the size of an index card (3½" × 5" [9cm × 13cm]). Keep your value sketches small and simple (no picking over details) so you don't spend all of your creative energies on them.

SCHEME 1

A piece of darker value in lighter value
This is a scheme with the character of a silhouette. Painting the subject (a building) in a darker value gives it a mysterious feel, and it appears farther away from the viewer. The reason is that the scale of the building is smaller.

The scenery seems to take on more importance in this color sketch. The colors suggest autumn and the leaves seem to be blowing through the air, which contributes to the feeling of the season.

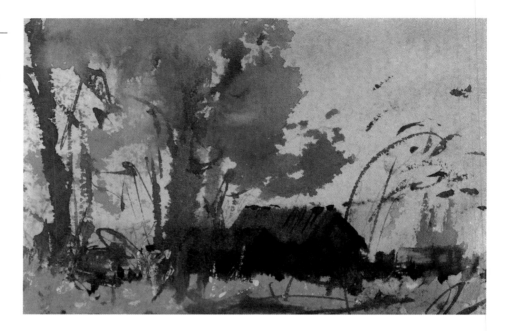

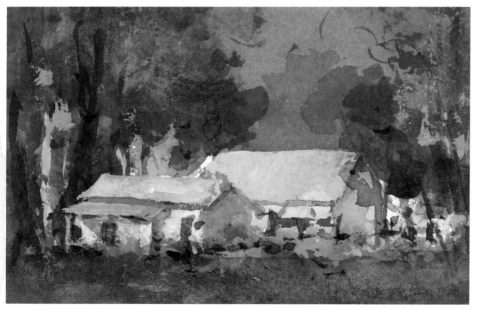

SCHEME 2

A piece of lighter value in darker value
The location and subject matter is the same as in the value scheme above, yet each sketch would result in a totally different painting. Painting the building in lighter value (and larger) makes it appear close and inviting to the viewer, while the surrounding scenery is painted in a vague manner with little detail. This keeps the focus on the subject itself instead of its surroundings.

SCHEME 3

A large light and a small dark in midtone

The entire range of the value scale is being used in this sketch. Where the lightest light and the darkest dark are used in unequal amounts, you have a value scheme. Varying shades of midtone surround the light shapes first, and then the darks are added. In watercolor the lights are usually painted first (or saved as the white of the paper), then the midtones and finally the darks.

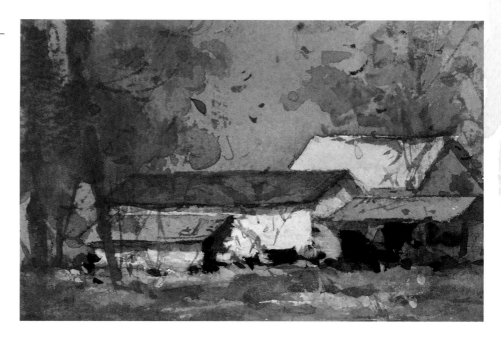

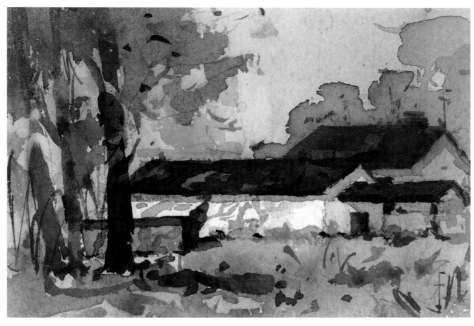

SCHEME 4

A large dark and a small light in midtone

The entire range of the value scale is used here, too. Darkening the roof on each of the three buildings, which makes it read as a large dark, made the simple change in the value scheme. By doing this the light shape was made smaller.

Consider content ∽

Once the value scheme is chosen and a color plan is made, it is time to put your interpretation and feelings into play. Ask yourself some questions and you may discover what you wish to say about this farm. Are people still living on this farm, or has it been abandoned? Are the people industrious and active? Does it remind you of visits to a grandparent's farm? What would it look like if it was snowing or if children were playing or feeding the cows? Once the planning is done, the artist is free to imagine something about the content of this painting-to-be.

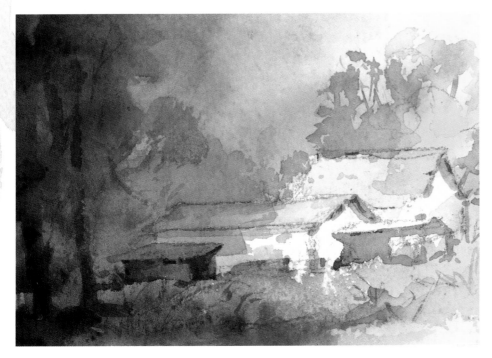

Scheme 5

Gradation in any direction

When gradation of dark to light value from the left to the right side is used, as it is in this sketch, it is helpful to let the light source come from the right side. This will create a more natural gradation for painting in a realistic style. In general the eye moves toward the light, so it is wise to plan your larger and most important light shape on the same side as the light source. This is also true when doing a realistic still life where the same gradation value scheme is used.

Scheme 6

Allover pattern (disconnected lights and darks)

In the beginning, most students think it quite an accomplishment to be able to copy or report what they see. However, as painters learn more about design structure, value, color, creativity and innovative concepts, the more they want to express something new and different to their viewers. This value scheme is more adaptable to the abstract and encourages one to venture into other styles that may be worth exploring.

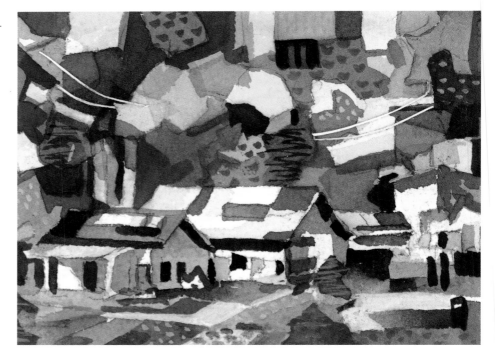

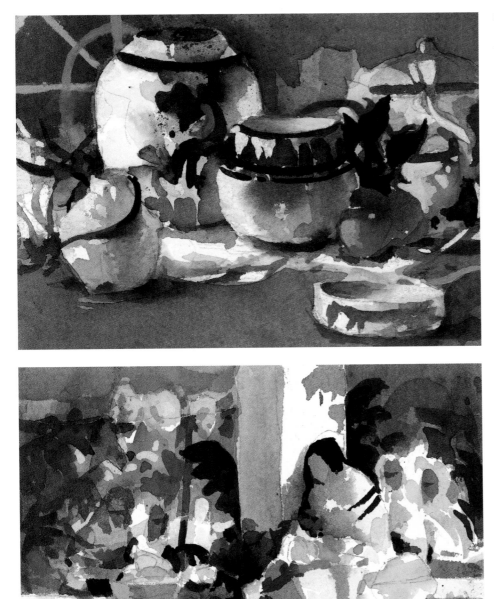

It is interesting to see how totally different the two paintings are on this page, yet the value scheme is the same (a large light and a small dark in midtone). Similarly, in music there are many different styles from classical to pop, yet the underlying theory is the same for all.

Keep a file of value and color plans ∾

I keep on hand a backlog of pencil and color value plans for paintings. That way I never run out of things to paint, and it keeps the desire to paint alive in me at all times. I'll never complete all of the paintings that I have value and color plans for, but if I should, I can reuse some of the same sketches and paint them in different ways.

Planning: Time well spent

You should do at least two different plans for a painting and then decide which one is the best to use for your subject. You may want to create versions using all six of the value schemes for practice.

These two value plans were done quickly with little detail and no refinement. They were made in less than thirty minutes and offered me two directions in which I could take the final painting.

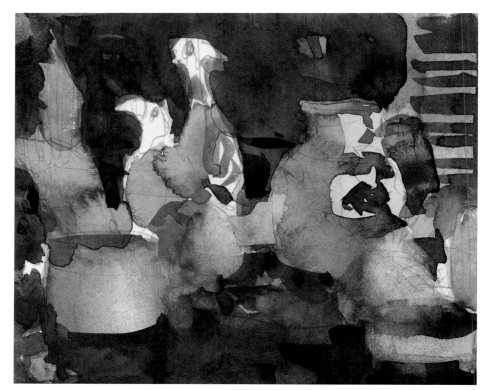

Sketch 1: A piece of lighter value in darker value

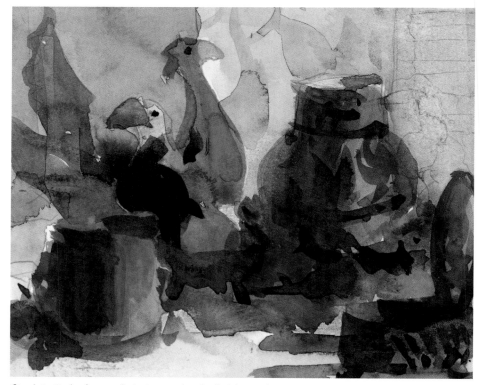

Sketch 2: A piece of darker value in lighter value

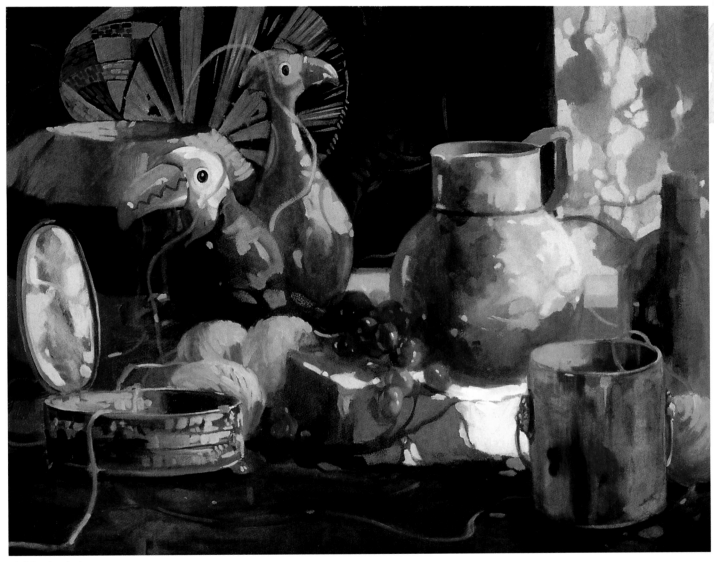

Finished painting

At Dawn was inspired by a children's story about toys that came to life when everyone was asleep. The objects and their arrangement suggest immediacy beyond the picture plane. I imagined the birds talking and playing with the curiosity that all animals usually have. Then, suddenly, from the expression on their faces they seem to be saying, "Oh! The sun is coming up. Quick, we will be caught!" The ribbon running through the arrangement was designed to give a sense of just-completed motion, of surprise and disarray.

The light coming in from the window and the strong light on the forms give a feeling of early morning. From the description of my thoughts and feelings about this painting, you can easily see why I picked the value scheme of a piece of lighter value in darker value. This painting was intended to lighten and stimulate the spirit of its viewers.

At Dawn

Jo Taylor · Oil · 24" × 30" (61cm × 76cm)

Paint a not-so-still life ∾

Painting a still life can be a wonderful way to study form, shadow and value. However, that same painting can be too still, even boring, without a little something extra to give it zing. For years in my own still lifes I incorporated a cat image hidden within the painting. This came about because of the balls of yarn that I used in one of the arrangements; my cat found them irresistible. Still lifes can sometimes benefit from a storyline that will catch the viewer's imagination.

Value key sets a mood and expresses feeling

Value is the measure of light and dark. The keying of value refers to the overall amount of lightness or darkness in a painting.

Every good painting has a dominant value, or key. The value key should be given top consideration when planning a painting because it can generate an emotional response regardless of the composition or subject matter. Together, the value scheme, value key and value chord can create a strong visual impact, especially when the painting is viewed from a greater distance.

I have pictured four value keys below: high (lightest), high middle (somewhat light), low middle (somewhat dark) and low (dark). Comparing these four value keys to the times of day will help you understand them better, but you aren't limited to using a certain key only at a specific time of day.

Think about the content of your painting, and then plan for the feeling or response that you wish your viewers to have. Sunlight lightens and stimulates our spirit; twilight may calm us or make us pensive; darkness has the

High key (sunrise)
The high key can be used to express a sunny day after a few days of clouds and rain or a field of early spring flowers in bloom. It enlivens and uplifts the spirit.

High middle key (midday)
This key has slightly more midtone but is still a light painting.

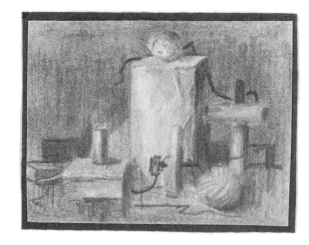

Low middle key (dusk)
This key could be used for a setting at dusk, and it would also be a good key for painting fog or a rainy day.

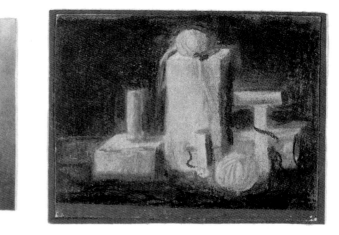

Low key (nighttime)
Many artists use the low key less often since most of our inspiration for painting is observed during daylight hours. However, the low key certainly has its purpose. It can be very effective for painting night scenes. A low key does not always indicate a gloomy scene; it can portray the beauty of nighttime with dramatic lighting effects.

power to depress us, fill us with fear or create mystery. Chose a value key based on the feeling or mood you want to create in your painting.

Can I use dark values in a high-key painting?

My first watercolor classes many years ago were under Gerry Pierce, AWS, a well-known artist and teacher from Tucson, Arizona, where he ran a very successful art school. At one of his summer workshops, Gerry gave us assignments to emphasize the importance of value planning in painting. He had us draw high-key, middle-key and low-key versions of the same image, as I have done on this page.

Choosing a high key does not mean that only light values are used—only that most of the painting is in lighter value. In a high-key painting, there may be only a very small area of value 8 or 9 used, mostly as a dark in the foreground, but value 10 should not used. The relationship of the areas of light, midtone and dark will remain the same for the six broad value schemes. The scale will merely be moved up to the lighter end of the scale for a high-key painting or to the darker end of the scale for a middle- to low-key plan.

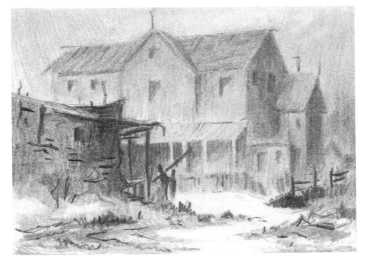

High key
Foreground—
 values 0 to 9
Middle ground—
 values 3 to 5 ½
Background—
 values 1 to 3 ½

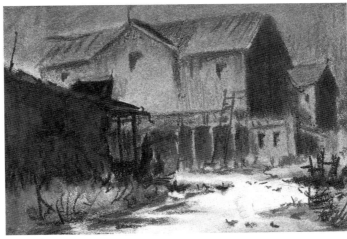

Middle key
Foreground—
 values 0 to 10
Middle ground—
 values 6 to 9
Background—
 values 5 to 7

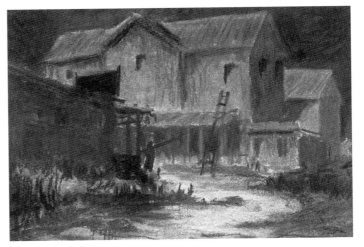

Low key
Foreground—
 values 0 to 10
Middle ground—
 values 6 to 8
Background—
 values 7 to 9

High-key painting

For me, no other subject can set the mood of a painting like spring flowers. The high key seemed an appropriate value key to choose for making a happy, light and airy painting. I am often in my flower garden in the early morning before the sun comes up, when the atmosphere is fresh and cool. I thought of the things that I love about my flower garden while doing this painting.

In this painting, if I were doing it again, I would make the dark part of the flowers a shade or two lighter for high key. The area of dark is all right for a high-key painting since the light area is much larger, but I would make a better connection between the dark iris on the top right side and the rest of the dark shape.

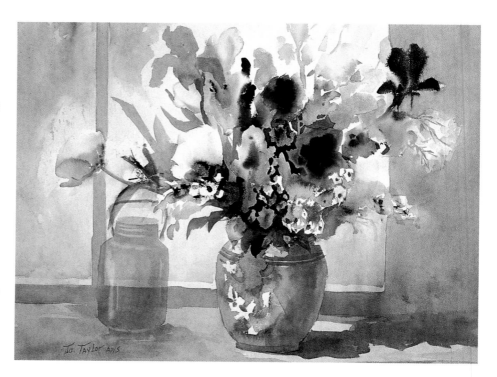

FROM MAMIE'S GARDEN
Jo Taylor · Watercolor · 22" × 30"
(56cm × 76cm) · Collection of Ron and
Beth Morgan

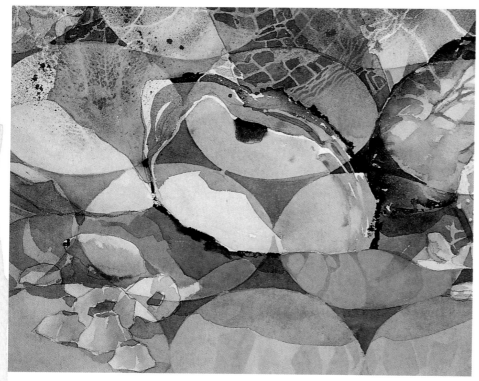

High middle-key painting

In this example there is more of the darker, midtone value than in the high-key painting above. There is more variety in the midtone as well. Very little dark has been used in this high middle-key image because I did not want emphasis on a contrasting shape of light or dark to distract from the pattern of the grid. My idea was to emphasize the design inside of each sea urchin shape in the grid. All of these things contributed to keeping this detail of *Sea Treasures* in the high middle key.

SEA TREASURES (DETAIL)
Jo Taylor · Watercolor · 22" × 30"
(56cm × 76cm)

Low-key painting

This painting is a sociopolitical statement. It is a small reflection of the climate in the United States in the 1960s. At the threshold of the civil rights movement, there was a mantle of fear and unrest that led to riots and the loss of property and life. Without adequate facilities, there was great uncertainty about the future of education. In this painting, a low key helps set that somber mood even aside from the subject matter.

PLIGHT
Jo Taylor • Watercolor • 22" × 30" (56cm × 76cm) • Collection of the Faber F. McMullen Family

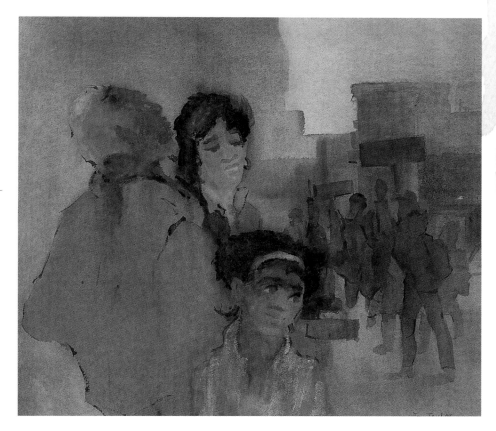

Low middle-key painting

Dark values can suggest fear and mystery, but this lovely night scene achieves the opposite. The bright light from the street lamp gives greater illumination because of the low key, midtones and dark values that surround it. This may be a low middle-key painting, but the wonderful shower of light evokes a feeling of warmth and comfort or a walk on a moonlit beach.

MOUNTAIN CABIN—NOCTURNE
Naomi Brotherton • Watercolor • 15" × 22" (38cm × 56cm)

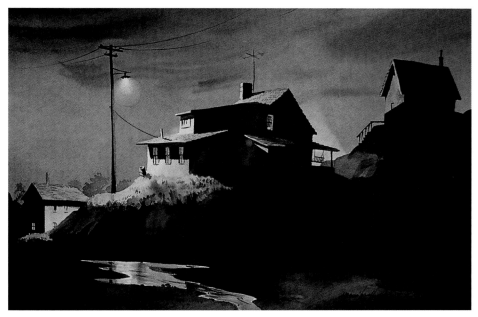

FIVE ✑

Painting Techniques in Action

In this chapter are paintings that show a few of the many experimental techniques I have explored throughout my painting career, as well as examples of basic technique, including wet-into-wet and glazing. A wide range of styles, techniques, designs and color are used in these paintings. With your new awareness of texture, you may discover where texture tools have been used in some of them. You will also explore a few different techniques, including monoprint and plastic pressing.

Admiration of another artist or of a teacher's skill in techniques, composition, brushwork or draftsmanship is a natural thing to have. However, in the spirit of learning, it is important to not get locked into one way of painting. Just as your style of handwriting is unique to you alone, every artist, through practice and experimentation, can eventually develop his own style and techniques. Many artists are dedicated to exploring new ideas, fresh methods and different means. In viewing and evaluating creative work, the point isn't merely to like or dislike—or even to completely understand. The creative artist is always in search of new horizons. ✑

Painting wet-into-wet

Wet-into-wet painting says what it is: You apply wet paint to a wet surface. One of the advantages of the wet-into-wet technique is that it's easier to make changes while the paper is still wet. You can sponge over a large area and have a second try at making it more successful.

With this technique, you are surrendering some of your control to the whimsy of the paint and water. This can lead to unanticipated results. However, the beautiful and somewhat unpredictable fusion of color and soft edges make this a popular painting technique in watercolor.

Preparing your paper

The traditional way to prepare watercolor paper for wet-into-wet painting is to thoroughly wet the front and back of the paper. I use 140-lb. (300gsm) paper, either rough or cold-pressed. A slightly lighter weight may be used, but I don't recommend using paper any heavier than this. The reason is because the heavier paper (300 lb. [640gsm] and up) acts as a sponge. When the back and front are saturated with water, the heavier paper will keep absorbing water and pigment until the brilliance of color is diminished. When you are working with heavier paper, wet only the surface, not both sides.

To prep your paper, start with a piece of 140-lb. (300gsm) watercolor paper, and use a soft sea sponge with plenty of clean water to wipe it down. Be generous with the water, applying as much as can be absorbed.

Next, flatten your paper on a piece of Masonite or a plastic laminated board so the paper overlaps the board by a quarter-inch (6mm) on all sides. This will help shed the excess water so it won't collect at the edges of your paper, causing unwanted balloons of color when paint is applied.

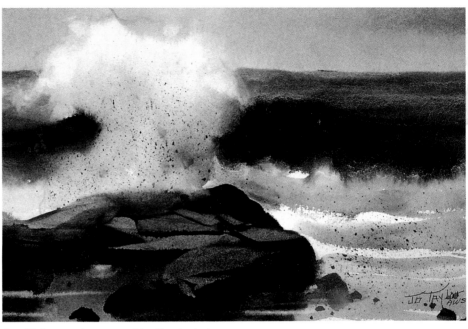

Combining wet-into-wet with other techniques
This seascape was created using several techniques, including wet-into-wet painting and the lifting of paint with a thirsty brush. Scraping with a plastic spatula created the light on top of the rocks.

RANGEMARK—MAINE (DETAIL) · Jo Taylor · Watercolor · 6" × 10" (15cm × 25cm)

During this process, the paper will expand and wrinkles will form. During the expansion period, which takes about ten minutes, lift one end of the paper and gently roll the wrinkles to the outer edge of the board. When wrinkles are no longer forming, take the soft sponge and wipe the surface of the paper to press out some of the excess moisture. Do not lift the paper any more after this and it will hold the moisture much longer. While the paper remains wet, it is easy to make changes.

Applying paint

You will add more water along with your pigment as you paint, so it is very important to control how much water is added. Keep your sponge or paint rag handy. After loading the brush with paint and water, gently lay the loaded brush tip on the rag to absorb some of the excess water. Paint an edge of an object with one side of your brush while keeping your eye focused on that edge.

As you paint, the brush gathers water from the paper and discharges it when the brush is lifted, sometimes causing unwanted bleeding into other areas. This may be done deliberately to achieve a soft edge. However, if you want a more defined edge, pull the brush away from the edge before lifting it. Also, using thicker pigment helps when you need controlled edges.

Setting the mood
If you imagine for a moment that the line is removed from this painting, you will see more clearly the soft, open color that is fairly typical of the wet look of this technique. In this case, the softness of the edges and open color add to the dusty, abandoned look of this little town of Tularosa in New Mexico.

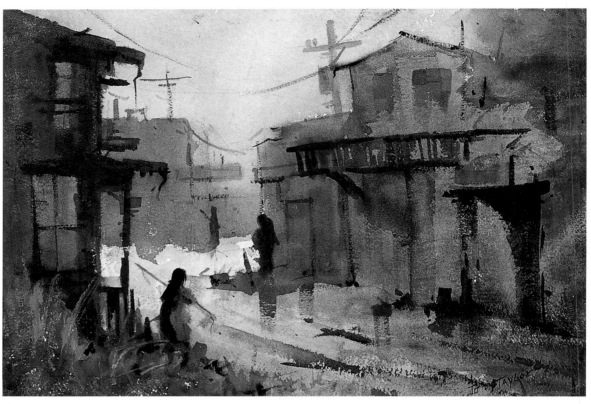

TULAROSA FORSAKEN
Jo Taylor · Watercolor · 15" × 22" (38cm × 56cm) · Collection of the Faber F. McMullen Family

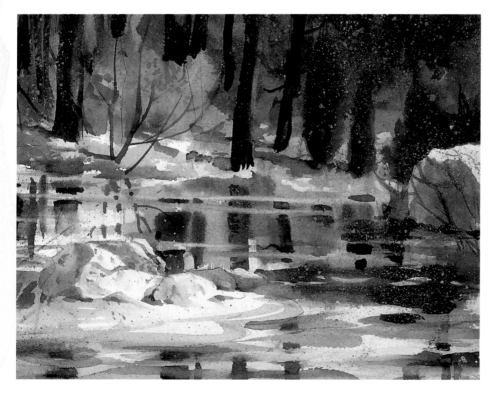

Wet-into-wet for water
No technique is more suitable than wet-into-wet for painting water and reflections. Reflections usually have a softer edge than the real object on shore. Reflections are painted in reverse, toward you, in a mirror-like image. When darker values are added to wet paper, they remain soft and luminous. Darks added to dry paper are often dull and opaque in appearance.

After painting reflections in the water, make thirsty brush lifts in a horizontal direction. The thirsty brush lifts represent the light reflecting off the water. You can make any color of rock, weed or foliage look wet and like a reflection by doing this. When the water is still, your lifts should be horizontal to indicate the stillness of water. When there is movement in the water, the lifts should swirl and wiggle. One side of the wave will reflect the object on shore, and the other side of the wave will reflect the sky.

Lost and found edges

A lost edge in watercolor can be an unwanted accident, or in many cases an intentional technique that gives a very soft and sometimes bleeding effect, especially at the edge of a form. A found edge is a more defined, controlled edge that usually requires drier paper and/or more pigment and less water in your brush.

Defined edges are most appropriate for painting stark realism. Soft, free-flowing edges can give an exciting freshness to watercolor. Many artists use these edges in combination.

The "lost and found" quality of edges plays a big role in the technique of all painting mediums, not just watercolor. It has often been said that lost and found edges are what separates the fine arts from photography. These edges allow the artist to portray a more creative realism than the ordinary stark realism of the camera.

In the two examples on this page, look carefully and see if you can identify the soft bleeding edges as well as the controlled defined edges.

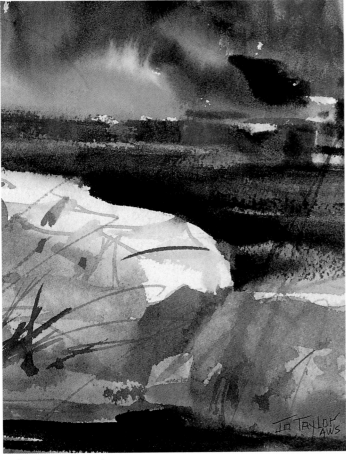

Unleashing watercolor
A lost edge in the wet-into-wet technique is very much like unleashing a young puppy. It is exciting, but perhaps a little dangerous and scary. After many years of painting, I still have the exact same emotions when unleashing watercolor!

Knowing when to leave lost edges alone is a valuable skill that will take time to develop. To get control of the edges again, remember to thicken the paint and lay your loaded brush on a paint rag or sponge so it can absorb some of the excess water in the brush. This is how the edges were handled along the top edge of the rocks in this painting.

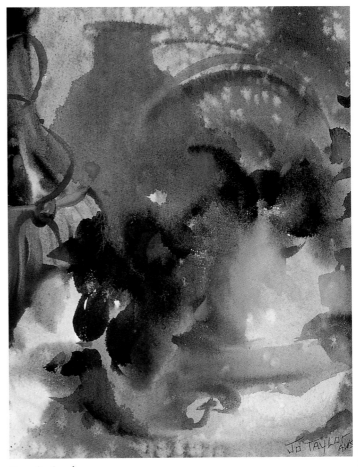

Keep it simple
The very few defined edges identify the mass shapes in this example. Even though there are dominantly lost edges in the shapes of the grapes, for example, the few defined grapes cause the eye to interpret the whole as grapes. This type of simplicity with lost and found edges is the essence of the wet-into-wet technique.

Margarita salt was used in this painting as an experiment. Because these grains are larger than table salt, this feature quickly gained more attention than it deserved. Salt lightly sprinkled in a wet wash absorbs the pigment and causes a light spot when brushed away. This can create a nice textural effect if only a little is used.

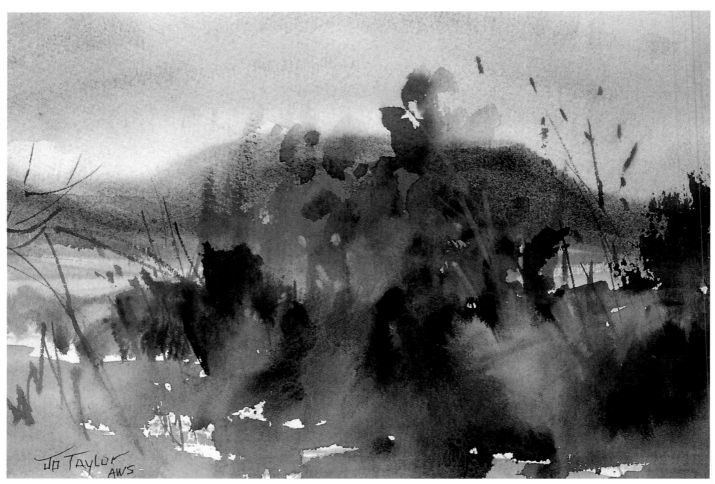

Variety at the edge

Remember that one of the guidelines for good shape in a painting is variety at the edge. I have found that most painters have a problem with this. When we find a good stroke, we don't like to change. Without change, there will be no variety. Look at this simple detail of a shape of foliage. Beginning at the top right side of the mass shape of foliage, my fully loaded rigger brush was positioned almost flat on the paper for a tap-tap-swing stroke. Next, the rigger was changed to a vertical position. Using only the tip of the brush, a couple of long vertical strokes were made, and then some shorter vertical strokes. All of the strokes along this edge were done with the rigger, changing to a different position frequently.

DESERT SOUTHWEST (DETAIL)

Jo Taylor • Watercolor • 6" × 10" (15cm × 25cm)

EXERCISE

Practice your edges. Load your rigger brush with water and several colors. Hold the brush parallel to a piece of flat or tilted paper and tap, tap, tap, each time in a different direction. With a small, clean brush, wet some of the edges with clean water to create a bleeding edge. This should give you soft and sharp edges.

Glazing and underpainting

Glazing, or the layering of color, is frequently used in isolated areas of a watercolor painting. Underpainting is similar to glazing, but is a broad application of color to the entire surface before you begin painting your subject. Underpainting affects all of the layers of color placed on top of it, and in turn the overall appearance of your painting. The greatest advantage of underpainting is that it gives you automatic color change. As you paint other colors over it, new colors emerge where you didn't paint them at all.

I use pure color in very pale shades of red, yellow and/or blue as an underpainting for nearly every painting I create. Since these colors make gray when mixed together, the underpainting is brushed on quickly with little mixing of color permitted.

To apply an underpainting, first wet the entire surface of the paper, front side only. While the paper is wet, apply your colors randomly, with little or no overlapping of colors. I usually begin with yellow (New Gamboge), applying it on whichever side of the painting the light direction is planned for to enhance the sense of a light source. Since the yellow is brushed on randomly, not all of the paper should be covered.

In the spaces left, apply red in the same way (I use Winsor Red). Any hard edges should be softened with a slight pushing stroke using the tip of your brush. Some overlapping of the yellow and red is to be expected; however, avoid too much mixing because the result will be orange, a secondary color, and it will be grayed by the colors washed over it. Individually, the yellow and red will not be grayed because they are primary colors.

After allowing this underpainting to dry, you may add a random application of Winsor Blue over the red and yellow, or you may begin the painting from there. There can be lighter or darker areas in this application by picking up a little extra pigment as you layer the wash on top of the dried underpainting.

When underpainting, I typically use the more permanent staining pigments that will remain visible even after the lift of a thirsty brush. As in all glazing, an underpainting should be allowed to dry completely before continuing to paint.

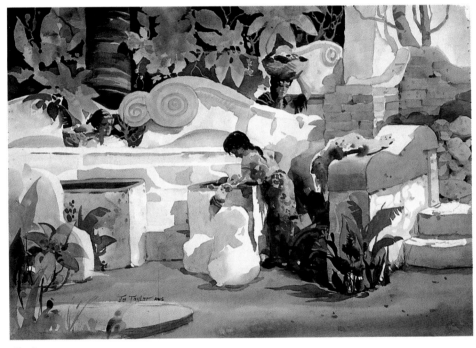

Glazing
This painting of mothers in San Miguel de Allende, Mexico, happily washing their clothes demonstrates the glazing technique. Their soft chatter and laughter inspired the title of this painting.

Oh, What a Beautiful Morning!
Jo Taylor · Watercolor · 22" × 30" (56cm × 76cm)

Watercolor warmups 〜

My first watercolor instructor, Gerry Pierce, started each painting class with exercises. First he had us breathe deeply, bending our arms and bodies. Then, with knees slightly bent, we shifted our weight from one foot to the other. He said we should always shift our weight from one side of our paper to the other as we paint. If we stand in a stiff manner, it is very likely that our paintings will reflect that rigidity.

Try for loose, rhythmic movement of the brush. I have found it very helpful to practice on a scrap piece of watercolor paper before starting a painting. Flex your arm and wrist first. After loading the brush with plenty of water and pigment, sweep the loaded brush to the right or left. With a little twist and turn, sweep the brush toward the top of the paper. Push and pull the brush while moving your elbow in and out.

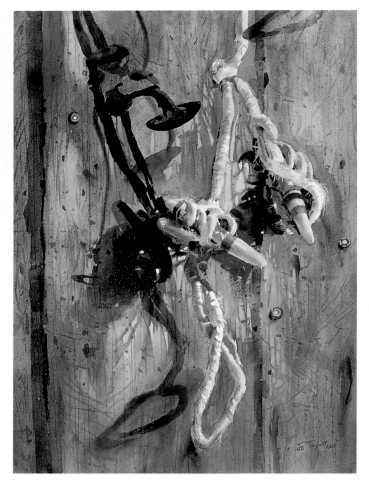

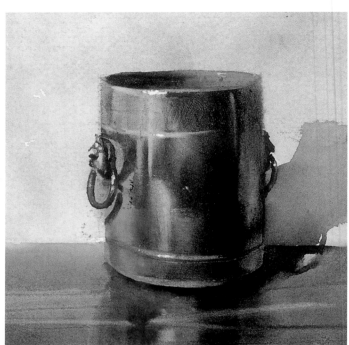

Underpainting

Barse's Barn depicts the memory of a great man's barn and his hobby, and is a good example of underpainting. First, I wet the entire surface of the paper with clean water. Then I applied a random wash of pale Winsor Red and New Gamboge (both staining colors) with a 1½-inch (38mm) wash brush for a warm underpainting. I added more New Gamboge to the right side where the sunlight was coming from. However, each color was repeated in at least three of the four quadrants of the painting to help create color unity. The underpainting was then allowed to dry completely.

Depending on the humidity and temperature, it is sometimes hard to carry a smooth wash over a full sheet of paper without parts of the painting drying and causing balloons or blemishes. Because of this, I re-wet the entire surface with water to ensure a smooth midtone-gray wash over the background. The underpainting created beautiful, subtle color changes in the transparent gray wash.

The emphasis in this painting is on the sunlight, shadows and the textures of the wood, rope and handmade fishing lures. Most of the sunlight on the gray background was negatively painted. The rope was painted with white gouache mixed with a small amount of New Gamboge. Using gouache made the light pattern stronger and the textures more interesting.

BARSE'S BARN
Jo Taylor · Watercolor and gouache · 30" × 22" (76cm × 56cm)

Underpainting and glazing

I began with a drawing in pencil. I used a ¾-inch (19mm) red sable bright for the rest of the painting, since it is small. First, the front side of the paper was wet; then a warm underpainting of New Gamboge and Winsor Red was made and allowed to dry completely. Next, the thicker, dark, warm browns, oranges and reds were glazed over the entire copper piece.

The light side of this vase was lifted with the flat side of a thirsty brush. In doing this lift, I moved the brush slowly to allow it time to absorb the water and pigment. Then the brush was cleaned, squeezed out well and dried with a dry paint rag before I used its flat tip to lift the highlights.

Lift tip ∾

If you have waited a little too long and your paper is too dry to make a good lift, try again by wetting your brush, leaving it a little wet, putting the flat tip on the highlight and agitating the paint slightly. Now quickly clean and dry the brush and try making the lift again.

A different kind of underpainting

Even though underpainting is technically only associated with glazing—in which layers of paint dry before more layers are added—there are advantages to underpainting with the wet-into-wet technique as well. Working wet-into-wet creates softer edges, and it is easier to make changes and sponge out unsuccessful areas. Also, there is no waiting period for drying time. The painting does get drier throughout the painting process, and because thicker pigment is used for the darks—which are usually painted last—there is more definition and control of edges near the end.

The paper for this painting was wet on the back and the front. After the wrinkles stopped forming and the paper laid flat on my board, a random underpainting of pale New Gamboge was applied. Then, pale Winsor Red was quickly applied in at least three quadrants of the paper. (Remember, repeating a color in at least three quadrants helps create color unity.) The paper was *not* allowed to dry first. All edges of the strokes were kept loose and undefined until the darker and thicker pigments were added later. When bringing the next washes over the underpainting, I moved my brush quickly, with very little brushing back and forth. The more back-and-forth action you have, the grayer the color gets.

A warm welcome ❧

Saving the white is important in watercolor; however, warm white gives a rich quality that cold white does not give to a painting. Consider applying a pale underpainting first instead of starting your painting on the raw white of your paper.

STRAW MARKET, NASSAU

Jo Taylor · Watercolor · 22" × 30" (56cm × 76cm) · Collection of the Faber F. McMullen Family

Glazing technique

Materials

- No. 2 drawing pencil

- Kneaded eraser

- *Paper* 140-lb. (300gsm) cold-press or rough, stretched and stapled to a board

- *Paint* Full palette of transparent colors

- *Brushes* 1 ½-inch (38mm) wash; 1-inch (25mm) one-stroke; ¾-inch (19mm) bright; no. 6 rigger

1 Make the drawing and apply the underpainting ∾ The drawing for this painting was a composite of several on-the-spot sketches. When the drawing is finished, wet the surface of the paper with clean water. Apply a very pale underpainting of Winsor Red, New Gamboge and Winsor Blue. Keep all edges soft, and repeat each color in at least three quadrants of the paper to help create color unity. Allow the underpainting to dry completely.

Prepping your paper ∾

There are several different weights of paper suitable for glazing. The most economical is 140-lb. (300gsm) paper, stretched and allowed to dry. To stretch your paper, follow these steps:

1. Wet the paper. Put it on a Masonite board to be sponged and kept wet until wrinkles quit forming. This wetting procedure is the same as for the wet-into-wet technique.

2. Staple it down. You must use a different kind of board, one on which the wet paper can be taped or stapled. A lightweight drawing board, Homosote board or a piece of acoustical tile makes a good surface on which to tape or staple. The board should be an inch (2.5cm) wider than the paper on all sides. The staples should be no more than two inches (5cm) apart all the way around the edges of the paper.

3. Let it dry. The paper expands while it is wet and then contracts as it dries, causing it to lie flat. Lay it down in a flat position to dry slowly and completely. Do not stand the board up vertically or near a heater to dry. This will cause the paper to pop and rip away from the staples.

Instead of stretching 140-lb. (300gsm) paper, you may choose to paint on 300-lb. (640gsm) paper, which is heavy enough to lie flat without stretching. However, it is much more expensive.

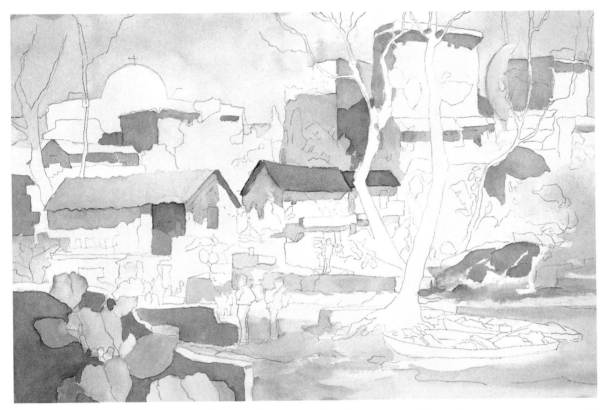

2 Begin glazing ॐ As you approach this step the paper will be dry, so use your big wash brush and completely re-wet the paper. Begin glazing colors on top of the underpainting. Notice the beautiful, automatic color changes, without overmixing and graying of color. To keep from losing the lights, surround a good light shape with a light midtone value. Allow each glazed layer to dry before applying another layer. This technique may test your patience in waiting for the drying periods, but it is worth it because of the beautiful effects of color that cannot be obtained any other way.

Is the paper dry enough to continue? ॐ

To make sure a painted area is dry, turn your hand over so the top side of your three middle fingers may be lightly placed on the painted area in question. Even if it looks dry but feels cold, it is not thoroughly dry. If it feels warm to the touch, it is thoroughly dry and ready for a new wash.

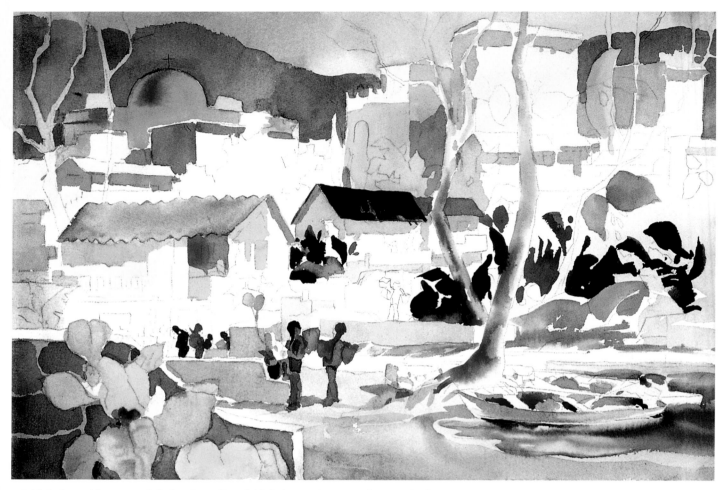

3 Add darker midtones and dark values ❧ Add darker midtones and some shadow. Although it is not always done, it can be helpful to add some of the darkest dark shape next. It will help in the keying of midtone value, which will help establish a pleasing value chord. The midtones are important because they serve as a transition between the darkest dark and the lightest light. If the midtones are too light, the light shape will not read well; if they are too dark, the dark shape will not read well.

In the glazing technique, you must pre-wet the paper often if you want to make soft washes or soft edges. This was the case when the water was painted in this demo. The area of beach and water under the boats was pre-wet with clean water. Then a pale wash of light Indigo was painted under the boats and onto the sand, grading the wash from muted purple to the slightly brighter purple of the sand. The purple appeared because of the Winsor Red in the underpainting. The trees were negatively painted, and the painted spaces between the limbs formed the mountain.

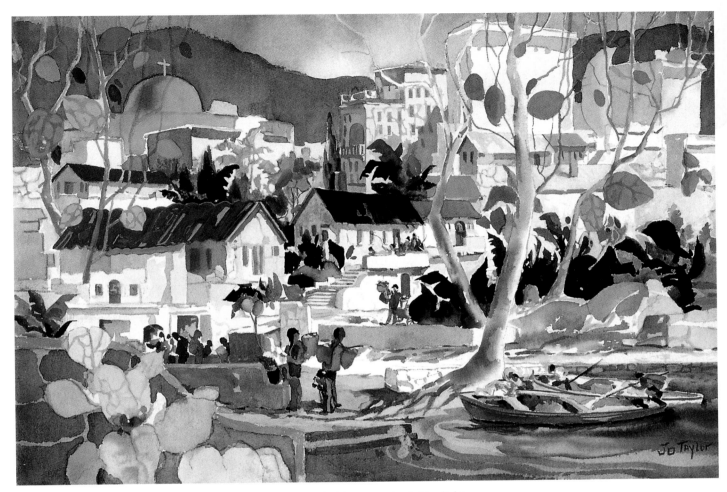

4 Finish ∾ Add more of the darker midtones to serve as a link between the lighter lights and the darker darks, establishing a better value chord. A very dark glaze was added to two more rooftops to help make the darks tie together as a good shape. The value scheme is a large light and a small dark in midtone. There must be careful consideration given to the size of the dark and light areas to keep them from appearing equal. To make the light "read" better, another wash of slightly darker midtone was glazed over the water and beach as well as the mountain.

I finished by adding more of the final details: colorful leaves on the trees, the detail on the figures, a few windows, doorways and steps. Detail was also added to the fishermen and boats coming into shore. This was my final attempt for the time being toward making this a successful painting. However, I usually do not sign my paintings for a long while because I keep studying them and making improvements.

SHRIMP BOATS COMING!—TOPO LA BAMCO, MEXICO
Jo Taylor · Watercolor · 15" × 22" (38cm × 56cm)

Negative painting

Negative painting is seeing space as shape. In order to paint this way, you must focus your eye on the shape being made while painting the space around it. After a little practice, the shapes seem to suggest themselves. Soon you will see the spaces first before the positive forms.

I have been asked before if masking can be used for negative painting. Masking is used for some techniques, but it is not really the same thing. Sometimes in nature you see spaces to be painted; however, many times in negative painting you actually invent the shapes of negative spaces as you paint to create new or different forms.

There are ways to train your eye to see negative shapes. Try this exercise: With a light pencil, draw the contour or outline of a positive shape, such as a flower (including the stems and leaves). Practice drawing and then painting only the open spaces around and in between the positive shapes of the flowers, stems and leaves.

Look for other negative shapes to draw and paint. Remember that a positive shape is something that can be touched; a negative shape is merely a space that cannot be touched. Negative painting is difficult to do at first, but practice will bring results.

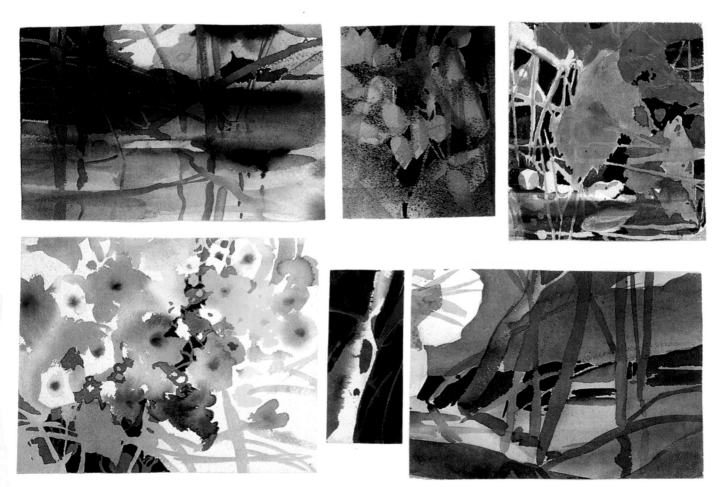

Examples of negative painting
Darks were used to paint the negative spaces in each of the examples shown. Notice in particular the example with small red, orange and yellow flowers in the bottom left corner. This example was left partially unpainted so you could see it before any negative painting was done. The light green leaf on the left is the same color and value as the weeds and stems on the other side. The shape of the large green leaf was formed when midtone green negative spaces were painted between the light-colored weeds and stems. When that was dry, some of the negative spaces were painted with a very dark warm color, shaping some new midtone green leaves and stems. Remember that in order to do this, the eye must focus on the form of the object while painting the spaces.

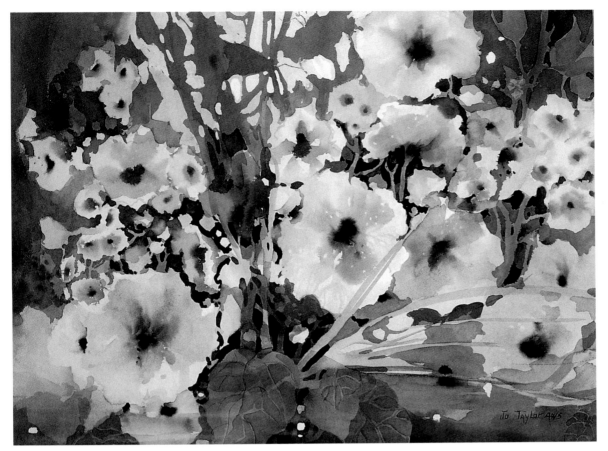

Dark and light negative painting

This was a very loose painting with a lot of white left but few flowers with distinct edges. Most of the darker midtone was a wash surrounding the good shape. Painting the negative spaces in dark and light values formed large and small flowers. Using a darker midtone gray, the small flowers were cut away from the bigger shapes of white. The centers were painted with a very dark Alizarin Crimson or Indigo, and they were wet with water on one side to create a soft edge and give a look of depth to the small flowers. In the upper left part of the background, painting the negative spaces with off-white gouache formed the leaves and stems.

WATERFRONT HIBISCUS
Jo Taylor · Watercolor and gouache · 22" × 30" (56cm × 76cm)

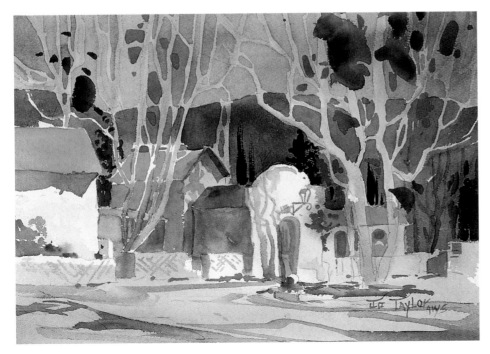

Positive and negative painting simultaneously

In this painting, instead of painting the background mountain first and then adding buildings and trees, the mountains were painted in the spaces between the limbs of the trees. The trees were intended to be there, but the shape of the tree and limbs were created as the mountain was painted behind them.

QUIET MOMENTS WAITING FOR THE TRAIN
Jo Taylor · Watercolor · 11" × 15"
(28cm × 38cm)

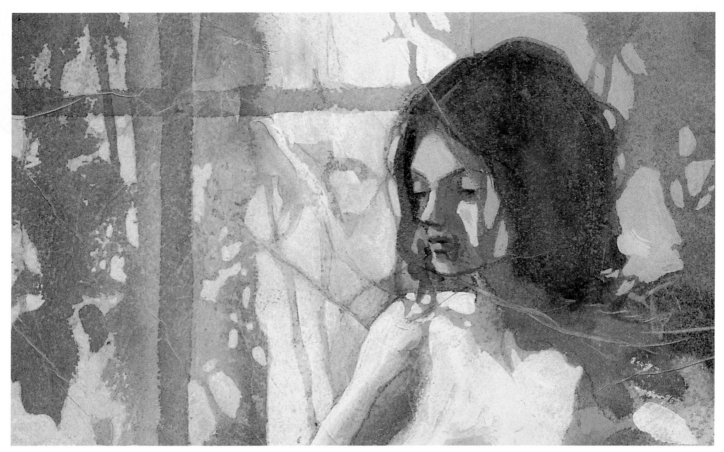

Negative painting for an interesting background

The painting from which this detail was taken was completed in watercolor first, and then tissue was applied on top of the entire painting (you'll learn more about tissue collage on page 120). There were few, if any, washes of color added after the tissue was applied. The negative painting was done mostly in the background with white gouache that was tinted slightly with either warm or cool colors, determined by the gradation of warm to cool in the painting underneath the tissue.

In this example, none of the leaves or vines were drawn first to indicate where they were or what their shapes might be. The pattern of wrinkles made by the tissue overlay was helpful in creating some of the shapes that suggest the vines and leaves outside the window.

A QUIET MOMENT (DETAIL)

Jo Taylor · Watercolor, gouache and collage · 14" × 11" (36cm × 28cm)

How do I soften a hard edge? ∾

In negative painting, the edges are mostly hard and defined. If some soft, blended edges are needed for variety, the already-painted edges may be feathered with a soft, slightly wet blending brush. By thinning gouache with water, a thin wash can be painted over any part of the underpainting. These edges may then be feathered with a blending brush. A ¾-inch (19mm) red sable bright is ideal for softening edges.

Ink line and wash

Drawings have been an important part of the world since recorded history began. I have found that viewers often respond more readily to the wonders of drawing than of painting. The technique of combining ink drawings with simple color washes can be an exciting one for artists because drawing usually comes first in their training.

Ordinarily the India ink drawing should be dry before adding the watercolor washes over it, unless bleeding is deliberately used as in the paintings *The Busy Market* and *Plaza de Costa Rica* (on the next page). India ink bleeds while it is still wet, but is absolutely waterproof when dry. It is very interesting to shave compressed charcoal into a wet wash. Try it sometime! Beautiful bleeding and fusion takes place.

Based on the principle of dominance, either the line or the paint should be dominant in any painting. If the line is dominant, it should have the ability to stand alone as a drawing. To help line become dominant, the color wash should be only a tinting, with little or no form description. Open color can be used (color flowing outside of its form). If the painting will be dominant, it should only be enhanced by line.

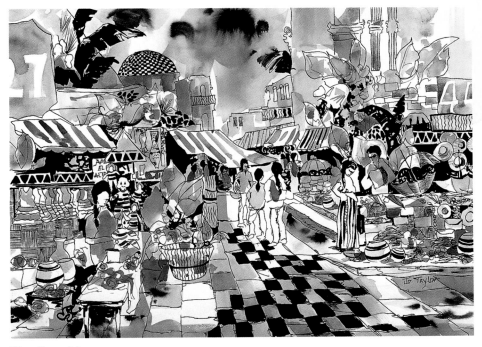

THE BUSY MARKET
Jo Taylor · India ink and watercolor · 22" × 30" (56cm × 76cm) · Collection of Traci Cavendar

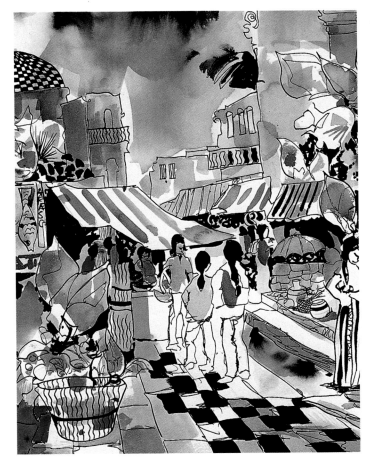

Detail
This detail suggests that there are other compositions to be found in a painting. Sometimes "zooming in" will make an even better composition.

Paint dominant

This is an example where the paint is dominant, enhanced by line. The dark value of the structures and the fact that there is a suggestion of light on the buildings, creating form, makes the paint dominant.

AND THE BAND PLAYED ON—NASSAU
Jo Taylor · India ink and watercolor ·
11" × 15" (28cm × 38cm)

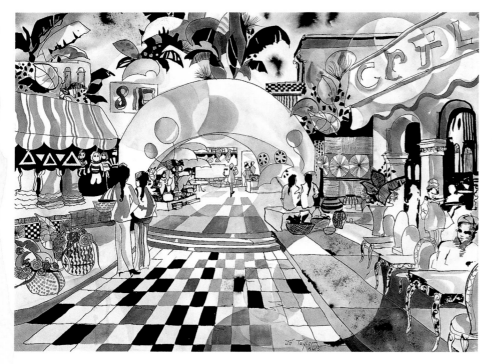

Line dominant

In this painting the watercolor wash is mostly a tinting of open color with no major darks in the wash. It is easy to imagine that the ink drawing could stand on its own as a drawing. However, it is enhanced by the color washes and becomes a painting by category.

PLAZA DE COSTA RICA
Jo Taylor · India ink and watercolor ·
22" × 30" (56cm × 76cm)

Painting with a palette knife

In this technique, color is laid on with moist, thick paint using a small, pointed palette knife. This is very much like palette knife painting in oils; however, you do not apply the paint all over the paper in this manner.

Plan a subject first and very loosely sketch it on your paper. Next, pick up two, three or more colors on your knife at a time, using primarily dark colors. The tip as well as the sharp edge of the knife can be used to apply paint to the paper. When you're finished applying dark colors, wipe your knife clean and pick up some lighter colors (for the background, perhaps).

After applying the paint, and while the thick paint is still wet, flood the paper with clean water using a large wash brush. This is very exciting and a little scary because the colors explode into many surprises and are so fresh and beautiful. Brush as little as possible while the beautiful fusion of color is taking place. Let the watercolor flow, and be ready to leave some of the lovely accidents that happen.

Smaller brushes may be used if needed for more detailed areas, but I seldom use anything smaller than a 1½-inch (38mm) wash, which can be turned to its side and the tip used for detail. Try not to overpaint. All of your palette knife paintings may not be successful, but keep practicing with different colors, brushes and amounts of water. You will have fun and eventually get more creative results.

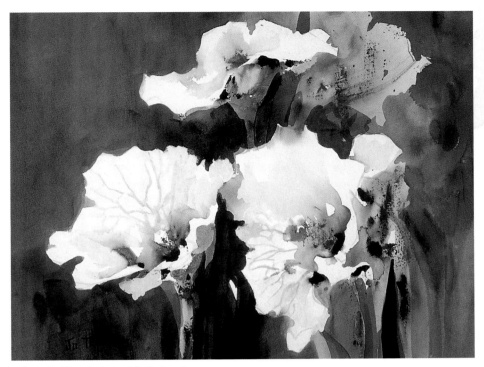

Palette knife painting with dark colors
Pure Indigo, Alizarin Crimson, New Gamboge and a small amount of Sap Green were used for the first application of paint to the centers and undersides of the flowers. Red, orange and a small amount of Burnt Sienna were used as accents on the stems of the flowers, and the paint left on the palette knife was applied lightly onto the background in a scumble (or rough brushstroke) to create texture. These strokes were barely visible after two wash applications on the background. The darker washes were needed to dramatize the flowers and give them more visual impact.

LOOKING FOR LIGHT
Jo Taylor · Watercolor · 11" × 15" (28cm × 38cm)

Detail
This part of the painting was not touched or worked on after the paper was first flooded with water. This detail makes visible the fusion and flow of color that took place.

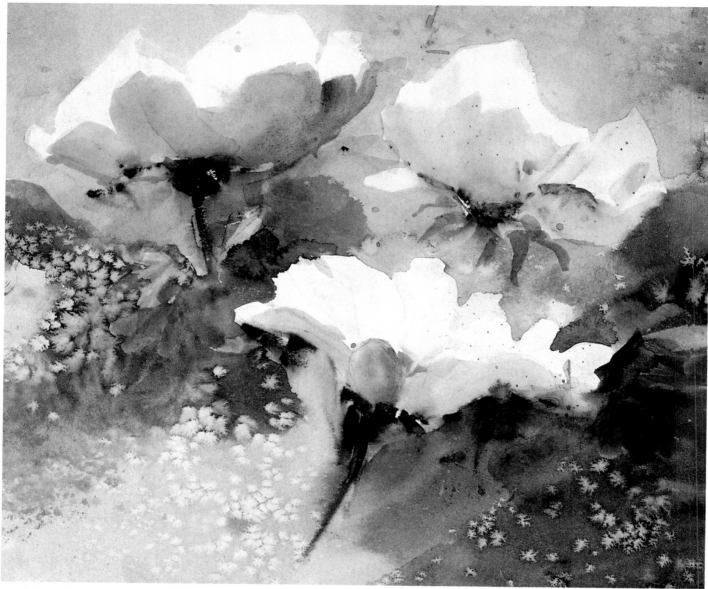

Combine techniques

A combination of techniques created this painting. The flowers were lightly drawn in pencil first. A palette knife was used to place accents of color underneath and on the outer edges of the flowers. I used a 1½-inch (38mm) wash to flood the dark accent areas with clean water. Using the tip of the same brush, the water and pigment was carried over the background and to the top where the petals of the flowers were defined.

While all of the paint was still wet, salt was sprinkled onto the background. Salt absorbs and bleaches the pigment, creating interesting textures. A ¾-inch (19mm) red sable bright was used to paint the shadows on the undersides of the flowers, and the detail of small leaves was drawn with the side tip of the brush.

Pedula Bouquet

Jo Taylor · Watercolor · 11" × 15" (28cm × 38cm)

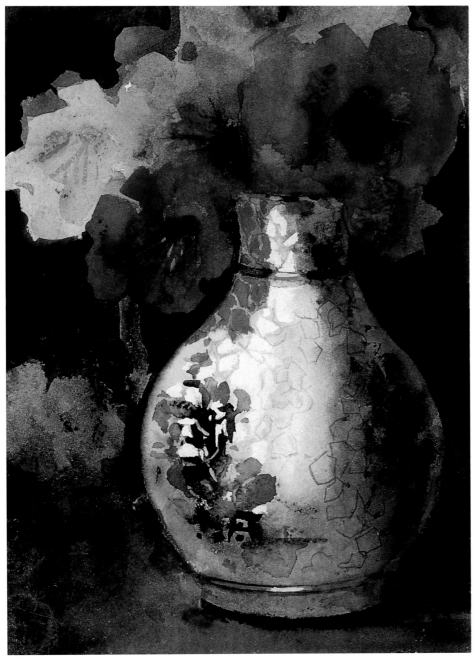

Warming up white ∾

Mixing a small amount of New Gamboge or Yellow Ochre into white paint of any medium will make a warm white.

Palette knife painting, with some help

Starting out, this vase was to be done using the basic palette knife technique. As it developed I could see that things were not going as well as usual. As I worked, it only got worse; I could see a complete failure on its way. This is when the thought occurred to me: What do I have to lose by doing something really experimental? With the exception of the dark blue design on the left side, I covered the entire ugly vase with off-white gouache.

After the warm white had settled a little on the surface of the vase, but before it was dry, I used the pointed end of a brush to draw patterns in the white paint. When the entire surface of the vase was dry, I added very pale yellow highlights to the broken lines to resemble gold. This gives the effect of a cloisonné vase, changing a near-disaster into a beautiful painting!

KISS OF THE PRINCE

Jo Taylor · Watercolor and gouache · 15" × 11" (38cm × 28cm)

Palette knife technique

Materials

- No. 2 graphite drawing pencil

- *Paper* 300-lb. (640gsm) rough watercolor paper

- *Paint* Indigo, Alizarin Crimson, Winsor Red, New Gamboge, Yellow Ochre, Sap Green, white gouache

- *Brushes* 1 ½-inch (38mm) wash; ¾-inch (19mm) bright; no. 8 round; no. 6 rigger

- Small palette knife

- Table salt

1 Make the drawing ∽ If you have trouble drawing the rounded bottom, turn your paper upside down. You will see it with a fresh eye, and your drawing error may become obvious to you.

2 Apply accents of thick, juicy paint ∽ Dark value used for the accents around the light cup will be effective because the contrast will make the cup have greater visual impact. For this, I applied Indigo and Alizarin Crimson with a palette knife, without pre-wetting the paper. The edge of the palette knife enables you to draw an edge as you apply the paint. The palette knife made a hard, defined edge along the edge of the cup. The red and green used on the cup were thinned slightly with water to make them lighter, and they were applied with the palette knife just as the dark accents were.

3 Flood it with water ✍ Use a 1 ½-inch (38mm) wash to flood the painted accents with clean water, pulling away from the cup as you make the stroke. With a camera it isn't possible to get the full effect of the burst of color you get when you first flood the paint with water. Repeat this in the background around the cup until most of that area has been painted. I like to pull some of the paint down into the foreground or the tabletop on which the cup is sitting. The objective is to create a reflection of the cup. Using your ¾-inch (19mm) bright, do the same things to the cup where the accents of green and red have been painted.

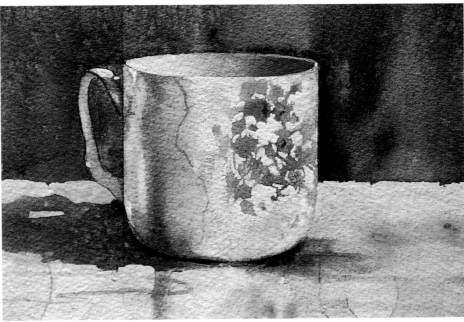

4 Finish ✍ I was not pleased with what took place in the washes in step 3. As a result, in step 4 I applied a darker Indigo wash and sprinkled table salt into it as a solution to the problem. Fortunately, some of the underneath colors could still be seen through the transparent Indigo, making very lovely shades of gray. The texture created with the salt made a more interesting background.

I was also disappointed with the tabletop wash. It was improved by painting a thin wash of warm white gouache over the entire tabletop. The point of the no. 6 rigger was used again to make some horizontal reflections, suggesting a shiny surface. Drawing with the pointed brush again made good use of the unifying principle of repetition, since it had been used on the cup. The detail was defined a little more, with shadows added to the cup and off-white gouache used to accent and define its edges.

If I were going to redo this painting, at step 2 I would use the palette knife to add more variety of colors to the background, foreground and cup. However, I thought the dark accents around the edge of the cup worked well. This finish was not the intended vision I had in the beginning, but I kept on going, and as a result there appeared a beautiful little reminder of my grandmother's cup.

Push on ✍

Many times you will not achieve the effect you planned for, but it is important to continue a painting to completion. Don't quit. Don't put it aside. Keep working on it. Make the effort to "push on" to improve it to the best of your ability.

Applying or scraping paint with a spatula

A plastic spatula or food scraper is a very versatile tool for both applying and scraping away paint. It can be very useful in getting textures of old wood, the top plane of an embankment in a landscape, blades of grass and many other things you will discover.

Use a hard spatula
For painting, you should buy hard plastic spatulas instead of the soft rubber ones. The soft ones are flimsy and will not have the strength to bear down as much as needed when you are scraping off paint. *Always* keep your painting spatulas separate from your food mixing ones!

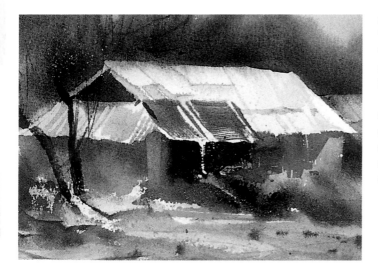

Scraping out for texture and light
This is a detail from a painting that was done in the wet-into-wet technique. With the paper still wet underneath, the entire barn was painted gray, in an approximate value of 5. The paper was then allowed to dry until the gloss began to disappear. If the paint gets too dry, it won't scrape off well enough.

To enhance the roof, I held a dry spatula upright while using the stronger, rounded end. The spatula gathers water and pigment and disperses it when lifted, much like a loaded brush does. To make use of this deposit of paint and pigment at the end of each scrape, the scraping was done in short strokes to resemble sheets of tin. Using the spatula on the roof also created light on the rooftop in a more innovative way.

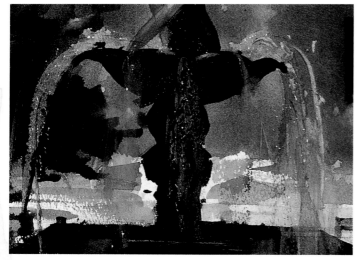

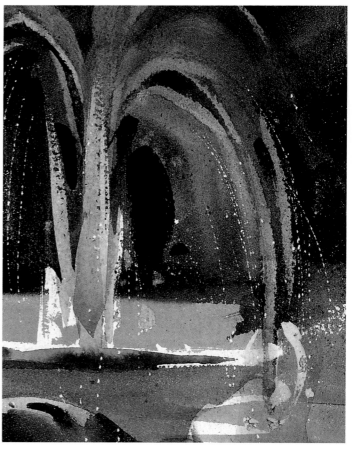

Painting water
Water, being transparent, reflects color around it and colors seen through it. Seeing a warm and a cool example of cascading water dramatizes this. Painting water is a mysterious feat, just as the painting of clear glass. One simple way of painting water or glass is to paint what is behind it first, wait until the gloss leaves the paper, then use a spatula to scrape out or a thirsty brush to lift out some of the color.

In both of these examples, a spatula, mat knife and thirsty brush lifts were used to re-create the effect of cascading water. In the warm example above, a very thin film of water and white acrylic paint (mixed to a milky consistency) was used in a few parts of the cascading water.

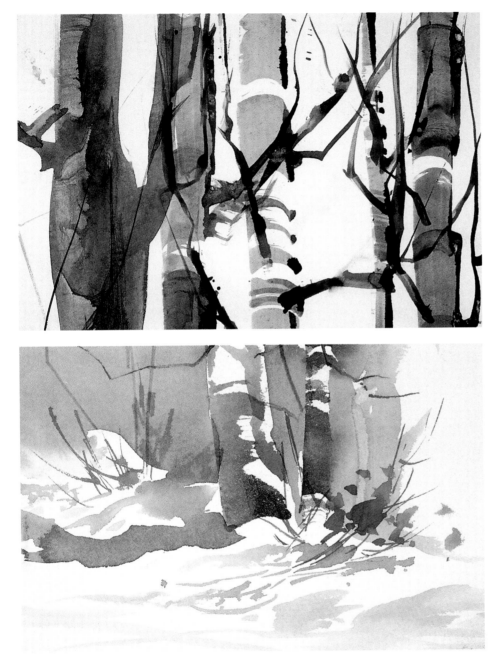

Scraping on for trees

With the exception of the large gray tree on the left in the top example, which was painted with a brush and then scraped out, these trees and limbs were painted entirely by applying paint with a spatula. Try it!

1. Have on hand rough, cold-press and hot-press paper on which to try this technique. Different surfaces of watercolor paper will call for different thickness of pigment and you will have various effects. Put out two or three colors on your palette, keeping each color separate. Using a wash brush, thin and mix each color to a different consistency so you can learn what kind of mark each one will make.

2. Pick up the scraper and hold it upright with the rounded end toward the puddles of paint and paper. Dip the entire length of the rounded edge into the mixed color. Place the loaded spatula on your paper and press down on it with your thumb (until it is almost flat) while making a stroke to the side to form tree trunks.

3. Make the limbs with much darker and thicker puddles of paint. Load the spatula as described above and either stamp the limbs or draw them with the rounded edge. Twist and turn your wrist and arm abruptly to make different angles. This stroke is very much like using a rigger where you use arm and wrist movements to make tree limbs and twigs.

Tissue collage

I keep facial tissue handy for many uses while painting. Placed next to dripping paintbrushes and water pans, they invariably get wet. One day I noticed the immediate wrinkling that happened when the tissue got wet and was reminded of the lovely handmade rice paper that I have used before. As an artist, I inevitably thought this could be a new way of creating texture in my paintings.

I was concerned about permanency of the art, and whether tissue would cause the paint to smudge or smear. I wanted to try it anyway, so I went to my closet of unsuccessful paintings, chose one and got started.

I painted over the watercolor painting with a thinned wash of approximately one part acrylic matte medium and four parts water. This solution did not make the tissue adhere to the paper because it became too dry before I could place the tissue on the painting. The matte medium painted directly on the painting also caused the thick, darker colors to smear only slightly, but the wrinkles did not form well enough.

I tried again. This time, I mixed half-and-half water and matte medium, and placed the tissue directly on top of the painting in places where I thought the texture could be more interesting. With a large wash brush, the half-and-half mixture was painted onto the tissue. It wrinkled beautifully and created interesting textures, shapes and patterns, and I had found an exciting, innovative painting technique!

After my discovery, I tried bathroom tissue, which makes a nice wrinkled texture that has turned out to be my favorite. I have experimented in the same way with a few rice papers, but I still prefer plain tissues with no pattern.

As for permanence, because of the use of acrylic matte medium, these paintings have a very durable and permanent surface.

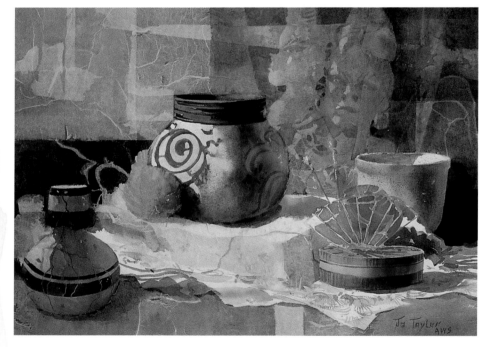

Paint, collage, then paint again

This composition was drawn in pencil on 300-lb. (640gsm) rough paper first. A sea sponge was then used to wet only the front of the paper. An underpainting was done using New Gamboge and Winsor Red, then allowed to dry. The painting was nearing completion when the torn tissue was placed on the painting randomly. After the decision was made where the tissue was to remain, it was dampened with half-and-half matte medium and water. I used a large wash brush to burnish the wet tissue in order to get all of the air bubbles out.

You may do more watercolor washes on top of the tissue after it is dry, if desired. In this painting, off-white gouache was used for finishing touches on the bowls and vases.

ESPIRET DE MAYA
Jo Taylor · Watercolor and tissue collage ·
22" × 30" (56cm × 76cm)

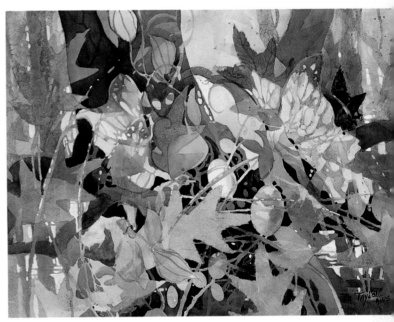

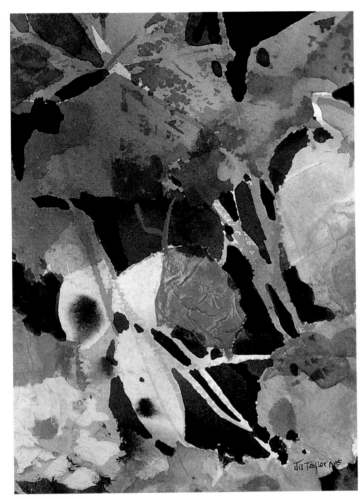

AUTUMN TREASURES
Jo Taylor · Watercolor and mixed media · 22" × 30"
(56cm × 76cm)

More examples

Both of these paintings were done on 140-lb. (300gsm) cold-press paper, wet on back and front and placed down flat on a plastic laminate board. When wrinkles were no longer forming (after about ten minutes), the water was pressed out from underneath the paper by gently rubbing toward the edges with a wet sea sponge. The paper was not lifted off the board after this.

When each painting was near completion, it was allowed to dry. Tissue paper was then put down in places where it could enhance the texture. A mixture of half-and-half water and acrylic matte medium was then brushed on top of the tissue paper. As this mixture was brushed on, wrinkles formed in the most interesting way. Then, with a 1 ½-inch (38mm) wash brush, I gently burnished the wrinkles to remove the air bubbles underneath the tissue. Each painting was once again allowed to dry completely.

After this, more details were added. Some washes of color and translucent acrylic paint were brushed lightly over the wrinkles of the tissue paper. In *Fauna Haven*, darks were used to paint negative spaces, forming the lighter leaves and stems. In *Autumn Treasures*, off-white was used instead.

Stay curious ∾

Autumn Treasures was the result of a fun day with Clark, my gallant prince of a Doberman pup. We were spending his first summer at our getaway cabin where there were seemingly endless woods and a beautiful lake for him to explore. He led the way to the waterfront, looking back to see if I was still there. I followed him and will be forever grateful that I did. This new world of his was so full of mysteries. He led me to trees and cubbyholes full of colored fall leaves, cocoons, webs and water reflections.

I had a great experience that summer experimenting with new ways of re-creating the many textures discovered along the waterfront. It occurred to me that, as artists, we should each have the insatiable curiosity of that young pup. Otherwise, we might miss something beautiful.

FAUNA HAVEN
Jo Taylor · Watercolor and mixed media · 22" × 11"
(56cm × 28cm)

Enhanced monoprint

There are many good books and articles available about monoprints and the myriad different techniques for making them. Briefly, one can describe monoprint as the process of transferring an image from a painted plate to a piece of paper, creating a unique work of art. The procedure shown here is intended to use monoprinting merely as an extension of watercolor painting. I call this an *enhanced* monoprint because after the print was pulled from the press, it was elaborated upon with brushwork.

How to create a monoprint

1. Soak the paper. Lay five or six quarter-sheets of 140-lb. (300gsm) cold-press water-color paper in a tub of water to soak overnight, so you have plenty of sheets to begin with.

2. Apply paint to the plate. Start with an 11" × 15" (28cm × 38cm) piece of Plexiglas (the size of a quarter sheet of watercolor paper). Use liquid dishwashing detergent as a binding medium to make your watercolor paint stick to this plate. Dip a wet brush into a small dish of detergent first, then your paint, and spread it on the plate. Use paint colors directly from your palette. The detergent is harmless to the other colors on the palette and can be washed off easily when you are finished. In this instance, the paint was put on the plate in a random pattern of open color without imagery. When finished, let the plate dry thoroughly.

3. Print and press. Lift the wet sheet of water-color paper out of the water, blot it and place it on the plate of dried paint. Next comes the pressing. Use a rolling pin or brayer on the paper, applying a lot of pressure while rolling over the paper multiple times.

4. Pull and enhance. Pull the paper off of the plate while the print is still quite wet. See what type of image or patterns resulted, and decide how you want to elaborate upon them with brushwork. How much you add to or develop the image is entirely up to you.

For the prints on these pages, I used a printing press instead of a brayer or rolling pin. After the first print was done, a new piece of wet (blotted) paper was placed on top of the plate, which still had ample paint on it, and was run through the press again. This was done for all three of the prints, which got progressively lighter. I wanted to give myself several options for paintings to develop.

First pull
This print indicates some of the patterns and textures that were used in the final enhanced mono-print on the opposite page. However, I felt it was a little too heavy with color and solid paint, and that it lacked the texture I was looking for.

Third pull
This is one of the pulls that I decided not to use this time, although I could see many ways of developing each of the three pulls.

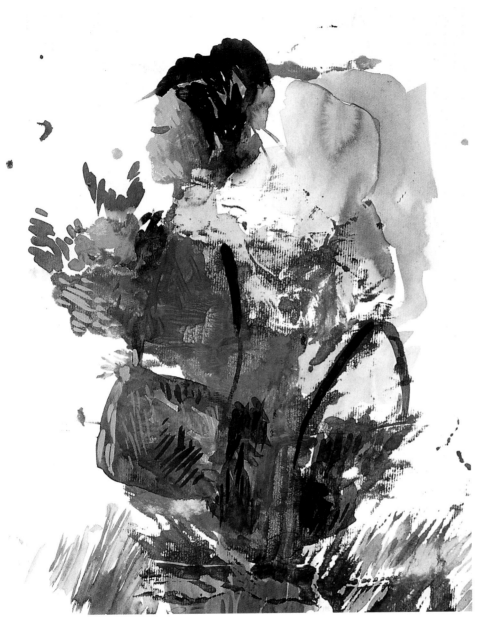

Second pull: The final enhanced monoprint

The second pull was chosen because of its fascinating texture. There were many exciting discoveries made while enhancing this monoprint. The most exciting thing is that not only did the figure seem to emerge, but the suggestion of a style of painting evolved unlike any I had ever seen before. The strokes created by the monoprint became the theme for the style of the painting.

Very little additional color was added, since the oranges, pinks and purples were already in the print. A dark mixed black was used to define the basket and the woman's hair. I used white gouache to paint around the figure, being careful to leave most of the dashes that naturally occurred in the texture of the print.

To Market, To Market
Jo Taylor • Watercolor and gouache •
14" × 11" (36cm × 28cm)

Using a printing press ∾

If you have access to a printing press and want to use it instead of a rolling pin or brayer, you'll need two pieces of felt. Place one piece on the bottom of the press, then add your plate of color, facing up. Next, place your wet, blotted paper on top of the plate and cover it with the second piece of felt. The felt protects the rollers, plate and paper as your contraption is rolled through the press, and it helps the paper and plate stay in place. It won't be necessary to run it through the press more than once for a single print.

Embossed monoprint

The preparation for this embossed monoprint was not much different from the previous monoprint with a few exceptions. Stems, twigs, acorns and found objects were gathered and put on a Plexiglas plate (sometimes plastic leaves, stems and berries are used because they are not as fragile). The wet paper that had been soaked overnight and blotted was placed on top of the prepared plate. Felts were then put in place on top of the paper to protect it. All of this was run through the press, with a lot of crunching taking place. The paper came through beautifully embossed. When the embossing dried thoroughly, painting was done with transparent watercolor and no gouache. The raised shapes of the berries, acorns and other found objects suggested the subject of stems, leaves and pinks.

PINKS

Nenie Duncan · Embossed monoprint and watercolor · 11" × 15" (28cm × 38cm)

Watercolor with overlay of pastel

Pastels used on the surface of a low-key watercolor painting can make the lights come to life and glow with more brilliance than any other medium I've seen. Watercolor papers of different weights and textures provide a very receptive surface for the combining of watercolor and pastel. Pastel may also be painted on the watercolor paper first to be used as an interesting resist.

In some of my paintings, I have combined watercolor with oil pastels. They work as well as traditional chalk pastels and might be considered by some to be more permanent. In the painting on this page, traditional chalk pastels were used, but I feel perfectly comfortable that it will have lasting quality while framed under the protection of glass.

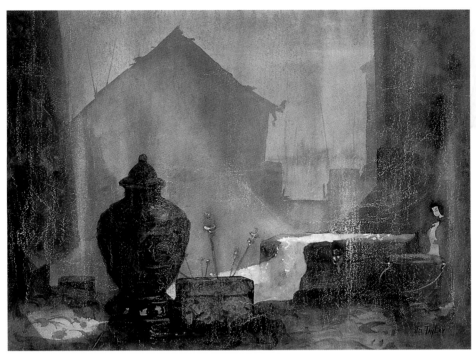

A final touch of pastel captures a mood

Some years ago my family took a vacation to Mexico. Our three children were studying Spanish in school and we thought they would enjoy hearing Spanish spoken as the Mexican people speak it. As fate—or rather, a cantaloupe truck—would have it, we had a wreck that totaled our car. It was a miracle that no one was injured seriously. However, our one-week trip turned into a three-week delay while our car was being repaired.

What seemed like a real tragedy at the time turned into a wonderful opportunity. Our children learned to speak Spanish better, and, as an artist, it was a chance to get ideas for paintings. As I wandered through the shops one afternoon, one of the shop owners apologized because it was time for siesta (the afternoon nap). Just as he dropped the thin curtain over the shop window to indicate that the shop was closed, sun rays came through it, creating a beautiful mood.

Later, at home and in my studio once again, I found it a challenge to find a way to paint my memory of that shop window. We usually think of peering into store windows, but in this case I was looking out. The interesting merchandise, the effect of the thin cloth with the sun rays and the distant view of the outside buildings seemed almost impossible to paint.

Finally I decided to begin a transparent watercolor using soft, muted colors, layering glazes over and over again. Each layer was dried between washes of new color. The biggest problem came in trying to achieve the effect of the thin, dropped cloth. I tried a rough brushstroke, stippling of paint, etc. before I finally thought of dragging the side of a cream-colored pastel over the rough surface of the paper. This technique worked well for the final effect of *Shop Closed*.

SHOP CLOSED

Jo Taylor · Watercolor and pastel · 22" × 30" (56cm × 76cm)

Plastic pressing technique

In this technique, color is laid or poured onto the paper and heavy, crumpled plastic wrap (or sheet of some sort, such as a trash bag) is placed on top and weighted down. After approximately twenty-four hours, the plastic is lifted and patterns emerge. This is fun to do and helps develop your imagination. No two pressings are ever the same, and no two people develop a pressing in the same way.

Create a symphony for the eyes ◡

The musician first conceives or hears a melody, and then uses basic music theory to put the musical composition together. Art is no different. Find inspiration and ideas in the images you see, then use design structure to form your composition.

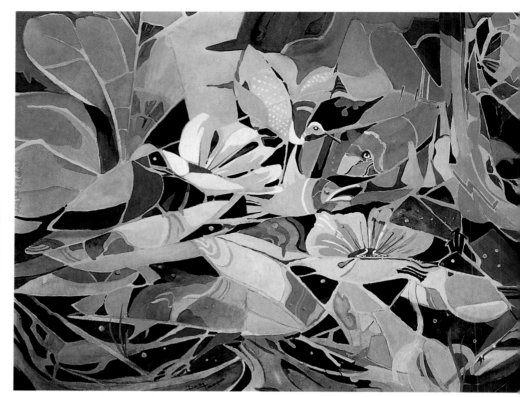

Force creativity with a pressing
To create this painting, the artist gathered twigs and other objects to put on top of the paper first. Then the color was poured on top of the objects—watercolor thinned with enough water to pour. Next, a thin, plastic laundry bag was placed on top of the pouring. Between the placed objects, the artist manipulated the plastic, pushing and pressing it about with her fingers. There were no shapes in mind at that time, just an effort to get textures and happenings beneath the plastic. This was allowed to dry, which took several hours, and the plastic was lifted. The artist saw many possible images emerge. She could see trees, flowers, birds and frogs. The question was where to start! She instantly recalled something that an instructor said to her once: "Make a stroke. That is a beginning."

BLUE LAGOON
Dean Teague · Watercolor and gouache · 22" × 30" (56cm × 76cm)

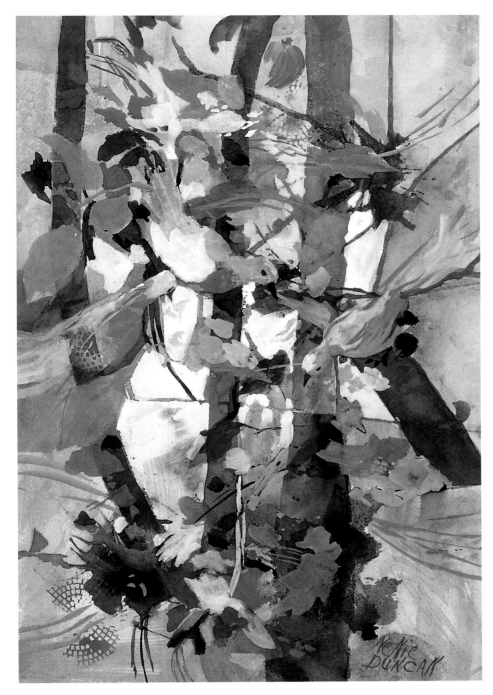

Search for an image

This example uses the same technique, yet it's very different. Thinned watercolor was poured on top of the watercolor paper. Thin plastic was placed on top and then moved about to help create more wrinkles and textures. When the paint and paper had dried and the plastic was removed, the first and most aggressive image to emerge was that of a tree with limbs and leaves. The angled wrinkles suggested birds gathering for a feast of fresh berries, or perhaps just a friendly chat or chorus. These suggested images were developed with gouache. Some textural imprints were also used.

No planning of structure was made at the beginning of this painting. The artist used her creativity and imagination to find the images, but used design structure as the underpinning to build the composition. She searched for interesting space divisions. Notice the large, medium and small space divisions as you look at each edge of the paper. The variety in the size of the rectangles used is very significant. While there are some horizontal lines, the more powerful verticals create dominance. The value scheme is an allover pattern of disconnected lights, darks and midtones.

BIRDS OF A FEATHER
Nenie Duncan · Watercolor and gouache ·
22" × 15" (56cm × 38cm)

The Language of Design

"*Artistic expression (a sonata for instance) is most beautiful when it does not obviously follow a fixed form. Thousands of sonatas have been written and thousands more will be written, all entirely different in expression, and still sonatas. Art is only art when it is confined within a self-imposed form. A sonata in music, an ode in poetry, a building in architecture. These become works of art through conformation to a form. All else is just noise, babble, or a pile of stone. Ends that anybody could achieve.*"

—Susanne K. Langer, from *Feeling and Form*

All artwork, whether it is realistic, abstract or nonrepresentational, is composed and analyzed according to fundamental design principles and elements. They are not arbitrary rules but natural forces that establish a basis for universal criteria. The principles are unity, conflict, dominance, repetition, alternation, harmony, balance and gradation. The elements are line, value, color, texture, shape, size and direction. The principles determine the way in which the elements may be combined to achieve certain effects. These design laws give us the vocabulary of thought with which to organize a work of art.

The twentieth century was a time of rules overturned and broken. The exciting art forms that evolved in painting began in part as a reaction to rules and limits in the arts of the nineteenth century. Since that time, artists have had more freedom to express ideas and genuine feelings, while at the same time realizing that even the various "isms" will have an underlying structure of design. Regardless of personal stylistic preference, the principles and elements provide the underpinning for any work of lasting importance, and give the artist a foundation for personal growth and development.

At the beginning of the twenty-first century, we have a great amount of information available through a wide variety of mediums. But all of that information is useless without meaningful organization of thought. In order to successfully communicate ideas to others, an intelligent artist will first analyze his feelings about the subject and do some thoughtful planning.

In this chapter, you will discover more about the principles and elements of design that you've already begun putting into practice in previous chapters. Combining and recombining the elements and principles can create new styles and new subject matter for painting. Learn how to translate nature and some of its truths into this fascinating language of design. ❧

The artist's ladder

The artist's ladder represents what I believe is the journey of growth many artists take. Some stay at certain levels; others climb to new heights. What separates these groups of artists is not only their skill level but what they aim to achieve. The skills and goals of beginners are more tangible, while those of the advanced artist are more intangible.

An important aspect of growth for the true artist is the development of the artist as a person. Travel and reading play a role. Consideration of values important to life and art plays an important role in the personal development of the artist. Last but certainly not least, it takes time, practice, patience and perseverance for growth and development in any endeavor.

The **beginner** learns the pleasure of art and concentrates on picking up the basics. There is nothing wrong with this stage of development—unless you stay here.

The **advanced learner** continues growth and development by exploring the principles and elements of design, and by developing the ability to compose a painting with these ideas in mind.

The **artist** has the more advanced goal of achieving personal expression while creating a piece of art with universal appeal. Skilled in technique and the application of good design, the artist has a broad vision of art and explores the value of:

Truth • Beauty • Courage
Uniqueness • Perfection • Necessity
Completion • Order • Simplicity
Richness • Effortlessness
Playfulness • Joy

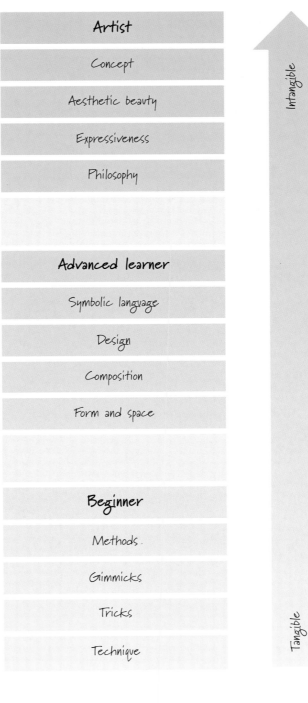

Artist
Concept
Aesthetic beauty
Expressiveness
Philosophy

Advanced learner
Symbolic language
Design
Composition
Form and space

Beginner
Methods
Gimmicks
Tricks
Technique

Intangible

Tangible

The key to design structure

Art, whether complex or in its simplest form, is an illusion. As a very young child I was fortunate enough to see an artist at work. The paint was swirled and mixed, and then the brush applied it to the flat surface of a canvas. Suddenly, a sky and a tree appeared. It was magic!

The elements and principles are not an illusion but actuality. All around you will see line, value, color, texture, shape, size and direction. Whether we are aware of it or not, and no matter how we represent them, realistically or abstractly, these are the ingredients of which drawings and paintings are made. The principles determine the way we choose to organize the elements to evoke a response from our viewers.

Each of the elements should be evaluated using the principles. For instance, when considering the element of line in a painting, ask yourself: Is there *unity* of line? Is there *conflict* of line? Is there *dominance* of line? If not, use *repetition* of line.

In other words, there should be *unity* of line, value, color, texture, shape, size and direction. There should be *conflict* of line, value, color, texture, shape, size and direction. There should be *dominance* of line, value, color, texture, shape, size and direction. If there is no dominance of any one (or more) of these elements, using *repetition* to create more of a particular element will achieve dominance. Repetition has that specific function: to achieve dominance, which in turn brings about unity.

I've heard it said that as long as four or five *dominances* of the elements are present in a painting, it will have significant character and structure.

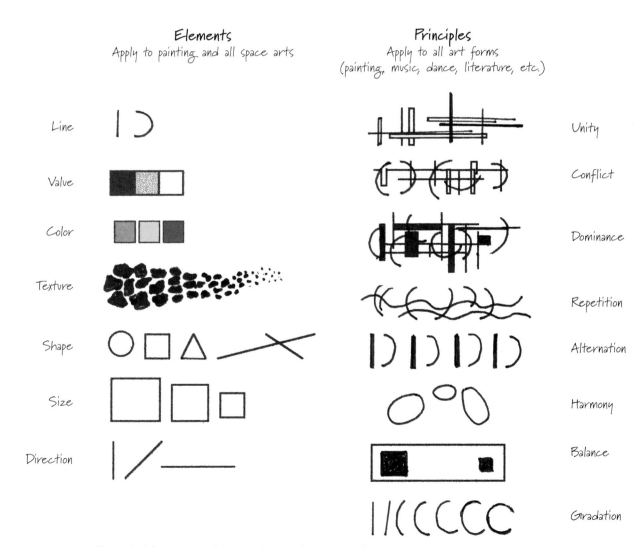

Elements
Apply to painting and all space arts

Line

Value

Color

Texture

Shape

Size

Direction

Principles
Apply to all art forms
(painting, music, dance, literature, etc.)

Unity

Conflict

Dominance

Repetition

Alternation

Harmony

Balance

Gradation

The **principles** are used to organize or judge the **elements**.

Relating emotions through the elements

Beauty in itself sometimes seems to be reason enough for a painting. However, an artist often has ideas that go beyond that of beauty alone. There are many design tools that enable us to express ideas, theories or emotions. In using and combining certain elements, you are presenting different emotions. This combination can greatly affect whether an artist's message gets across to the viewer.

Line, direction, color and value are the essential elements we use to effectively express emotions. Following are some examples of the emotions we relate to these elements.

Line and direction

In nature, there are only two kinds of line: straight and curved. There are only three different directions: vertical, horizontal and oblique. Straight lines can leave impressions of strength, rigidity, forcefulness or tension, while curved lines are generally more peaceful, calm, warm and active. Straight and curved lines can coexist in a painting, but one must dominate over the other.

Vertical direction tends to represent poise, dignity, balance and strength. Horizontal direction indicates calm, restfulness and tranquility, and oblique direction represents change and movement.

Color and value

The warm colors of yellow, orange and red are positive, aggressive and stimulating. They typically appear in the foreground of a painting. The cool colors of blue, green and violet tend to be negative, retiring and tranquil. These colors usually recede in a painting. Some other emotions commonly associated with specific colors:

Red—attraction

Yellow—pleasant, cheerful, lively

Blue—serene, passive, tranquil

Orange—cheerful, lively, attention-getting

Green—passive, fresh, new

Violet—stately, rich, pompous

Gray—sedate, sober, humble

Black—subdued, evil, depressing

Brown—somber, sad, timid, inconspicuous

White—pure, innocent, truthful

In terms of value, paintings that use a variety of darks, lights and midtones in unequal amounts are exciting, while paintings with less variety are not. Also, the value key of a painting affects the viewer's perception of its mood (see page 92).

Design exercises

Few art students at first have zeal or fervor for design, so I created these particular exercises to force students to "think" design. The purpose is not to steer you toward an abstract or nonrepresentational mode of painting, but to better understand the tools of design. Paintings that have structural content will better stand the test of time.

These examples show only one way of doing these exercises. The possibilities are almost limitless, as I found out by giving them to many students. There were never any two sketches or paintings done from these exercises that looked anything alike.

Line

Line is indispensable, and drawing is an art form in itself. Before the age of real understanding and beyond the age of teething, babies pick up a pencil or crayon and know what to do with it. Wallpaper, books, floors and cabinets in the nursery often prove this point!

There are only two kinds of lines: *straight* and *curved*. There are many versions of these types of lines, and many uses for line in general. Lines can be used to create texture or gray value. A line may be formed along the edges where two contrasting values meet. There are thin lines and fat lines, light lines and dark lines, real lines and implied lines. Lines may be used to express emotion, from harsh, intimidating lightning strikes to a happy, spontaneous line like that of a child's scribbling.

Start here
On a piece of paper, draw five straight lines on the left, and five curved lines on the right. This initial arrangement lacks unity and dominance.

EXERCISE 1

Unify the design through the use of repetition. Repeat five curves and five straight lines on their opposite sides. (Make two photocopies of this image for exercises 3 and 4, or you will have to redraw it each time.)

EXERCISE 2

Create dominance by adding more of one line. In this example, straight lines are dominant.

EXERCISE 3

Starting with the same design used in exercise 1—equal numbers of straight and curved lines—create dominance through use of value contrast by adding accents of black.

EXERCISE 4

Starting with the same design used in exercise 1, create dominance through the use of one intense color by adding accents of red or whatever color you choose.

Shape

In nature there are only three basic shapes: *square*, *triangle* and *circle*. The rectangle is derived from the square; an oblique angle is derived from the triangle; the ellipse is derived from a circle. A shape appears flat, in contrast to a form that appears to be three-dimensional.

In art, shapes are used in many ways for many different purposes. However, a design lacks unity when shapes have no obvious relationship to each other. There are geometric shapes and invented shapes. Sometimes enlarged lines, letters and numbers are grouped together to make a shape. Shapes may be overlapping, abutting or interlocking.

In the exercises on this page, look for some of these shapes. Try selecting a different combination of the three basic shapes and follow the same procedure.

Start here
On a piece of paper, draw five circular shapes on the left, and five rectangular shapes on the right. This initial arrangement lacks unity and dominance.

EXERCISE 1

Unify the design through the use of repetition. Repeat five circular shapes and five rectangular shapes on their opposite sides. (Make two photocopies of this image for exercises 3 and 4, or you will have to redraw it each time.)

EXERCISE 2

Create dominance through value contrast by adding sections of black.

EXERCISE 3

Starting with the same design used in exercise 1, create dominance through the use of one intense color.

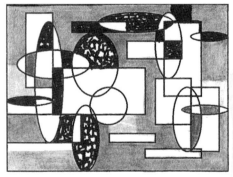

EXERCISE 4

Starting with the same design used in exercise 1, use values to weave a connecting light shape and dark shape through the design.

Size

Size and proportion are very nearly the same. Size means the dimension or area of something—its length, width and depth. Very close to that meaning is proportion, the relation of one part to another (relative size or ratio).

Remember that the most satisfactory or interesting space division is one in which the parts are not of equal size or area. Vary the amounts of *large*, *medium* and *small* shapes in a painting in order to have dominance.

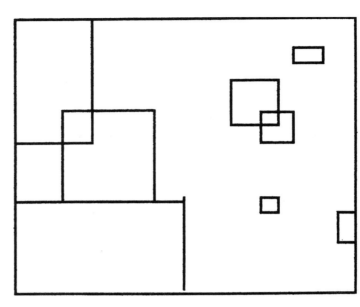

Start here

Pick one of the three basic shapes (square, triangle, circle). Now pick two sizes (large, medium, small). On a piece of paper, draw all large shapes on the left and all small shapes on the right. This initial arrangement lacks unity and dominance.

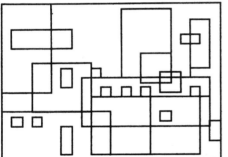

EXERCISE 1

Unify the design through the use of repetition, repeating the large and small shapes on their opposite sides. (Make three photocopies of this image for exercises 3, 4 and 5, or you will have to redraw it each time.)

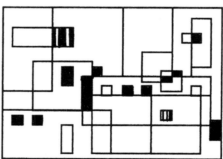

EXERCISE 2

Create dominance through value contrast by adding sections of black to the small shapes. Small sizes are made dominant through the use of strong value contrast.

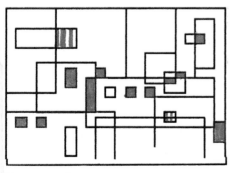

EXERCISE 3

Starting with the same design used in exercise 1, create dominance through the use of one intense color. Small sizes are made dominant through the use of bright color.

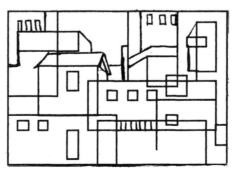

EXERCISE 4

Starting with the same design used in exercise 1, create something representational.

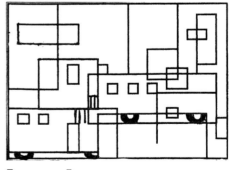

EXERCISE 5

Starting with the same design used in exercise 1, create a different representational subject matter.

Direction

All lines have direction—*horizontal, vertical* or *oblique*—and each direction has a very different effect on the viewer. Horizontal suggests repose, peace, and quiet, as well as the horizons of the seas and plains. Vertical direction suggests poise, balance and strength. It is a symbol of uprightness, honesty and dignity. It may also express the severe and austere. Oblique is dynamic, suggesting movement and excitement. The oblique usually requires an opposite thrust of another oblique to give balance and support.

Direction is one of the many tools aiding the artist in conveying emotion or self-expression.

Start here

Pick two of the three different directions (vertical, horizontal, oblique). On a piece of paper, draw all vertical lines on the left and all horizontal lines on the right. This initial arrangement lacks unity and dominance.

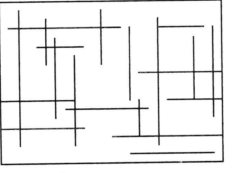

EXERCISE 1

Unify the design through the use of repetition. Repeat five verticals and five horizontals on their opposite sides. (Make one photocopy of this image for exercise 3, or you will have to redraw it later.)

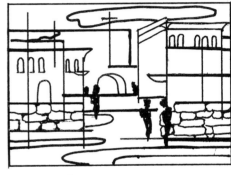

EXERCISE 2

Make the collection of lines into something representational with a horizontal directional dominance.

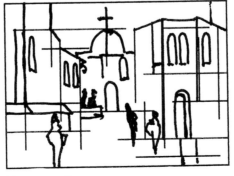

EXERCISE 3

Starting with the same design used in exercise 1, re-create the same subject matter or scene you made in exercise 2, only with a vertical directional dominance.

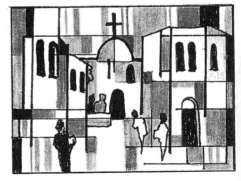

EXERCISE 4

Starting with either of your representational scenes, create an allover value pattern of disconnected lights and darks.

Design variations: Space division

Often an inexperienced artist will think like a camera without realizing it. If it is beautiful, why not record it as we see it? A great teacher once said to me, "While nature provides us with beauty and inspiration, it does not provide us with the perfect composition."

The variations of space division (or size) on these two pages and the examples of value emphasis on the following pages show some of the ways in which you can arrange nature into a good design using these elements.

View from the inside out ∾

Test your creativity and imagination by trying this assignment, which I've given to my advanced painting classes. Paint your view from the inside of something, or inside out. One student imagined that she was inside of a stump and painted it.

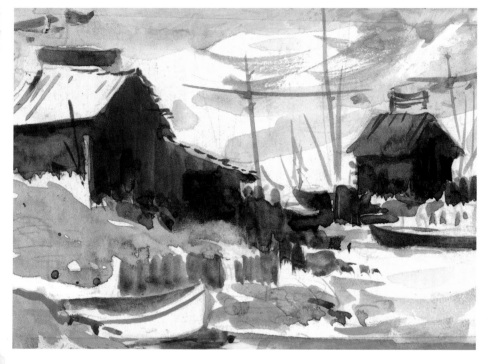

First sketch
This first thumbnail sketch was done on location in Maine. The sky, foreground and structures occupy equal areas, much like a camera might record the scene. There is no dominance, which would make for an uninteresting painting. It was very hard to think of fitting this subject into a good design while waiting for lobsters to be cooked! I sketched the scene just as I saw it, with plans to try different variations later in the studio.

OPTION 1

A dominant foreground
On a two-dimensional surface, we cannot encompass the entire view of what we see in nature. As a result, our painting will naturally be a process of selection and exclusion. Take time to see and feel what is of greatest interest to you, then devote the larger spatial area to it. For instance, if the interest is in the foreground, make that your largest spatial area.

Option 2

A dominant sky

There is nothing so uneventful as a perfectly clear blue sky. It might make us feel good after a long winter storm, but it would not be logical to give it the largest space in a composition. When the sky is given the largest space, use the opportunity to paint dramatic effects of storm clouds or of beautiful colors. People are so often in awe of the unbelievable, beautiful effects that happen in a sky.

Option 3

Dominant structures

Emphasis on structures is a favorite space division for so many artists. It can offer endless possibilities in design arrangements. If the sky is uneventful but there are beautiful lights and shadows on structures, the largest spatial area should be devoted to them instead. Structure can be a wonderful subject to zoom in on to paint a detail or texture that catches our eye when others may have missed it. Once I gave one of my classes the assignment of looking closer to find something they had never seen painted before. One student painted a marvelous interior of a knothole.

Same space division, different emphasis

These examples show how the use of strong value contrast can shift the emphasis in a painting. In the top sketch, the boats and boathouses in the middle ground are dominant. In the bottom sketch, the water is dominant. Although the two sketches appear entirely different, they portray the same subject matter and the same space division. Contrasting value and color determine the path of the viewer's eye. The eye will always be drawn to areas of the greatest value contrast.

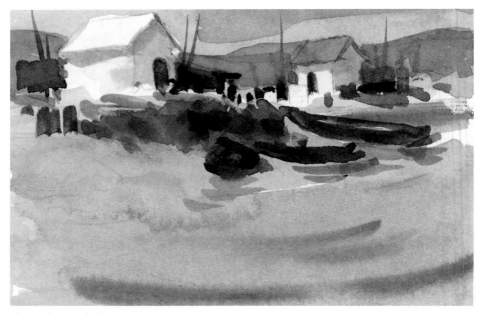

Emphasis on middle ground

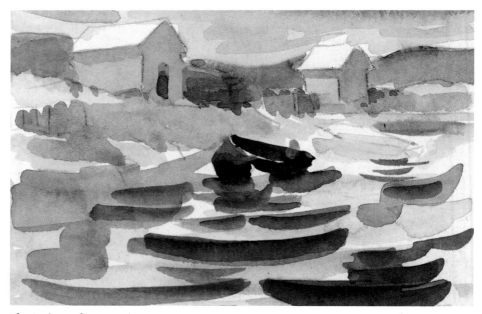

Emphasis on foreground

Contrast supports focal points ∾

There is a lot said about the importance of focal points in a painting. The way to create a focal point is with the same tool that makes the shifting of the emphasis work. Bright color and strong value contrast will help create focal points where they are needed, which will carry the viewer's eye throughout a composition.

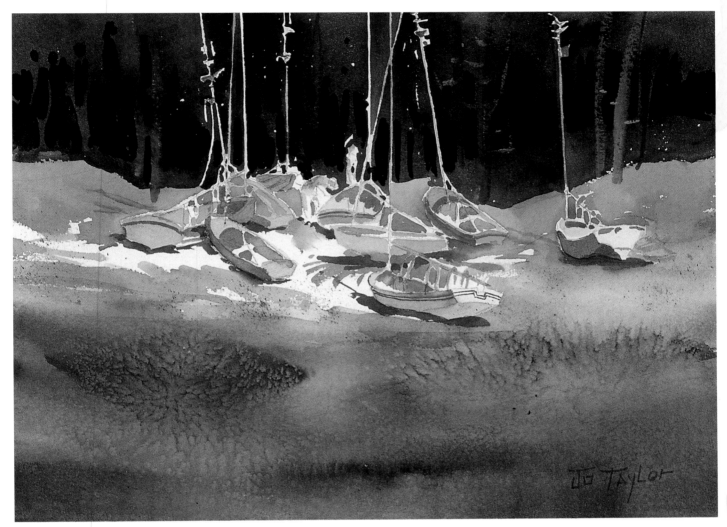

Shifting the emphasis with value contrast

The largest space in this instance includes the water, boats and the land on which they rest. This division is evident because of the great value contrast between this area of the painting and the dark shaded woods. The water is interesting but subdued because the emphasis is on the sunlit ground and boats.

REGATTA

Jo Taylor · Watercolor · 22" × 30" (56cm × 76cm) · Collection of Robert Taylor, Jr.

Create dominance ∾

If there is ever doubt about which line, value, color or direction dominates, a simple solution is to add more intense color or greater value contrast to one or the other of the elements to strengthen its dominance.

Design variations: Line and direction

Line and direction are important elements used to express emotion in painting. To add interest in any composition, there should be conflict of line as well as direction. Even after developing the ability to see lines, basic shapes and directions in nature, it takes practice to create plans that have conflict as well as dominance of these elements.

Repetition with variety of line and direction achieves unity and interest. The choices we have to express our emotions through the different combinations of line and direction are almost limitless.

Variation and exaggeration of line and style

In nature, curved and straight lines are subtle and sometimes harder to see or determine. To help you see the same subject done in the two different lines, stylization and exaggeration were used here. Our memory is sometimes strengthened by exaggeration of a subject. The purpose of these examples is to reinforce the idea that we can create new works of art by using the design elements and principles in different ways. These two small sketches may be of the same subject, but there is a completely different feeling in each.

This is the same lobsterman's shack used in the sketches on pages 136-138, but in another variation. To create dominance the curved or straight lines were exaggerated. Some straight lines were turned into curves, and some curved lines were made straight. As a result, each of these sketches achieved a dominance of line and became stylized in a very different way.

Curved-line dominance

Straight-line dominance

EXERCISE

One assignment I've always enjoyed giving my students is this: Draw or paint a realistic still life with mostly round forms (vases, pitchers, fruit and so on). Now re-create the same still life, changing all curved lines to straight lines. Practice changing the character of line on landscapes, florals and figures for interesting results.

Curved lines and cylindrical shapes

The shape of cylinders and curved lines comes from the basic shape of the circle. Gentle curves can give your viewer a feeling of peace, calm and warmth. Vigorous, forceful curves indicate activity that can be joyous and exciting (such as a festival) or foreboding and dangerous (an impending storm).

Straight lines and rectangular shapes

Straight lines usually suggest tension, stiffness, rigidity, power or strength. In the structure of any work of art, there should be conflicting lines as well as dominant lines. There is dominance of straight lines in this sketch but a few peaceful curved lines were added for conflict.

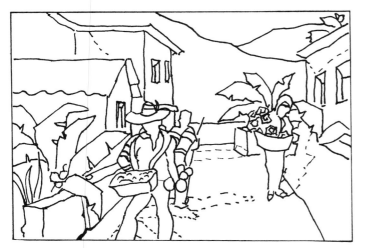

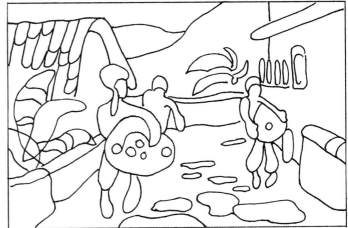

Straight-line sketch

This sketch was first done in pencil while walking with a group on an interesting street in Jamaica. There was not enough time to stop for a more detailed sketch, but the general impression and architectural reference was there. After studying the sketch I realized it did not capture the feeling of happiness one felt when seeing these friendly joyful people, with their music and laughter, taking their wares to market.

Curved-line sketch

Calm, peaceful curves would express these gentle people better than the stiffness or poise of straight lines. This thinking led to this stylized design that conveyed the feel of the rhythm of their music and the calm and peaceful demeanor of the Jamaican people. Rather than reporting what was actually seen, as in the first sketch, this drawing expresses what I felt about the subject. This sketch was later used as the basis for a finished painting.

Oblique dominance

The oblique direction is dynamic and moving. Well-known artist John Marin used oblique slashes of color to express the movement and excitement in his paintings of the busy city.

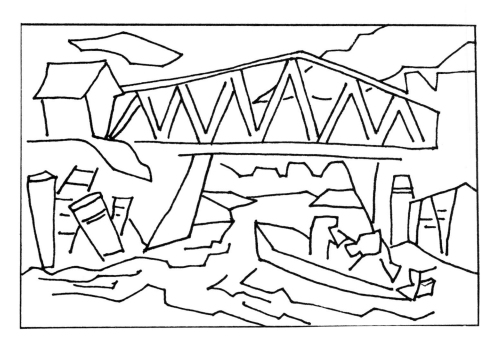

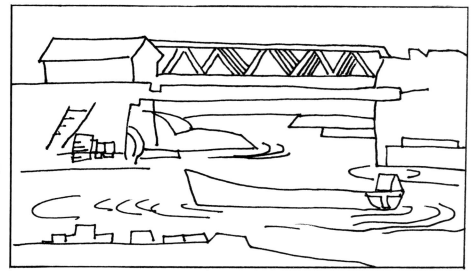

Horizontal dominance

The horizontal direction conveys a feeling of rest and tranquility.

Vertical dominance

The vertical direction gives the feeling of dignity, poise, balance and strength.

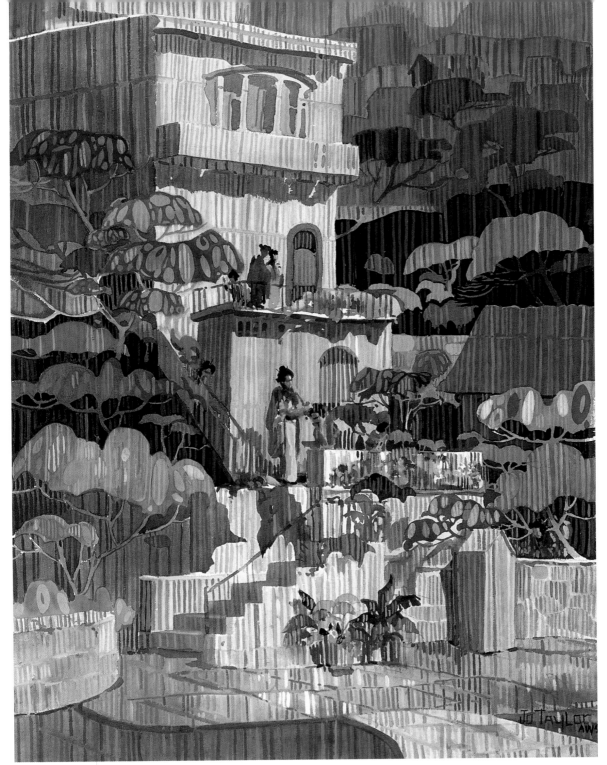

Vertical directional dominance

This painting has dominance of straight lines and dominance of vertical direction. The value scheme is a large light and a small dark in midtone, and there is a dominance of cool color. I used texture as a tool to help reinforce the vertical dominance by applying stripes. This painting is a strong example of how we can create art that we never would have seen or thought of doing by combining and recombining the elements of design. This painting, based partly on reality and partly on imagination, was the result of a thought process involving the design elements and principles.

A step in the right direction ↷

Accomplishing a vertical dominance is made easier when a vertical format is used.

AFTERNOON ON LOMBARD STREET

Jo Taylor · Watercolor with acrylic lines · 22" × 30" (56cm × 76cm) · Collection of
John Truitt

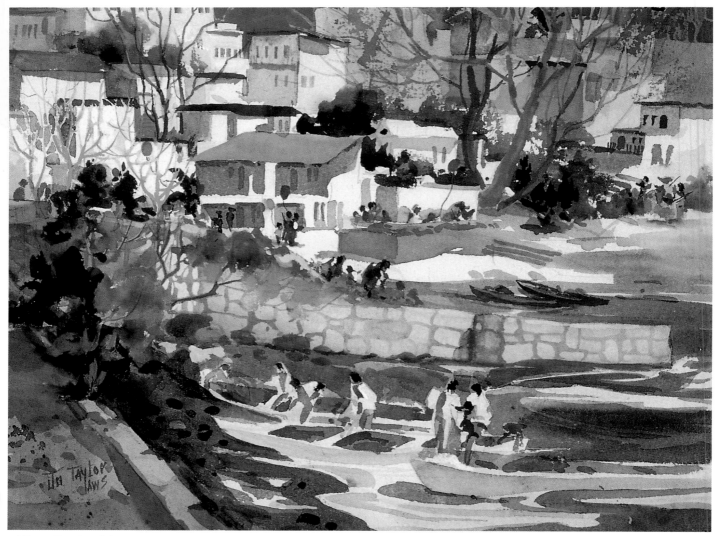

Oblique directional dominance

In this painting the higher side on the upper left balances the lower side on the right where the fishing boats are coming in. This creates an oblique placement, which helps to suggest movement. Some of the buildings are stair-stepped downward, leading the eye into the painting in an oblique direction. The trees on either side are leaning in an oblique counter-direction to enhance the dominance of the oblique direction. The line dominance is straight, but it would be challenging to make another version with mostly curved lines. The value scheme in this painting is a large light and a small dark in midtone. The design structure in this painting is not entirely obvious but in its own subtle way leads the viewer's eye through the composition.

BOATS ARE COMING—TOPO LA BAMCO

Jo Taylor · Watercolor · 11" × 15" (28cm × 38cm)

Design variations: Value

On page 141 you saw this subject in a curved-line dominance and then it was changed to a straight-line dominance. These sketches are done from the same sketch, showing how the same subjects may be created differently through the combining of different elements and principles as well as different value schemes.

On this page and the next, the same subject is presented in each of the six broad value schemes. Only the line dominance and value scheme are changed. Note how each image, when compared to the others, has a unique feel and even a different atmosphere.

Original sketch
This original sketch has an exaggerated curved-line dominance with a few straight lines for conflict. While the subject matter is the same, the different sketches below have been changed somewhat to support the various line and directional dominances.

A piece of lighter value in darker value
With straight lines dominant and lengthened in this sketch, there is a vertical directional dominance. There are a few curved lines added for conflict. This scheme gives the feeling of warmth and sunshine, since the sun seems to be in front of the subject.

A piece of darker value in lighter value
It is interesting to see these two sketches side by side to see the extreme difference that the value plan can make. Straight line is still dominant in this sketch, but the value plan indicates perhaps a different time of day, when the direct light is behind the subject. This creates the effect of a silhouette.

A large dark and a small light in midtone

The line dominance is curved with only a few straight lines for conflict. After some consideration, if you think that more straight lines are needed, this planning stage is the time to do it. It is more difficult to make changes in the painting process.

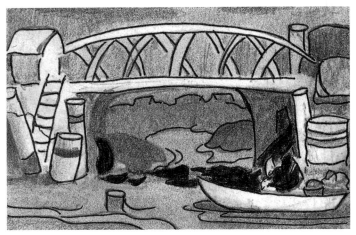

A large light and a small dark in midtone

Curved line is dominant in this scheme. The oblique direction is dominant, although there is no special emphasis on direction. This scheme gives the feeling of a sunny, bright day because of the larger area of light.

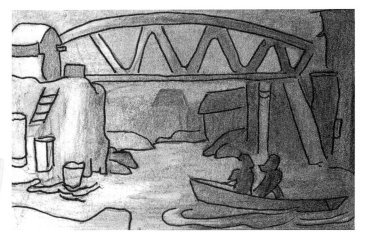

Gradation in any direction

The line dominance is curved with conflicting straight lines. The directional dominance is oblique. Gradation is used to create the feeling of a light direction—maybe an early morning sun coming up, creating an atmosphere of fog or mist.

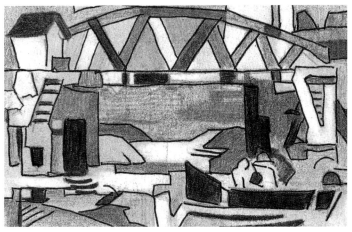

Allover pattern (disconnected lights and darks)

This value scheme adapts more to an abstract style than to realism. It is very dynamic and exciting because the value hops, skips and jumps. It has the character of a checkerboard. Even though it is an abstract concept, there remains the same line and directional dominance. Can you determine which they are?

Start light ❧

For any value scheme, remember that it's easier to begin by first surrounding the light shapes with a light midtone value. Then add darker midtone values, and place the darks last.

An experiment in abstraction

Look closely at the original sketch on this page. Now flip back to page 145 and look at the original sketch on that page. Notice any similarities? I have taken the realistic scene and made it abstract by reducing most of the shapes to their basic geometric shapes. The value schemes that give visual impact to realism will do the same for abstract art.

Original sketch

This original sketch of geometric shapes symbolizes some of the shapes in the realistic value schemes. In the beginning, this abstract sketch was made only for the purpose of illustrating the value schemes. However, as I worked it became more exciting to realize that this abstract could have significant structure and also enable me to explore distortion of perspective.

The horizontal bands, symbolizing the bridge, create large, medium and small negative spaces in between. The bands also function as a line holding the two side groups of shapes together to make a larger shape. Variation of size as well as alternation of size has been used in the large and small bands. The placement of the small squares in the two bottom horizontal bands creates large, medium and small sizes in the negative spaces between them. There is a dominance of straight lines, with some conflicting curved lines.

A piece of lighter value in darker value

The light horizontal band connects the light pieces, holding them together as a shape. In this sketch you see the seldom-used principle of alternation. In the light connecting band near the center, you see alternation: midtone, light, midtone, light. In the midtone band at the bottom you see alternation of dark and light midtones. Do you see more alternation of value?

A piece of darker value in lighter value

There is greater emphasis on the alternation of size in this sketch. There is also alternation of value. The large, medium and small sizes have been alternated in the band at the bottom, as well as the large, lighter horizontal bands alternating with darker midtone. Notice that within the midtone connecting band there is alternation of size and dark value.

A large dark and a small light in midtone
Both the light and dark shapes are connected. There is a connecting band of dark reaching from the group of dark shapes on the left to the other group of dark shapes on the right. The same thing is happening with the light. The eye goes to the largest group of light shapes on the right side and travels back across, following the broken dashes of light to the group on the left. This makes the small light connect as a shape. Without these connecting bands, the darks would not hold together as a shape. In the realistic version of this subject, the bridge functioned in the same way to connect the shapes.

A large light and a small dark in midtone
This is a good example of how the value schemes, regardless of painting style, may provide the same feeling or mood. There seems to be sunlight and a greater feeling of warmth in this scheme since the light is the larger shape. When the effect of sunlight and warmth is what you wish to express, choose the value scheme that has the larger shapes of light.

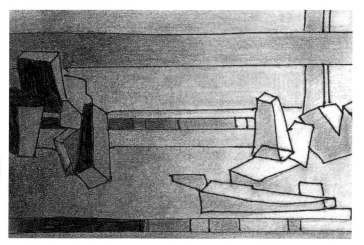
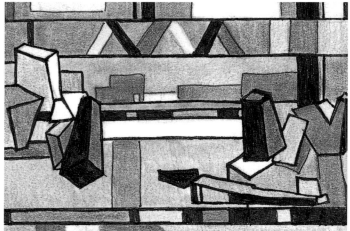

Gradation in any direction
The gradation from dark to light, even in this abstraction, gives a strong feeling of mood, atmosphere and light direction. Look back at the realistic version of gradation. In this version the light direction has been reversed. However, in comparison, it still implies light direction, creating a misty fog. Does it depict the same feeling?

Allover pattern (disconnected lights and darks)
Once again, compare this with the realistic version of the allover pattern. The realistic version is abstract but somewhat representational; there is recognizable subject matter. This version is nonrepresentational and still expresses the same feeling of movement and excitement. This sketch, which lacks conflict of line, would have a different feeling if a few curved lines were added.

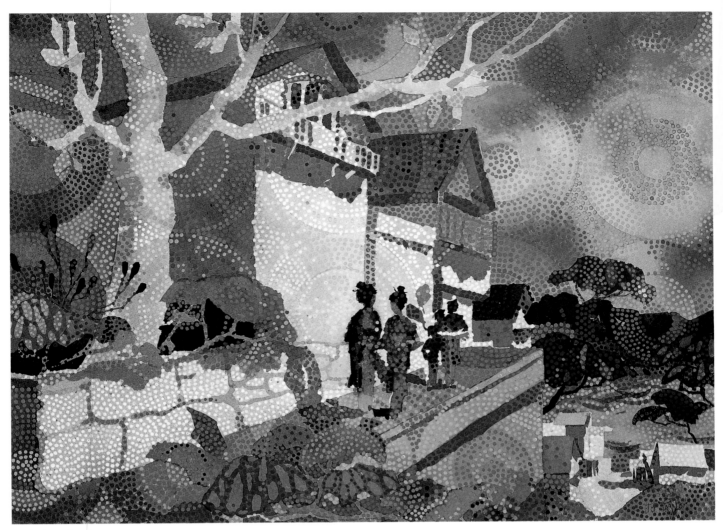

Variation of style

This painting was a completed transparent watercolor before the dots were added later. Typically, I add dots to a painting to achieve total unity by reinforcing the dominance of curved lines. In this painting, straight lines are dominant, which makes the design idea for this painting seem very different, if not a contradiction. We have all heard that you must know the rules in order to break them, and it is sometimes a challenge to do this with your art. The design idea in this work was to maintain the straight-line dominance even though the surface was covered with a grid of circles. How could I do it successfully?

Though quite a challenge, it was accomplished with the precise control of color and value. As the circles crossed into lighter or darker value or any different color, the color and value of the dots were changed. There are eighteen circles on the surface of this painting, and each circle took three to four hours to complete. Every hour and every dot was worth it because it was something I had never tried before.

Most people are curious about how the dots were applied and would probably never guess: medicine droppers! The bottles were filled about halfway with white gesso. Acrylic color was then added to make almost every color and value in the painting. There were probably one hundred or more droppers of different colors. The medicine dropper makes perfect round dots. This project was a lot of fun and an exciting adventure.

FISHERMAN'S WHARF—SAN FRANCISCO
Jo Taylor · Watercolor with acrylic dots · 22" × 30" (56cm × 76cm) · Collection of the Faber F. McMullen Family

EXERCISE

Use a pencil and the same subject matter for each of the following sketches:

1. Create a sketch with a straight-line dominance. Remember to start the composition with an overall good shape.
2. Do the same sketch again, only with a curved-line dominance.
3. Re-create one of the first two sketches with an oblique directional dominance.
4. Now do it in a horizontal directional dominance.
5. Next, try a vertical directional dominance.
6. Pick your favorite sketch from steps 3, 4 and 5 and do it in each of the six broad value schemes, realistically.
7. Reduce the same sketch to its basic geometrical shapes and do the six broad value schemes abstractly.

Planning a painting

The setting for this painting is a Japanese tea garden in San Francisco, where I spent a lot of time making sketches to use later for architectural reference. The planning for how it was to be painted was done in my studio. This demonstration shows the progression of the planning that took place.

Line and directional dominance options

Curved line/vertical dominance

Straight line/horizontal dominance

Straight line/oblique dominance

Value scheme options

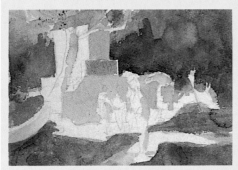

A piece of lighter value in darker value

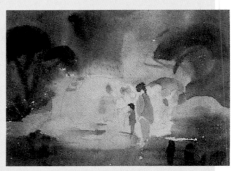

Gradation (to a spotlight)

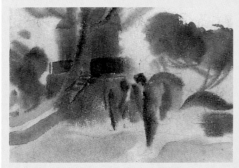

A piece of darker value in lighter value

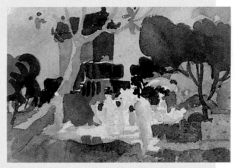

A large dark and a small light in midtone

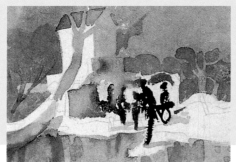

A large light and a small dark in midtone

Allover pattern (disconnected lights and darks)

1 Start with sketches of options ∾ Each sketch was put down on paper before I made any decisions. I went with a dominance of curved lines and a vertical direction. The value scheme selected was a large light and a small dark in midtone. The peaceful curved lines seemed to express my feelings. The vertical direction was chosen because I could see the possibilities of exaggerating and elongating buildings and figures. The value scheme provided an abundance of light for the painting. Damp, cold fogs roll into San Francisco many mornings, but this particular afternoon was sunny and warm. For this reason, the warm side of the color wheel was selected using an analogous scheme (red, red-orange, red-violet and blue-violet).

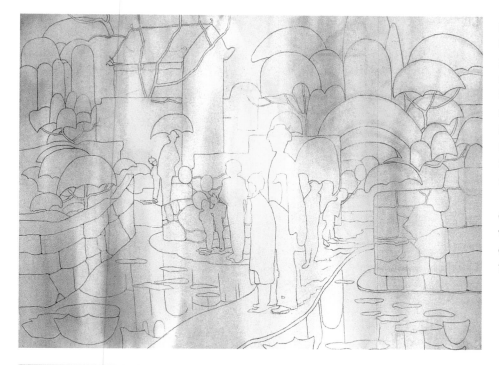

2 The underpainting 〰 After making the final drawing on 300-lb. (640gsm) cold-press paper, the entire sheet was wet with clean water. While the paper was still wet, the first washes were applied in a vertical direction using New Gamboge, Winsor Red and Winsor Blue. I used more pigment than usual for these washes, making the colors brighter to reinforce the warm color dominance.

Don't forget to let these first washes dry completely, then surround the light shape with light midtone value *before* adding darker midtones and darks. Without this step, the shape of light will be lost.

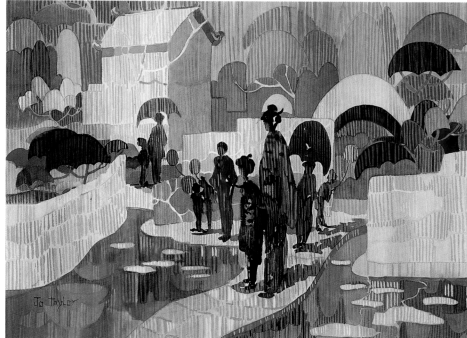

3 Finish 〰 From the first application of the underpainting to the elongated figures, structures and vertical stripes, the design theme of verticals should embody the entire composition. But how would I make vertical texture? Suddenly, the light bulb came on: vertical lines on the surface! The lines were painted with acrylics and a no. 8 round.

The painting was done in this style because of a design idea: that of total unity, including the element of texture. This painting is another example of how thinking and planning in the artist's language of design can lead to exciting new discoveries.

THE JAPANESE TEA GARDEN

Jo Taylor · Watercolor with acrylic lines · 22" × 30" (56cm × 76cm) · Collection of the Faber F. McMullen Family

Plan another painting

There are many more varieties and a lot more planning that could have been done for this painting. Beginners may want to try every combination they can think of before committing to a final sketch. Advanced artists may do this too, depending on the painting.

However, as you gain more experience and a good understanding of the other options possible, you may not need to sketch as many options during the planning stage to figure out what you want.

After all of the planning one might do,

there is still that crucial communication that takes place between the painter and the painting while the work is being done. Listen to what your painting tells you during the process, and be open to making changes.

1 Choose line and direction dominance ✥ I made two sketches: one with curved-line/oblique directional dominance (left), and the other with straight-line/oblique directional dominance (right). I decided that a pleasing afternoon chat with a friend in the garden would be best expressed with gentle, peaceful curved lines.

2 Pick a value scheme ✥ I chose the scheme with a piece of lighter value in darker value because there could be a greater abundance of sunlight for the lovely cast shadows that helped to inspire this painting.

3 Make a color plan ✥ I chose a triadic harmony of violet, orange and green, with the dominant color being the more aggressive orange, simply because I had never used this triad of secondary colors before.

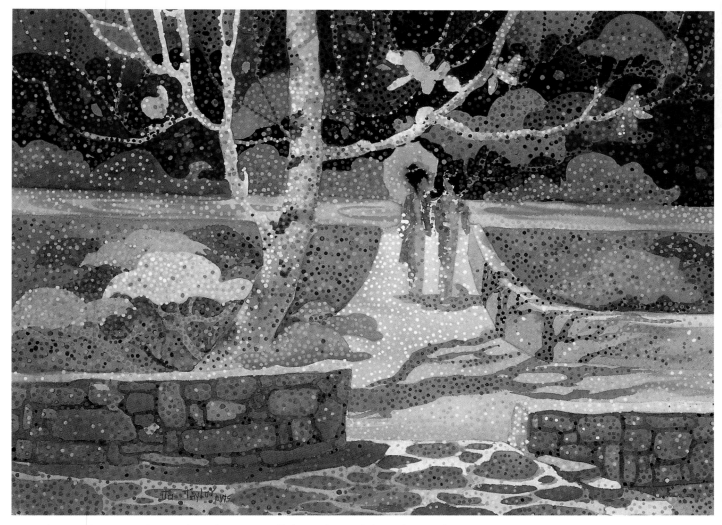

4 Finish ∾ The value scheme selected—a piece of lighter value in darker value—without the use of a dark positive shape provides a greater area of light. The sun is not visible, but cast shadows and the umbrella the woman is holding give the effect of warmth and sunlight. The feel of sun and light is made even brighter by the contrast of the very dark negative spaces in the background.

The purpose of the round acrylic dots in this painting is similar to the use of acrylic lines in the demonstration on page 150. In trying to incorporate as many principles as possible, this was another effort to have a totally unified design. Texture is one of the design tools that can be used as a unifying factor. Since curved lines are dominant, the dots seemed appropriate.

GARDEN ART CENTER
Jo Taylor · Watercolor with acrylic dots · 22" × 30" (56cm × 76cm)

Good design can be subtle

The three paintings on these two pages are
more traditional in style. They are of different
subjects with no unique design idea and yet
the structure is there as the underpinning.

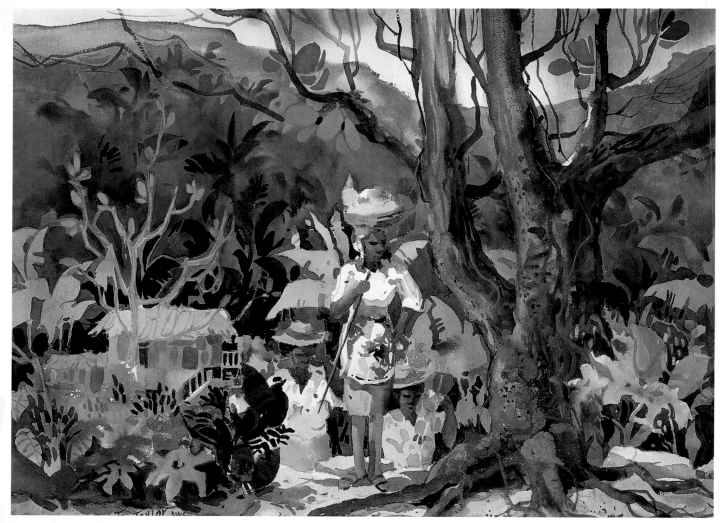

A natural composition

I took a walk behind the Sign Great House one morning to look at the beauty that surrounded me. Sign
is a township in Jamaica, and the Great House, a plantation house-turned-hotel, sat on top of a moun-
tain. Some of the locals were on their way to the market with their wares. If there ever was a time where
nature provided both the inspiration and a good composition, this was it. I painted this very close to the
way it looked, after uprooting a few banana trees to put them where they looked best in the painting.

 Direction does not play an especially important role in this painting. There is a dominance of gentle
oblique direction, which is sufficient to describe the activity and pace of the people going to market.
The value scheme is a piece of lighter value in darker value. The lines are dominantly curves created by
the rounded forms of the people and trees.

To Market

Jo Taylor · Watercolor · 22" × 30" (56cm × 76cm) · Collection of the Linda Taylor
Family

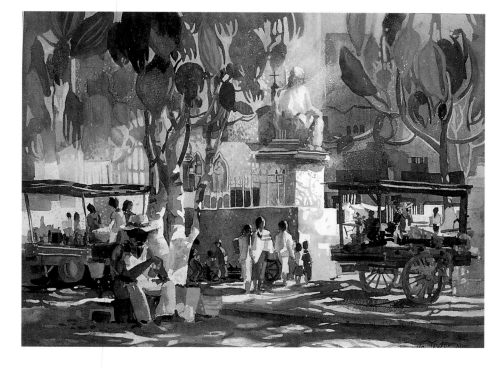

Senses can be better than a snapshot

The active setting around this town square might have been like other ordinary scenes found in small towns in Mexico. With the eye of an artist, I started seeing things that a camera could not have recorded. There was an abundance of shade trees and lovely sunlight creating shadows. There was a ray of light that scampered in and out among the trees, the statue of a national hero and the people. The atmosphere gave the scene a feeling of mysterious beauty that might not have been there otherwise.

The painting is executed largely in shades of gray except for the warms that are mostly in the foreground. Each time I glance at this painting those warms make me recall the wonderful food offerings with the aroma of cilantro and garlic.

CHIHUAHUA SQUARE, MEXICO
Jo Taylor • Watercolor and gouache •
22" × 30" (56cm × 76cm)

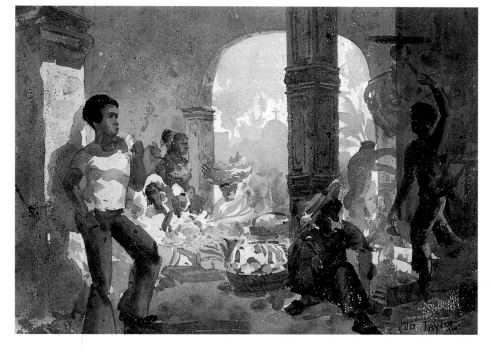

Capturing a moment in time

The dark interior of this huge, busy market created a very dramatic effect of light, which came into the building from a large window on the right side, outside of the picture plane. Painting the light was one of the motivations for choosing this subject matter. However, the interaction of human activities, attitude and emotion is the main content of this painting. There was no talk of political rebellion at this time in Jamaica. There was love, laughter and the joyful sound of calypso music everywhere.

The one exception to this was observed in the attitude of the young teenager. I thought at that moment that his attitude might be the forerunner of problems to come for the country. I painted the attitude into the face of the young teenager leaning against the column on the left. As it happened there was rebellion in their country a year or two later. Tourists have only been returning to the beautiful country of Jamaica in very recent years.

THE JAMAICAN MARKET
Jo Taylor • Watercolor and gouache •
22" × 30" (56cm × 76cm)

Same subject, different designs for a series

Most series plans are done in the structural planning of a single painting. Usually only one is chosen for the painting, and the other plans are thrown away. Most of the time the discarded ones would also make good paintings. This series happened in a bit of a different way. I painted the *Sea Treasures* series many times because I liked exploring the ocean beaches as well as the water's edge on inland lakes. I shall never tire of exploring beaches, but after a time I looked for different variations for painting this beloved subject. Variety is the spice of life, and in art, as in life, a variety of experiences will bring development and growth.

A piece of lighter value in darker value

In this painting there was a pitfall that I must share with you in order for you to avoid it. In pencil, I drew the intended "high" on the top left side, including the fisherman's net, coral and seaweed. On the bottom right side, shells were placed as the "low." All was well! In my sketch I had a good shape. The pitfall? I had envisioned the value scheme as a piece of lighter value in darker value, not realizing that the shape of the light must include the net at the top as a part of the light shape. Without it I would not have a "high" on that side.

SEA TREASURES #1
Jo Taylor · watercolor and mixed media ·
22" × 30" (56cm × 76cm)

A large light and small dark in midtone

The first morning of the first summer I spent in Maine was a time of exploring new territory for painting material. Just as the sun began to rise I saw a glimmer of sparkling, translucent white coming from the discarded nets of the fishermen. In the abandoned nets, the buoys, ropes, barnacles and broken, sun-bleached sea urchins were a beautiful sight. The sun was creating wonderful light and shadow. The intention in this painting was to make the shells appear to be caught up in a net just as I first saw them.

An airbrush was used to spray a gray watercolor solution for the background texture. Actual coral, fishnet, bones and shells were used as a stencil. Anyone having this much fun is very likely to forget the "high" and "low"! If it happens, forget it and just have fun.

SEA TREASURES #2
Jo Taylor · Watercolor and mixed media ·
22" × 30" (56cm × 76cm)

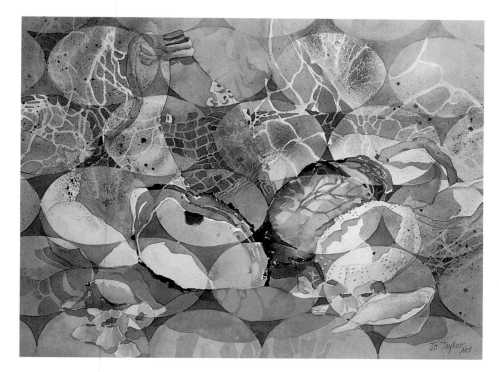

Abstract interpretation

The idea behind this painting was to create an abstract version of a favorite subject that I had painted in a realistic style many times before. I started with the shape of the sea urchin and used pencil to draw a grid of that shape over the entire sheet of watercolor paper. Next, I superimposed a double image of a composition of sea treasures using items from the fisherman's net. The pencil lines of the grid were made dark enough so they could be seen through the painting of the shells, sea urchins and the old barnacle-covered bottle. After the painting was completed, each grid shape was rendered as if it was a complete design of its own.

THE TREASURE GRID

Jo Taylor • Watercolor and mixed media
• 22" × 30" (56cm × 76cm)

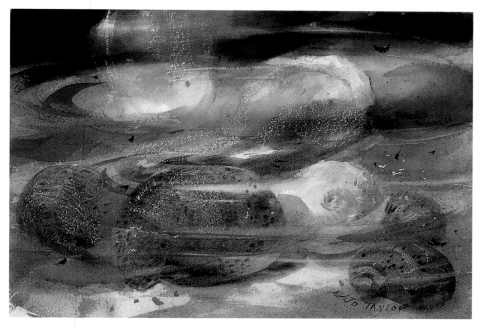

Underwater view

As a young girl I was a good swimmer and could hold my breath for a very long time. I was able to enjoy the sights underwater in the ocean. With the help of a snorkel and the crystal-clear water I could see the coral reef and minute details on the bottom of the ocean. There were lovely sunspots and water currents that swished about to make wonderful subjects for painting.

If you want to re-create reflections in water or paint something underwater, simply paint the objects underwater as they appear first. Before it dries completely but after the gloss has begun to leave the paper, make a thirsty brush lift mostly in a horizontal direction for the reflections. The sunspots on the top left and bottom right side of the painting serve as an oblique thrust that creates the beginning movement of the eye.

ANOTHER WORLD

Jo Taylor • Watercolor • 22" × 30" (56cm × 76cm)

Painting an abstract

Materials

- No. 2 drawing pencil

- Kneaded eraser

- Sketchbook

- *Paper* 300-lb. (640gsm) cold-press

- *Brushes* Your usual set, with separate brushes for the acrylic paint (nylon bristles will do)

- *Watercolor paints* Full palette

- *Acrylic tube colors* Burnt Umber, Cadmium Red Light, Naphthol Crimson, Phthalo Blue, Yellow Medium Azo (I used Liquitex)

- Stir sticks (or the handle of a small brush)

- Empty medicine droppers (for applying acrylic dots)

Storing acrylics ❧

Store leftover mixed acrylic colors in medicine bottles, discarded film containers, pimento jars or other small containers for later use.

The idea of this painting was conceived after an argument with my husband. I perceived that he thought he had won. Quietly steaming, I planned and drew this momentary viewpoint of mine.

By the time I finished painting, I thought it was comical rather than real. I showed it to my husband. He looked long and hard and then said, "Do you believe I really think you are a birdbrain?" We both laughed and laughed. After all, it wasn't real; it was merely the abstraction of an idea. Not his, but *mine!*

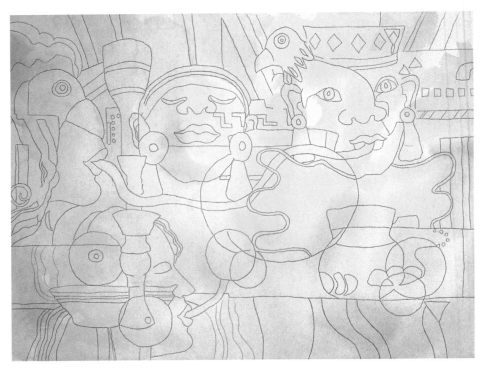

1 Pencil sketch and underpainting ❧ I began by laying out the abstraction of my idea in my sketchbook. The drawing was carefully worked out as a double image, using some of the still life objects in my studio to weave in and out of the design. With multiple faces and the rounded form of the birds, it seemed natural to choose a curved-line dominance. There is a subtle oblique dominance with conflicting horizontal bands. With the sketch carefully worked out, it was then transferred to my watercolor paper.

I chose a split complementary color scheme of violet, green and orange. Regardless of the color scheme, I use only the three primary colors of pale red, yellow and blue for the underpainting, which was done with a large wash brush without very much mixing and merging of color on the paper. This gives automatic color change without graying of color.

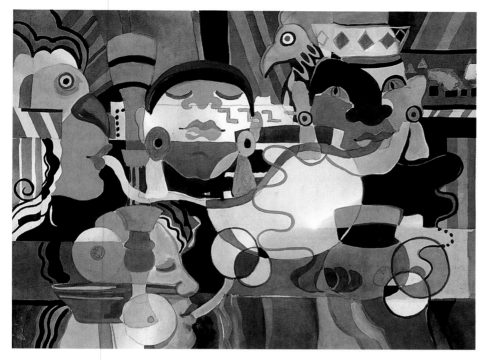

2 Add midtones and establish a value scheme ∾ The value scheme is a large light and a small dark in midtone. The light is a connected shape. In adding middle values, we should first surround light shapes with the lighter midtone value so they will be visible throughout the rest of the painting. The next step is to keep adding shades of darker midtone to establish a transition between the lightest lights and darkest darks. This will give you a good value chord, which is just as important as a value scheme. Although most of the darks do not actually touch, they are held together by implication because they go behind objects and come out on the other side.

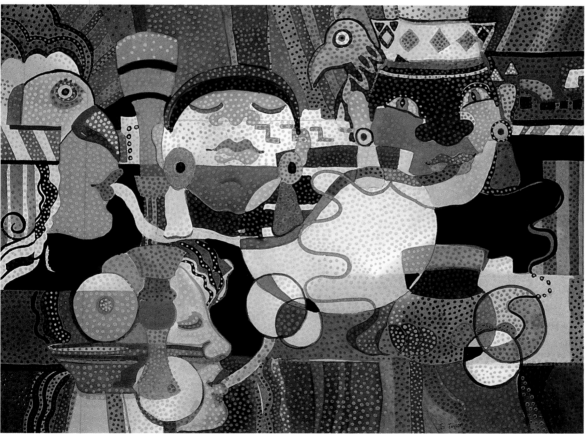

3 Finish ∾ Curved lines and rounded forms are dominant in this painting, and for the sake of total unity, the texture of round dots seemed appropriate. Each dot painting that I have made has been done for different design reasons. In this instance, I wanted to use complementary colored dots to see if the color would have more vibrancy and luminosity. Some of the dot colors in the painting look almost electric, whereas others do not show up as much. Finding out why may be my next area to explore.

THE ARGUMENT

Jo Taylor · Watercolor with acrylic dots · 22" × 30" (56cm × 76cm)

Finding new compositions within a painting

There are at least two or three sections in this painting that I think would make better paintings than the original full version. This is often the case. I think the reason is that the enlargement creates a simplification of design. Always look carefully at your work for new compositions that might become something even more beautiful.

PINKS AND PETUNIAS
Jo Taylor · Watercolor · 22" × 30" (56cm × 76cm)

Interpreting vs. reporting ∿

When I paint, I aim for the essence of a design and not a photographic report. This may not be how you choose to paint. Your way may be to paint flowers as they actually appear, with every detail and every petal. How could you go wrong, if they are painted masterfully and beautifully?

It takes courage to not paint things as they actually are. The reason for this is because most of our aim since childhood has been to draw things from nature as they appear. Therefore, it is difficult to make the transition from drawing to painting the essence of something—your own unique interpretation of the subject.

Detail
This section of *Pinks and Petunias* could stand on its own as a painting.

Evaluating paintings for good design

The next couple of pages show a few images and the elements used in each. The first image is a color sketch done prior to the final painting, and the other pages show paintings you may remember from earlier in the book. For every example, evaluate each of the elements according to the design principles. Remember, to be considered structurally sound, a painting should have four or five dominances of the elements. Examining your paintings in this way will help you improve your design skills.

In order to evaluate the elements according to the principles of design, you must choose what will be dominant in each individual element. Ask yourself, Which line should be dominant: straight or curved? Which value: light, dark or midtone? Which color: warm or cool? Which texture, shape, size and direction? Then, each chosen element must have unity and conflict as well as dominance.

If any element you chose lacks unity, conflict or dominance, then use the principle of repetition. Repeating the chosen element will give it dominance and unity. With dominance and unity in place, you now can add conflict to stimulate interest.

Unity, conflict and dominance are the fundamental principles of aesthetic order. Repetition is used to create dominance and unity. The other four principles—alternation, harmony, balance and gradation—are each important principles and are also useful tools to use in analysis. However, they are not always requisite for good composition.

This kind of analysis will reveal to you the weaknesses and strengths of your paintings.

Structural analysis ❧

For every painting, judge the elements of:

line · **value** · **color** · **texture** · **shape** · **size** · **direction**

...according to the principles of:

unity · **conflict** · **dominance** · **repetition** · **alternation**
harmony · **balance** · **gradation**

Elements of design
Line—straight line dominates, with conflicting curved lines
Value—large light and small dark in midtone
Color—split complementary of yellow, purple and blue
Texture—dominantly smooth
Shape—rectangles dominate
Size—variation of large, medium and small shapes
Direction—horizontal dominance

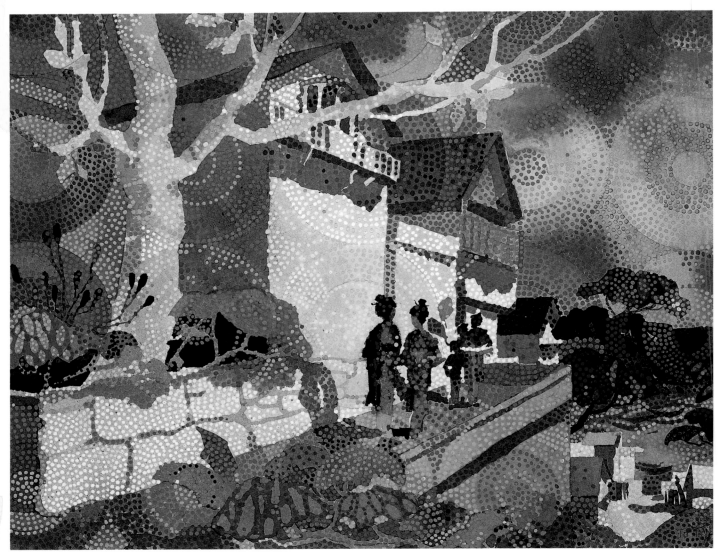

Elements of design

Line—dominantly straight lines with conflict of circular grid

Value—a large light and a small dark in midtone

Color—complementary color scheme with varying shades of red and green

Texture—dominantly rough with an allover grid of dots

Shape—dominantly rectangular forms

Size—large, medium and small shapes

Direction—dominantly oblique

Something interesting to note is that while there are more curved circles and a myriad number of round dots, optically the straight lines are still dominant. The design objective in this painting was that through careful control of value in the round grid patterns, there could still be a dominance of straight line. That is the reason for both light and dark dots within most of the circles.

Recommended reading ❧

Design Principles and Problems (Second Edition) by Paul Zelanski and Mary Pat Fisher (Fort Worth, Texas: Harcourt Brace College Pub., 1996).

Evaluating a sociopolitical painting

The original concept for *Plight* progressed over a period of many years. The painting was done during the time just prior to total racial integration in the 1960s, a period marked by intense unrest, with the burning of buildings, riots and families turning against one another. As people felt the heartaches from the past, there were mixed emotions. There was fear, and at the same time, hope for the future.

Some of those emotions are evident in the final painting. Concern and fear for the future can be sensed in the older man, hat in hand, looking to the heavens for guidance. The indifference of the woman who doesn't want to be bothered seems evident. She may be saying, "Who needs education or equal rights? Just let me get the ironing done!" The innocent little girl, caught in the middle, doesn't realize that her future is at stake but wonders why she can't sit down in the drugstore for ice cream with her best friend.

This painting is a social subject; it demonstrates sympathy for oppressed people everywhere. It is also a historical record of a day when man took a great step toward human decency and compassion for his fellow man.

In general, social subjects do not do well in art competitions because there is always the opposition to its content. For instance, I can't imagine that the political murals and paintings of Diego Rivera were popular with the Mexican government at the time they were rendered. However, it remains that an important purpose in art is for the artist to express his ideas, feelings and experiences. In spite of being a sociopolitical subject, *Plight* did get into competitive shows and won many awards.

Incidentally, I was the best friend of the little girl pictured.

The first sketches for *Plight*

There is subtle emphasis on direction in this composition. There is an oblique directional movement beginning with the faces of the man and woman on the left. The inside line of the man's coat leads your eye down to the child. The eyes of the female are also leading to the child. The child's eyes are focused back toward the rioters and the signs they are carrying. This leads the viewer's eye toward the light of the sky above, which is established in the finished painting. Notice that the buildings on the right side of the finished painting stair-step downward, leading your eye back in toward the adults' faces.

Elements of design

Line—dominantly curves
Value—a piece of darker value in lighter value
Color—monochromatic with a warm-color dominance
Texture—mostly smooth
Shape—dominantly round forms
Size—large, medium and small figures, buildings and negative spaces
Direction—oblique dominance

Experimentation and Discovery

Through many years of teaching I have found that students are eager to understand abstract and nonrepresentational art. This is a broad field, and I am not presumptuous enough to think I understand it all or always know what another artist's intentions are. A painting means one thing to the artist but evokes many different interpretations from its viewers. We each bring our own set of experiences and preconceived ideas with us as we view a work of art, and it doesn't have to be the same interpretation as that of the artist.

In this gallery you will see several variations of style. A few of these paintings are the result of assignments I've given to students in an effort to improve their understanding of design structure, regardless of personal taste or choice of style. For all of their differences, the one thing that connects all of the paintings is the application of good design. Some of them were created with mediums other than watercolor. The same design principles and elements apply to any medium.

Many artists have confided to me that they were not born creative, inventive or imaginative. I respectfully differ with every student that has ever said this to me. I realize that most of us cannot compare to the Einsteins of this world. However, through the understanding and use of the elements and principles of design, we have the means to formulate our thoughts and express our emotions visually. Every person, every artist, is filled with endless creative ideas that can be expressed through art. ❧

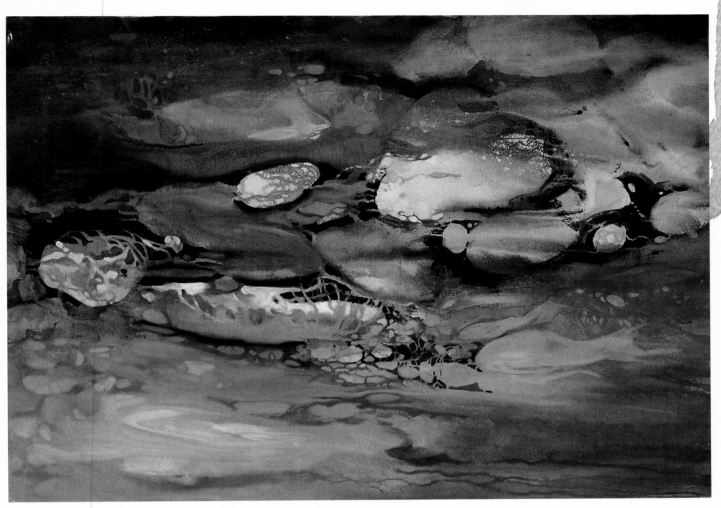

Looking close

There is a lot of hidden and undiscovered beauty around us to be enjoyed. I have been near the ocean in many places and examined the backwaters and tide pools extensively. I discovered the most beautiful tide pools on top of the enormous boulders on the rugged upper coast of Maine. The cold, pristine, crystal-clear water on top of the boulders made it possible to see the most minute detail among the coral, seaweed and barnacles.

There were moody mists and fog rolling in most of the time, but I saw many lovely sunsets as well. Quite often I would still be out on the boulders painting or filming tide pools as the sun went down. Under certain weather conditions the sunset colors would be reflected in the tide pools. Because of that, I decided to paint a dominance of warms in this tide pool without actually painting the sunset.

TIDE POOLS

Jo Taylor · Acrylic and oil · 28" × 40" (71cm × 102cm)

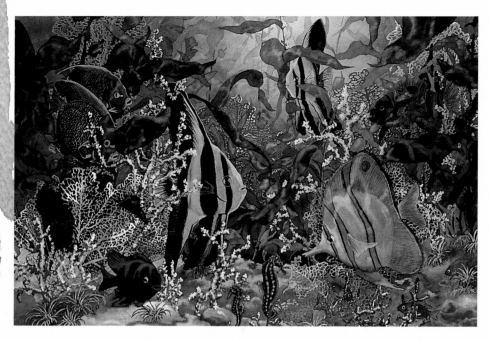

Some like it real

When looking at this image, you almost feel that you could reach out and touch the beautiful fish. There is a great understanding of depth, value and color in recession in this painting. Sandra Spann has studied with me for many years. She has been one of the most thorough students in her studies of value plans and design assignments. There are as many ways to paint as there are painters. Although Sandra paints abstract art equally well, I chose this particular painting to show because when one paints so beautifully as a realist, there is always an audience to enjoy it.

JEWELS OF THE SEA
Sandra Spann · Watercolor · 22" × 30"
(56cm × 76cm)

More than one way to catch a fish

In this painting, the underlying theme of repetition is expressed in many ways through the subject of fish. Since these fish are a figment of the artist's imagination, it seems to me that the emphasis in this piece is on design (and its title certainly gives a clue!). Even the title of the painting is indicative of the design theme. In music we so often hear the phrase "repetition with variety" in reference to the main melody of a song. It is helpful to see repetition with variety also used in a painting. There are large fish, a medium-sized linear grid of fish over the entire painting and the repetition of small fish in the border.

REPETITION
Calleene Shelton · Watercolor and gouache
· 22" × 15" (56cm × 38cm)

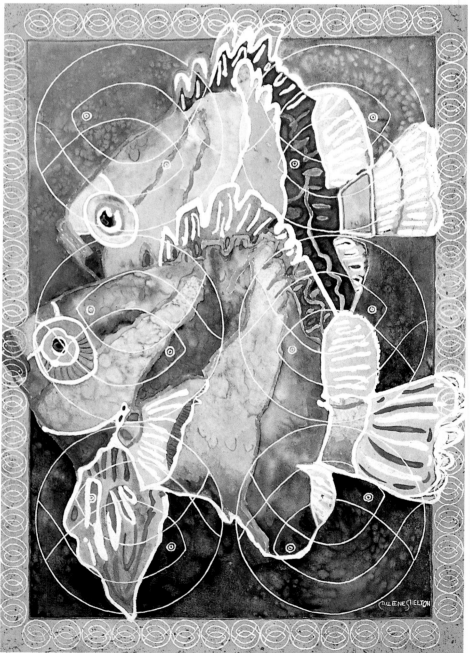

Searching for your subject

This breed of bird is called the skimmer. It is a very large and beautiful bird that flies along the Texas coastline at a great speed to skim the surface of the water looking for small fish to feed its young. One day my family happened upon a family of skimmers. By being still and very quiet, we were privileged to observe the mother and father feeding their young and preening their wet feathers. Suddenly there was a commotion among the young ones; birds were jumping and flapping their wings, and quickly the mother stepped in to settle the argument, which I gather must have been over the food. The thought occurred to me at that moment how very much like humans the animal world is—or maybe I should say how very much like the animal world *we* are!

It wasn't possible at the time for me to sketch or photograph this family of birds. However, as I observed, it was obvious which birds were the young ones fighting in the background, which ones were preening and which one was the worried mother feeding the young. I made many preliminary sketches from memory before transferring the sketch to 140-lb. (300gsm) rough watercolor paper. I used enough definition of edges and drawing to distinguish the different birds in the family, but at the same time was free and loose in style to express the commotion and movement of the group.

THE FAMILY
Jo Taylor · Watercolor · 22" × 30" (56cm × 76cm) · Collection of Mary Aslan

Art must speak for itself ∾

In the test of time, a piece of art must stand on its own. The artist is not present to explain, radiate enthusiasm or identify the subject. Some will judge a painting's structure and content. Some will wonder about the technique and how it was rendered. Others will ponder the artist who created it. Regardless, a painting stands alone to be loved, liked, appreciated or hated. A great teacher of mine once said, "It is the amateur who likes only the best." It is important to look for the good, the unique and what we may learn from each and every piece of art.

Symbolism

The horizontals and gentle curved lines in this painting symbolize rest and quiet after devastation and destruction. In the upper part of the painting there is darkness, with a single tree barely visible but still standing. The top red stripe is the symbol for fire, which has ravaged the earth. The dark green stripe and the red stripe represent the strata of the earth. Below there are the seeds that are growing toward the light and roots—a new beginning.

This painting is intended to be symbolic of the human race. Today and throughout the ages we come back to the same problem of the struggles involving power, greed and prejudice. Since early history there has been war and devastation. The quiet, overpowering awe after a great disaster only prevails for the moment, because within the resilient human soul is a seed already growing toward the light. Such is the seed of hope within the spirit of all humanity—and the inspiration for *Survivors*.

SURVIVORS

Jo Taylor · Watercolor and acrylic · 22" × 30" (56cm × 76cm)

Abstraction of an idea

This artist's idea was to express the busy rush that life has become for most people. The technological changes of recent decades are almost overwhelming. I have often said, "Being too busy has become a national disease." In the upper right section of the painting, the artist placed a very small figure in a running silhouette. This represents the life of one person—so insignificant, so small, trying to keep up. It portrays how one can feel in the overall scheme of our vast and fast-paced world.

The structure of this very expressive painting is made up of interesting geometric shapes of curves, squares and rectangles. The curved lines are dominant and create an interesting path leading the eye through the composition. The color scheme is a split complementary one of purple, yellow and muted shades of reddish brown. It uses an allover value plan of disconnected lights and darks.

RUNNING IN CIRCLES

Judith L. Barry · Watercolor · 22" × 30" (56cm × 76cm)

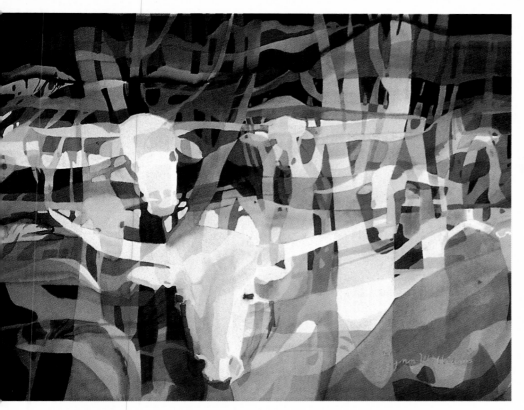

X-ray painting

This type of painting comes from the idea of seeing through objects as you would in an x-ray picture of the human body. This effect can be accomplished in a painting by (1) overlapping all objects or forms in your composition; (2) drawing objects in the background first and overlapping the objects as you draw toward the front, leaving all lines showing; (3) changing color, value or texture each time you cross a drawn line as you paint; and (4) embellishing the finished painting with interesting texture.

The way in which this painting is done brings to mind the survival of the frolicsome longhorn throughout the history of Texas. The overlapping in this well-composed painting gives the effect of an entire herd of longhorn. An allover value plan of disconnected lights and darks was used, which is very applicable to this abstract style.

RED TEX
Lynn Williams · Watercolor · 22" × 30"
(56cm × 76cm)

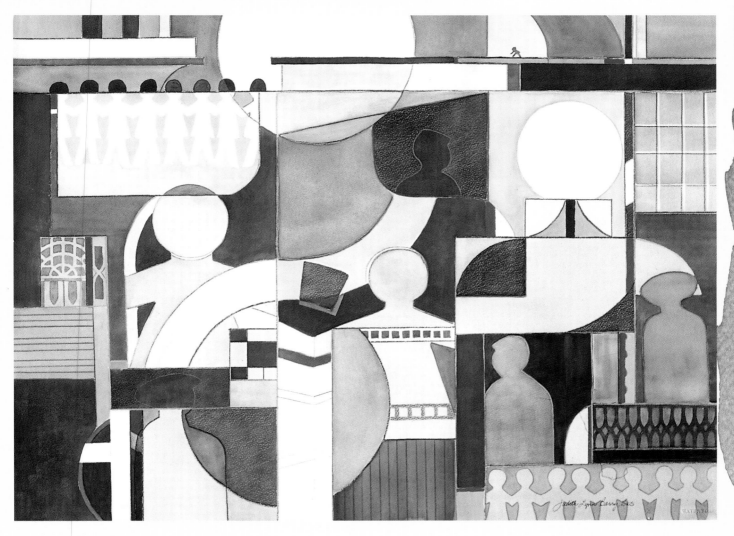

Double-image painting

The difference between double-image painting and x-ray painting is that the x-ray involves seeing through overlapped objects. The double image consists of images of two different subjects juxtaposed to produce a composite picture. Make a detailed drawing first as a guideline for both subjects. Then, while painting, change color, value or texture when crossing the lines of each subject.

My first approach to this painting was to make a pencil sketch of a geometric shape. I chose the square because I thought it might be the easiest for my first attempt. I drew a grid of squares on my drawing paper. That didn't look very interesting, so I put a dot in the exact center of one square. From that dot I drew lines out to the edge of the first square. When I drew the lines out from the center of the next square, I discovered that it gave the squares a three-dimensional appearance. This was intriguing to me.

Now I needed to think of a subject to combine with it for the double image. After looking through my sketchbooks I chose the sketch of a couple that posed for a drawing class. I made a sketch of both the squares and the two figures. The painting behind the grid was started first. Then the grid was painted in light midtones to better define it. After that, it was a slow process of painting the midtone stripes of the grid a little darker while painting the negative spaces in the center square lighter. This brought the couple forward so they became more prominent.

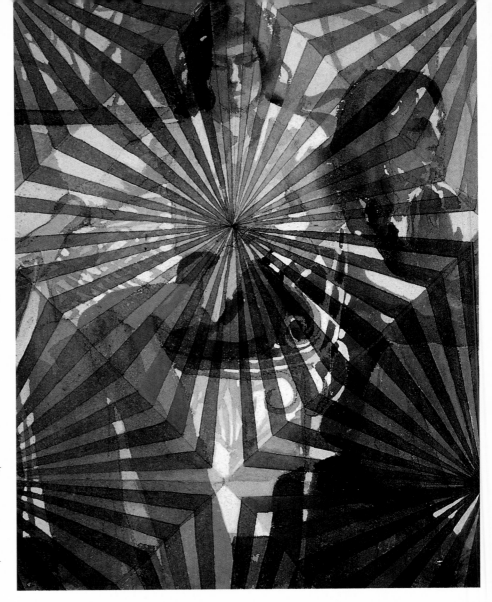

WHATEVER WILL BE, WILL BE
Jo Taylor · watercolor and gouache ·
15" × 11" (38cm × 28cm)

Weaving

I learned about the weaving technique, in which two paintings are cut into strips and woven together, from Maxine Masterfield in an experimental workshop years ago. Immediately I thought about the many old paintings of mine and those of my students stored in closets and under beds. Finally, I had found something interesting to do with them.

The first few weavings I tried were cut into one-inch (25mm) strips. The weaving pictured here was cut into half-inch (12mm) strips. After the weaving, you may wish to save some of the colors and patterns from the two original paintings in some areas, or embellish in other areas. Often the weaving at this stage will suggest ideas or areas for development. In this piece, embellishing each of the small squares seemed to bring about an overall unity that made the two paintings belong together. I used inks, foil and acrylic paints.

I used some mats to complete the design. To make the large, dark circular mat a meaningful part of the design, small squares were cut out of leftover scraps of paper, painted like the squares in the weaving and glued onto the round mat, repeating the square motif.

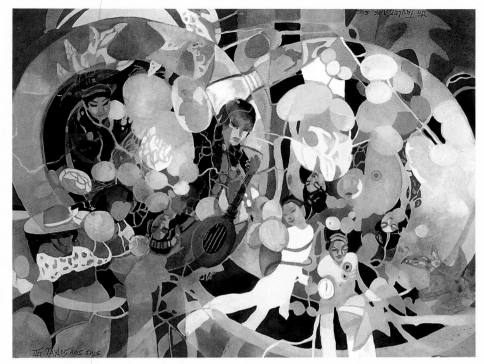

Right side up...

In this image, look at the small nymph-like figure just to the right of center. She has a chain around her that restrains her just as she begins her joyful flight. Now look to the far left and you will see a female figure wearing a hat and an elegant lace collar on her dress.

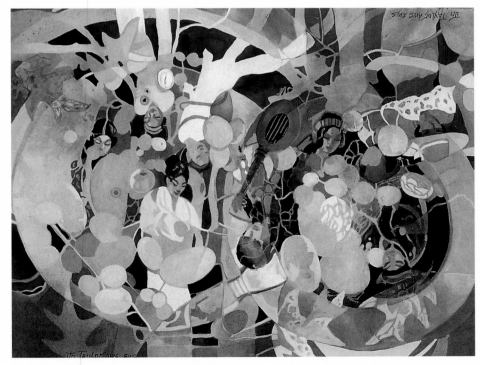

...and upside down

From this perspective, the little nymph seems to be an optical illusion. Instead there is now a large tree with branches and limbs, and beneath the tree is a new figure dressed in a long dress and a white fur stole. Also, on the far right, the lady in lace appears to have been an optical illusion as she fades completely into the background.

Optical illusions

My family and I lived in a wooded area with a creek running through it at the time I conceived the idea for this painting. For years I enjoyed sitting on a large bent tree that leaned out over the creek. I studied light and shadow, the lovely textures of nature and watched the trees and clouds in the reflections of the water. While enjoying the tranquility and quiet I often reflected on my past, present and future.

One day while sitting on my leaning tree, an acorn suddenly dropped into the water. The still water was transformed into wonderful circles of fragmented pieces of sky, clouds, trees and thoughts of my life. This image stuck in my mind for years before I had time to paint it. The human mind is a storehouse for ideas. Many times ideas like this lay dormant for years and then surface at a time of need.

I had originally planned to paint *Reflections* as a circular painting with a motor behind it to slowly rotate the image, allowing the viewer to see it from all directions. It was a challenge to make it interesting to look at in any direction. The idea of optical illusions was a part of the planning along with the revolving of the painting. However, every detail could not have been planned. Details must be allowed to unfold or evolve while painting.

This painting is now framed with wires on the top and bottom so it can hang either way. Study these two views of the painting to see the different images you can find.

REFLECTIONS · Jo Taylor · Watercolor and gouache · 22" × 30" (56cm × 76cm)

Conclusion ❧ To continue to grow and develop as an artist, you must seek a broad vision of art and realize the enrichment that art brings to life and its essential value to humanity. There also must come a time, if you are to grow, for some philosophical contemplation.

During recent years, we have become acutely aware of disturbing transitions in all areas of life. Volumes could be written about the oppressive feelings and the dehumanizing effects of our technological era. The mind and spirit cry out for fulfillment.

There are trendy painters who imitate and exploit, and who are exploited. Much of the work of the avant-garde artists is a reflection of the disbelief and cynicism of their generation. It is often a gesture of liberation from values: political, aesthetic and moral. I believe that a new system is needed, a fresh start. Perhaps therein lies a part of the purpose and responsibility of the artist today.

As artists, we should feel our work is something of importance to our heirs and to the world around us. No matter what the style or history of a painter may be, the antiquity of a work of art becomes precious to generations to come. This is evident in museums where we often see exhibits of artifacts and works of art remaining from crumbled and vanished civilizations. The people are gone, the architectural structures crumbled and vanished, yet much of the art and artifacts remain. Each person who visits a museum is given the opportunity to look into a window on a place in time and a chance to experience the work of artists past, present and future.

There seems to be a need as well as an ability within all of us to create some form of art. I believe that this need for art reaches beyond the realm of human understanding, and that it serves our basic human needs in ways too complicated and too unexplored to explain. Because of this need within, a steady flow of discerning, genuine painting continues on as new forms of art emerge and others fade.

It excites me to think of the mysteries of the human mind yet to be explored, and I eagerly anticipate the discoveries yet to be made by artists of the future. Meanwhile, it is comforting to know that within the short span of our lives, there are boundless discoveries of our own to be made. The challenge for us is neverending.

Art is a power; a pathway toward a deeper understanding of all things; a personal journey toward truth and realization; a social renaissance; a fresh start for humanity. It is a spirit of joy and hope. Art is a servant to the creator of beauty, and we are its ministers.

Jo Taylor

BARSE'S BARN · Jo Taylor · Watercolor and gouache · 30" × 22" (76cm × 56cm)

Index

Get more of the best watercolor instruction!

Painting the Allure of Nature

Nature paintings are most compelling when juxtaposing carefully textured birds and flowers with soft, evocative backgrounds. Painting such realistic, atmospheric watercolors is easy when artist Susan D. Bourdet takes you under her wing. She'll introduce you to the basics of nature painting, then illuminate the finer points from start to finish, providing invaluable advice and mini-demos throughout.

ISBN 1-58180-164-5, hardcover, 128 pages, #31914-K

Painting the Things You Love in Watercolor

This gorgeous book shows you how to colorfully combine your favorite nostalgic items like handmade quilts, china and lace with small songbirds or kittens, then bathe them all in beautiful sunlight. You'll find guidelines for developing any heart-warming memory or curious story into a lovely composition. Each step is shown through invaluable mini-demos with finished examples.

ISBN 1-58180-181-5, hardcover, 128 pages, #31948-K

Watercolor: Pour It On!

Create startling works of art that glow with color and light! Jan Fabian Wallake shows you how to master special pouring techniques that allow pigments to run free across the paper. There's no need to worry about losing control or making mistakes. Wallake empowers you to trust your instincts and create glazes rich in depth and luminosity.

ISBN 1-58180-161-0, hardcover, 128 pages, #31910-K

The Watercolorist's Essential Notebook

Beautifully illustrated and superbly written, this wonderful guide is perfect for watercolorists of all skill levels! Gordon MacKenzie distills over thirty years of teaching experience into dozens of painting tricks and techniques that cover everything from key concepts, such as composition, color and value, to fine details, including washes, masking and more.

ISBN 0-89134-946-4, hardcover, 144 pages, #31443-K

THESE BOOKS AND OTHER FINE ART TITLES ARE AVAILABLE FROM YOUR LOCAL ART & CRAFT RETAILER, BOOKSTORE, ONLINE SUPPLIER OR BY CALLING 1-800-448-0915 (US) OR 01626 334555 (UK).